5-3-2018
Received a
job Today at International
Institute. Went to "Mass"
at St Mary's to say "Thanks"
- This book was free. A
special book on the Blessed
Mother ME

Many have painted her. But there was one

Who drew his radiant colors from the sun.

Mysteriously glowing through a background dim

When he was suffering she came to him,

And all the heavy pain within his heart

Rose in his hands and stole into his art.

His canvas is the beautiful bright veil

Through which her sorrow shines.

There where the frail

Texture o'er her sad lips is closely drawn

A trembling smile softly begins to dawn—

Though angels with seven candles light the place

You cannot read the secret of her face.

—Rainer Maria Rilke, from The Book of Hours

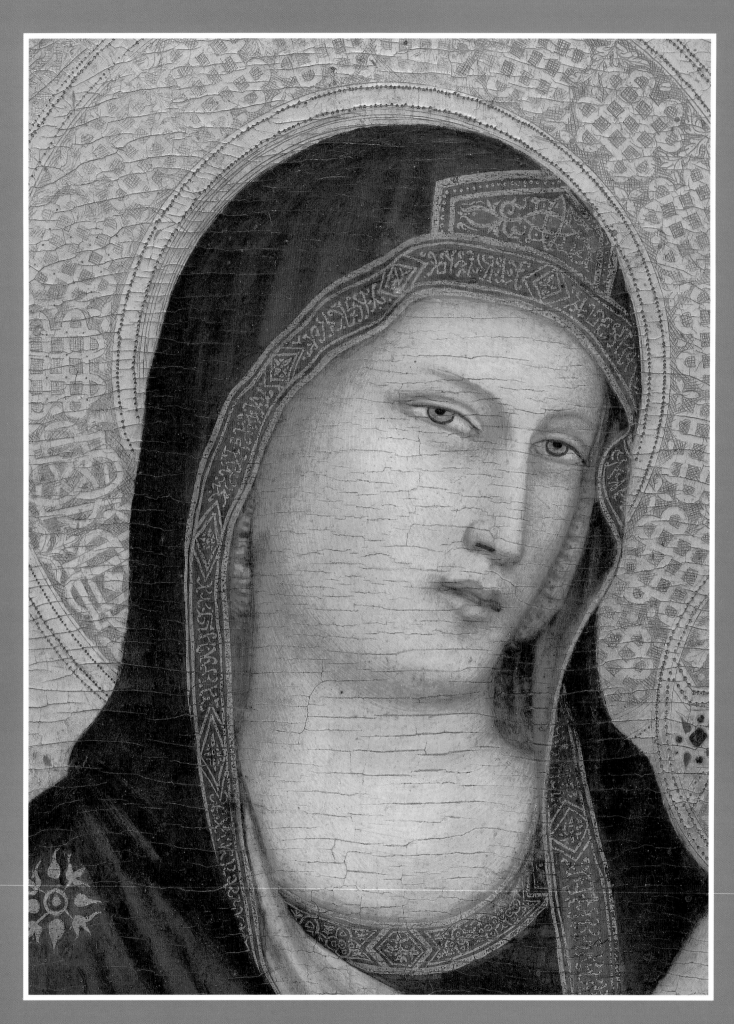

Salutations unto thy face, O holy and glorious face,
the splendour of which is sweeter than the splendour of the sun and moon.

HER FACE

Images of the Virgin Mary in Art

Selections from
The New Testament,
Apocryphal Gospels,
Devotions, Hymns,
Legends, and Poetry

by

Marion Wheeler

FIRST GLANCE BOOKS, COBB, CALIFORNIA

For Esther and Nancy,
Amy-Elizabeth and Olivia

Frontispiece:
GIOTTO, *Madonna and Child*

REPRODUCTIONS FROM PUBLIC COLLECTIONS

National Gallery of Art, Washington DC
Metropolitan Museum of Art, New York
The Cleveland Museum of Art
The Sterling and Francine Clark Art Institute, Williamstown, Massachusetts
Museum of Fine Arts, Boston
The Freer Gallery of Art,
Davenport Museum of Art, Davenport, Ohio
The Art Institute of Chicago
University of Michigan Museum of Art, Ann Arbor
The Minneapolis Institute of Arts
The Nelson-Atkins Museum of Art, Kansas City
The John and Mable Ringling Museum of Art
The State Art Museum of Florida, Sarasota
The University of Arizona Museum of Art, Tucson
The Brooklyn Museum of Art
Portland Art Museum, Portland, Oregon
Smith College Museum of Art, Northampton, Massachusetts
The Putnam Foundation, Timken Museum of Art, San Diego
North Carolina Museum of Art, Raleigh
Isabella Stewart Gardner Museum, Boston
San Diego Museum of Art, California
The J. Paul Getty Museum, Los Angeles
The Detroit Institute of Arts
Phoenix Art Museum, Arizona
Kimbell Art Museum, Fort Worth
Norton Simon Museum, Los Angeles
The Toledo Museum of Art, Ohio
Cornell University, Ithaca, New York
Memphis Brooks Museum of Art
The Lowe Art Museum, University of Miami, Coral Gables
LaSalle University Art Museum, Philadelphia
Seattle Art Museum, Washington
Birmingham Museum of Art, Birmingham, Alabama
National Museum of American Art, Washington DC
The Philbrook Museum of Art, Tulsa, Oklahoma
Maryhill Museum of Art, Goldendale, Washington DC
Beinecke Rare Book and Manuscript Library, Yale University
The Fogg Art Museum, Harvard University Art Museums, Cambridge

Grateful acknowledgment is made for permission to reprint passages from the following:

From *Miracles of our Lady* by Gonzalo de Berceo, translated by Richard Terry Mount
and Annette Grant Cash. © 1997 by The University Press of Kentucky. Reprinted
by permission of The University of Kentucky Press.

"At the Manger Mary Sings" by W. H. Auden. From W. H. Auden: *Collected Poems,* edited
by Edward Mendelson. © 1944 and renewed 1972 by W. H. Auden. Reprinted by
permission of Random House.

CONTENTS

Introduction
6

Her Youth
12

Her Joy
22

Her Sorrow
89

Her Glory
100

List of Color Plates and Credits
144

Notes on the Text
157

Selected Bibliography
158

Feast Days of the Virgin
159

Acknowedgments
160

The Death of The Virgin
Manuscript Illumination, late 10TH century
School of Winchester
Bibliothèque Municipale, Rouen

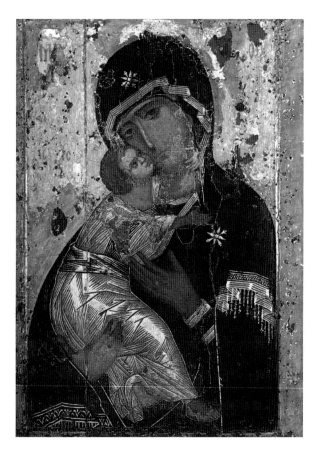

The Virgin of Vladimir
Icon, early 10TH century
Tretyakov Gallery, Moscow

Byzantine icons, whose style was derived from late antique portraiture, were copied by early Russian icon-painters.

According to legend, St. Luke painted three pictures of Christ's mother during her lifetime, but no such images have survived. Unlike her son, she is a minimal presence in the New Testament: she is referred to directly in ten chapters in the four Gospels and speaks but five times. Yet the Virgin Mary is second only to Christ as a subject in Christian art. The transformation of Mary from an absent presence in scripture to an active presence in sacred art is inextricably linked to the history of the cult of Mary which emerged officially in the fifth century.

Although Mary is mentioned only once in the epistles of Paul (Galatians 4:4), there is evidence of an early Marian doctrine in opposition to Gnosticism in the second century, and of Marian devotion in third-century Alexandria. By the fourth century, the Eastern church venerated Mary as Theotokos, Mother of God, although the Latin church resisted the incorporation of Marian devotion into the liturgy. But by the end of that century, plagued by heresies that denied the doctrines of the Incarnation and Redemption and by popular pagan goddess cults that continued to resist a male-centered monotheism, the Latin church turned to the Gospel of Luke to authenticate the doctrine of the Incarnation. There they found a fully human, articulate Virgin Mother who provided not only proof of Christ's humanity but a model of Christian piety and womanhood.

Despite the reluctance of the Latin fathers to emphasize what might be taken for a pagan mother-goddess, an ecumenical council of Eastern and Latin churches convened at Ephesus in 431 and officially proclaimed Mary Theotokos. Official recognition of Mary's unique role in the Incarnation by the Latin church fathers initiated, within the hierarchy of the church, a long and still-continuing doctrinal debate about her nature and her place in Christian theology and worship, but the cult of Mary continued to flourish.

During the reign of Justinian in the sixth century, the shrine of Isis, one of the most enduring and popular pagan goddesses, was converted into a church. In hymns of praise Mary assumed both the attributes and the titles of pagan mother-goddesses to whom worshippers had long prayed for divine intercession. Mary was hailed as Star of the Sea (one of Isis's epithets) and as Queen of Heaven (one of Juno's epithets), among many others.

Evidence of the cult of Mary in the Latin church from the eighth century until the thirteenth is found in legends, poems, devotions, meditations, and accounts of apparitions. Increasingly, following the Eastern tradition, Mary was invoked in the Latin church as a mediator before God. Yet according to scripture Jesus is the only mediator before God, and the doctrinal ambiguities created by Mary's new role as Mediatrix were to be zealously exploited by reformers in the sixteenth century. Medieval interpreters read the Old Testament allegorically, reinterpreting the Song of Songs and certain passages in the psalms as foreshadowings of Mary. The Gospels and the Acts of the Apostles, especially the Magnificat of Luke (1:46–55) [31] and Revelation (12:1) [21] exalted Mary's wisdom and compassion, her efficacy as Mediatrix, and her heavenly office as Mother of the Church and of the true Jerusalem. Chivalry contributed secular metaphors for Mary's role in Christian life and introduced a romantic vocabulary into Marian devotions.

The schism between Eastern and Western churches that began in the ninth century was formalized in the eleventh, but by

this time Marian devotion in the Western church had its own established tradition. In the sixteenth century, church reformers, objecting to medieval doctrines, practices, and abuses by the ecclesiastical hierarchy, refocused attention on the Bible as the sole source of doctrine and liturgy. The doctrines of salvation through faith alone, Christ as the only mediator before God, and predestination revised the nature and practice of Marian piety. The reformers Martin Luther, John Calvin, and Ulrich Zwingli recognized Mary's role in the Incarnation and acknowledged her as the exemplar of the chaste, silent, and obedient Christian woman, wife, and mother. She was due honor and even praise, but not worship or invocation. Nevertheless, among the second and subsequent generations of Protestants, the strictures of this austere Mariology were forgotten.

Protestant opposition to Mariolatry was not ignored by Catholic reformers, who also looked to scripture to renew church doctrine. Once again the distinction between idolatry and veneration was invoked as it had been in the fourth and fifth centuries, but no official consensus governing Marian devotion emerged. And although the person of Mary was an issue raised during the Council of Trent (1545–1563), the persistent questions of the Immaculate Conception and the Assumption, critical issues in terms of Marian doctrine and devotion, remained unresolved. (The Immaculate Conception was not defined by papal decree until 1854, and a papal bull issued by Pope Pius XII in 1950 codified the doctrine of the Assumption.)

The conquest and colonization of the New World brought the cult of Mary to the Americas. The rule of the Spanish conquistadors was enforced not only by imposing allegiance to the King of Spain but by requiring the native people to accept and profess Catholicism. Devotion to the Virgin Mary in Spain had a long tradition in spite of official controversies in Rome, and the substitution of Mary for popular native earth-goddesses in Latin America was undertaken with zeal. As in the Roman Empire and the Mediterranean world in the early centuries of the church, the attributes of pagan goddesses were assimilated into the person of the Virgin Mary. Unlike the apostles and their successors, Spanish missionaries attributed the Christian virtues of mercy, compassion, and reconciliation to the Virgin Mary, not to the alien male Christian God. This not only facilitated conversion but provided a model of how the conquered should relate to their conquerors.

The history of the cult of the Virgin Mary in Latin America reflects a pattern of compliance and resistance adopted by the conquered and converted indigenous tribes. While the cult of Mary quickly took root, there is evidence to suggest that the syncretic Virgin Mary may have been accepted readily because traditional devotion to familiar pagan goddesses could simply be transferred. Over time, Latin American Catholics created a unique vision of the Virgin Mary, which has endured long since the defeat of Spanish domination. Under many titles in every country in Latin America, she is patroness and protector and mediator before God for the oppressed, exploited, and afflicted. In 1754, Pope Benedict IV named her Patroness and Protectress of New Spain, and Mexican revolutionaries carried her banner into battle chanting "Long live the Virgin of Guadelupe and down with bad government." The Virgin of Guadelupe, formerly the Virgin of Tepeyac, had appeared in 1531 to Juan Diego, a newly converted Aztec, at the summit of Mount Tepeyac, the site of the shrine of the Aztec earth-goddess, Tonantzin, whose name means Our Mother. A church in her honor was built on the site, and the cult spread to Mexico City and later throughout Mexico.

Since the eighteenth century, the cult of the Virgin Mary has endured in an increasingly secular world. Marian devotion among the laity in Catholic churches all over the world is ritualized and integrated into the liturgy. Theologians have continued to debate Mary's redemptive role and her definition in Church doctrine, but since the nineteenth century secular piety and papal writings and decrees have brought unofficial and official devotions closer. The recognition among all Christians that the virtues of forgiveness, compassion, and reconciliation are necessary for peace in an increasingly troubled world has initiated an ecumenical movement to define the rightful place of the Virgin Mary in Christian life and theology. Whatever the outcome, there is too much evidence to the contrary to suggest that the cult of the Virgin Mary is going to go away.

The history of Mary in art is as closely linked to the history of holy images in Christian worship as it is to the cult of Mary. There are no images of Mary—or Christ—that can be traced to the first three centuries of Christianity. The first extant images of Mary are found in the catacombs. These late-third- and fourth-century mosaics, frescoes, and bas-reliefs, depicting mother and child, or tableaux from the New Testament, imitate Graeco-Roman funerary art and its reassuring scenes of immortality. The absence of imagery in the early years of the Church, due in part to the enduring influence of Old Testament prohibitions against images among Jewish converts and in part to official vigilance against any suggestion of pagan idolatry in Christian worship among pagan converts, began to yield somewhat after Constantine's conversion in the early fourth century.

Christianity became the official religion of the Roman Empire early in the fourth century, and as churches were built in the new capitol of Constantinople and throughout the empire, the pagan belief that images signify actual presence was appropriated and revised to permit images in churches. For the newly-Christianized pagans, images of holy persons signified not real presence but rather spiritual presence. Images inspired devotion and the desire to emulate Christian virtues, but they were also pictorial representations of sacred doctrines.

The images of the Virgin Mary which are found in mosaics and frescoes decorating churches in Italy, Greece, Egypt, and Syria reflect the Christian distinction between real and spiritual presence. The compositions are formal, almost abstract, and the Virgin is figured frontally, with or without the child Jesus, her expression fixed and solemn. Another fresco, in the Monastery of St. Apollo in Bawit, Egypt, portrays a gently smiling Virgin among the apostles; she bears a remarkable resemblance to an image from nearby Karanis of the gently smiling goddess Isis with her son, Harpocrates, at her breast. The more "plastic" and human pagan prototype of the Madonna apparent in the Batiwa fresco is evidence of the continuing synthesis of pagan and Christian art in late antiquity.

Byzantine icons portray Mary as Theotokos or Bearer of God, holding the child Jesus (supposedly copies of St. Luke's lost images and known as *elousa* or tenderness icons), and other, more linear and schematic compositions depict Mary's childhood, Dormition, and Assumption, as well as scenes from scriptural passages. These were produced on a large scale for churches throughout the empire and in smaller, more portable form for private and

communal veneration. The spread of Christianity to Russia in the tenth century brought Greek Orthodox priests and Byzantine artisans to build churches to replace the pagan shrines, but the frescoes decorating the churches were painted by native artists who developed their own techniques, while the subject matter followed orthodox tradition. The *elousa* icon, epitomized by the Virgin of Vladimir, the oldest surviving icon brought from Byzantium, has been copied or imitated with variations by Russian painters for centuries. [124, 134, 141]

The ninth-century schism between the Eastern and Latin churches, which became official in the eleventh century, was the result of a number of political and ecclesiastical differences, but was exacerbated by the bitter controversy about the religious use of images. In 730, the iconoclasts, who equated holy images with idolatry, prevailed, and the veneration of images was prohibited by the Emperor Leo III. But in 787, the Second Council of Nicaea, the last ecumenical council recognized by both Latin and Eastern churches, renounced previous iconoclastic decrees, ordering the restoration of holy images to churches where they should be venerated but not worshipped. Iconoclasts were not silenced, and the persistence of opposition to religious images, primarily within the hierarchy of the Latin church, led not only to the schism, but to a style of religious art that attempted to heal the breach: one that sought spiritual revelation rather than naturalistic representation. The legacy of Iconoclasm was a highly symbolic, nonrealistic style of art that prevailed until the late thirteenth century.

During the Middle Ages, interpretations of the Virgin Mary, her virtues, titles, offices, and mysteries, expressed symbolically in metaphors, paradoxes, personifications, and allegories, were depicted, also symbolically, in sacred art. The art in churches until the high Middle Ages followed the Byzantine tradition in wall paintings, mosaics, and bas-relief and free-standing sculptures. But manuscript art, often produced by monks and nuns for wealthy patrons for private devotion in Britain, Ireland, France, the low countries, Germany, and East European kingdoms, took on a character of its own, a character distinguished by an elaborate system of symbols.

Symbolic representation, linguistic or pictorial, both reveals and conceals. What is shown in words or images means, by virtue of association, something more. In the ninth to twelfth centuries, symbolism gradually came to represent a wide range of associations among themes, subjects, ideas, and beliefs that simultaneously encoded and decoded theological analogies, metaphors, and allegories in visual terms.

Outward signs, colors, objects, flora, and fauna revealed inner truths and deeper meaning. In most paintings of the Virgin Annunciate and those of Madonna and Child that illustrate narrative passages in the Gospels, blue, which symbolizes divinity (and heaven), spiritual love, truth, fidelity, and constancy, is the color of Mary's mantle, while her red robe, symbolizing her humanity, divine love, and suffering, is often edged in white, an emblem of her purity and a color symbolizing joy, faith, and glory. [31, 38, 46] Brown, gray, red, or black garments signify Mary's suffering and sorrow during the passion and death of her son. [88; 94; 98; 99] In many paintings of the Crucifixion, the color green, symbolizing immortality, reveals the deeper truth that through suffering immortality will be achieved (a lesson) and that Christ's death is a victory over death (a sacred truth).[92, 95] Green, the color of hope, regeneration, fertility, victory, and peace is also used in devotional paintings that portray the Virgin adoring the Christ-child or enthroned in glory. [74, 75,116, 136] Purple or violet are colors of sorrow and penitence,

and also of love and truth. [109] Gold is a powerful color, the symbol of God and divinity, of marriage and fertility, and is frequently used in both narrative and devotional paintings. [54, 58, 93, 95, 110, 113, 119]

A mirror symbolizes Mary's nature as a reflection of God, and a crescent moon refers to the Song of Songs (6:10) and links Mary to it. The serpent and the apple symbolize her as the New Eve, who reverses the effect of Eve's sin. The palm branch, present in almost all paintings depicting the end of her earthly life (the Dormition or Assumption), signifies her triumph over death. [102]

There are many symbols of Mary's virginity and purity: the closed book (opened, it signifies her wisdom [17, 23, 24, 25, 29, 50, 121]); the enclosed or walled garden (another reference to the Song of Songs); the lily, the flower of the Annunciation; a well closed up; and the unicorn, which only a virgin can capture.

A single star symbolizes Mary's virginity, which is undiminished, like a star whose light illuminates the darkness without losing its brightness. A single star is also the attribute of Mary, Queen of the Sea; in the Byzantine tradition, three stars on Mary's mantle signify her purity at birth and her virginity before and after the birth of Christ. [141] Twelve stars associate Mary with the woman of the Apocalypse (Revelation 12:1) and symbolize her freedom from sin and her Immaculate Conception. [113] The sun and the moon in devotional paintings of Mary again associate her with the woman of the Apocalypse.

The cedar of Lebanon is a symbol of Mary's beauty and dignity, and the rose represents her as the Mystical Rose, a rose without thorns, a rose without sin. A peacock in scenes of the nativity is an emblem of immortality, and the ox and the ass may refer to a passage in Isaiah (1:3) that was thought to prefigure the Nativity.

The painlessness of the birth of Christ is depicted when Mary is seated in nativity scenes. When she is reclining near a raised manger Christ's sacrificial death is prefigured. On her knees at the manger adoring her child, she is the image of devotion to Christ, to be emulated by all Christians.

The advent of naturalism in the late thirteenth century did not eliminate symbolism from religious art. Viewers were familiar with it, and patrons, whether clerical or secular, expected it. For artists pursuing naturalism, symbolic representation was an economical means to satisfy the devotional and didactic function that justified the production of sacred art. Iconoclasm, although dormant, was not dead.

Toward the end of the thirteenth century, the Florentine painter Giotto is reported by Giorgio Vasari in his *Lives of the Artists* (1568) to have "convincingly depicted the fear and trembling of the Virgin Mary before the Archangel Gabriel; Our Lady is so fearful that it appears as if she is longing to run away." Drawing on the *Protevangelium of James,* Giotto painted scenes from the Virgin Mary's life in a series of frescoes in the Scrovegni Chapel in Padua.

The Giotto Madonna reproduced as the frontispiece of this book is a transitional image. It cannot be described in the animated terms Vasari bestows on the Virgin Annunciate in Florence (which now is lost), but the iconic image is animated by an expression that suggests more than a spiritual presence. Here the Virgin's head is slightly turned and inclined forward, her expression is thoughtful and contemplative and her straightforward gaze that seeks the viewer's eye is somewhat challenging. Her lips just parted might speak or may have just spoken. There is a presence here that suggests more than a symbolic representation of the Incarnation. Giotto's Madonna is a

real woman. The child she holds, however, lacks her naturalism. Giotto's Christ-child, like the Christ-child depicted in Byzantine icons, is a miniature man, but unlike the iconic representations, he wears the swaddling clothes of his humanity, not the robes of his divinity.

The Madonna of the Master of Saints Cosmos and Damian, dating to the late thirteenth century, in contrast to Giotto's more "plastic," human image, follows the traditional formalized Byzantine *elousa*-style icon—and the little man-child Jesus is painted in his divine robes [140]. The Florentine Gaddi, a century or so later, portrays the Virgin Annunciate in profile, sitting, head bent forward, displaying in the sweeping curved line that describes her body a physical grace and acquiescence within a composition of linear spaces that seem to enclose her supple shape.

In 1435–36, the appearance of Leon Battista Alberti's handbook *On Painting (Della pittura)* introduced a new approach to art that the work of Giotto and Gaddi, among others, anticipates. Although he is best known for his detailed mathematical description of one-point perspective, Alberti also provided a new theory of painting that made the theme or the content of the story, its meaning and significance, the epitome of visual representation. His theory also placed the brush in the hand of an artist/creator whose job it was to produce works of art that would bring the dead to life, bring fame to the artist, and inspire the viewer.

> *Painting contains a divine force which not only makes absent men present . . . but moreover makes the dead seem almost alive. Even after many centuries they are recognized with great pleasure and with great admiration for the painter. Plutarch says that Cassander, one of the captains of Alexander, trembled through all his body because he saw a portrait of his King Thus the face of a man who is already dead certainly lives a long life through painting. Some think that painting shaped the gods who were adored by the nations. It certainly was their greatest gift to mortals, for painting is most useful to that piety which joins us to the gods and keeps our souls full of religion. They say that Phidias made in Aulis a god Jove so beautiful that it considerably strengthened the religion then current.*
> —Alberti, On Painting

Using the principles of perspective, the artist should strive to achieve visual, temporal, and spatial unity. Further, according to Alberti, artists should look to the artists of antiquity, whose aesthetic followed the ancient credo that art should imitate nature.

Alberti's theories of art belong to the philosophical and literary movement of humanism which emerged in Florence in the late fourteenth century and contributed to the development of a new aesthetic in Renaissance and Baroque sacred art. The discovery of texts from antiquity initiated a program of study and translation by humanists that revived interest not only in classical literature and philosophy, but also in classical art, which celebrated natural physical beauty and grace. The humanist belief that art could "teach" by touching the soul renewed the fifth-century justification of holy images for their power to move viewers and to disclose sacred truths, but imitation of classical figural art elided the fifth-century distinction between spiritual and real presence. Renaissance artists sketched, painted, and carved real human bodies and idealized their beauty in secular and religious works. Realistic outward signs—gesture, expression, posture—disclosed inner feelings and character, while traditional symbolic outward

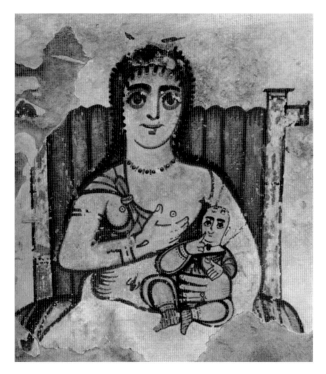

Isis Suckling Harpocrates
Fresco, 3RD-4TH century
Karanis, Egypt

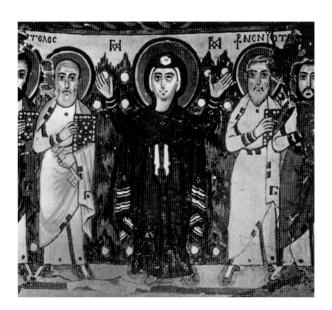

Orant Virgin with the Apostles
Fresco, 6TH-7TH centuries
Monastery of St. Apollo, Bawit, Egypt

Early images of Mary may have been modelled on depictions of pagan goddesses such as Isis [above].

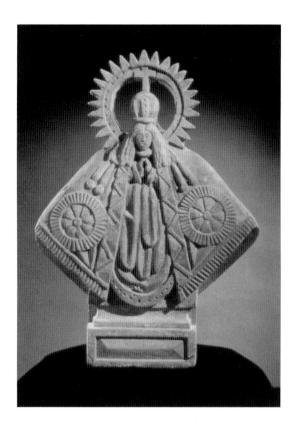

La Virgencita del Nuevo Mundo
Mexico, c. 1521–1550
Stone, 14 3/4 x 11 x 4 1/2 in.
Collection of Jann and Fred Kline

This stone sculpture of the Immaculate Conception of Mary, who is portrayed as a young Mexican Indian girl, may be the first example of the "Indian Madonna." The blend of Pre-Columbian and European Christian symbolism characterizes the native artists' response to the religion of their conquerors.

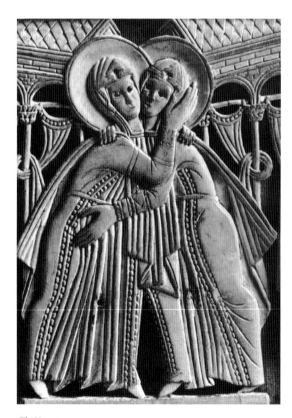

The Visitation
Ivory, late 12TH century
Musée Royal, Brussels

signs revealed spiritual significance and sacred truth.

The construction of the Vatican and other religious buildings and the rise of a wealthy patriciate created a market for sacred art. Sumptuary laws prohibiting public or personal displays of wealth encouraged patronage of religious art not only for churches but for private dwellings. Although there was a market for secular paintings, sacred art depicting scenes from the life of Christ and the saints and images of the Virgin and Child were displayed for devotional purposes in private chambers or chapels. Patrons who commissioned paintings were often depicted in them, sometimes with members of their families, as onlookers or participants. Devotional paintings of the Virgin Mary with the child Jesus and saints were particularly popular among donors.

The new synthesis that classicized and to a large extent commodified sacred art revived the controversy about the nature and use of holy images. Girolomo Savonarola, a Dominican and the prior of San Marco (which is decorated with paintings by Fra Angelico, whose work is esteemed for its spiritual expressiveness rather than its realism [115]), preached against the materialism, worldliness, vice, and paganism of late-fifteenth-century Florentines. In one of his sermons, he condemned the new style of sacred art not for inducing idolatry but for profaning the holiness of churches and the Virgin Mary:

> *You have the figures in churches painted in the likeness of this woman or that other one, which is ill done and in great dishonor of what is God's Do you believe that the Virgin Mary went dressed this way, as you paint her? I tell you she went dressed as a poor woman, simply, and so covered that her face could hardly be seen You make the Virgin Mary seem dressed like a whore.*
> —Savanarola, from "Sermons on Amos"

A little more than a quarter century later, Erasmus of Rotterdam, a priest and humanist scholar, advocated a more moderate and conciliatory approach to correct the excesses of Italian art. He acknowledged the power of holy images to inspire and instruct, and called art a silent poetry which is more eloquent and better able to convey an idea or emotion than the words of an orator. But care had to be taken in its making. Subjects for sacred art should be appropriate and images in churches should take for their themes events from the Bible. Those in homes should depict Christ and the saints. Erasmus criticized the classicization of sacred art by Italian artists and discouraged its use. He also deplored the large amounts of money patrons paid for the production of sacred art, which served as a sign of wealth rather than piety. Artists should not be permitted to include blasphemous or impious details, nor should they depict religious subjects in fantastic or fabulous terms. Irreverent or profane images should be removed from churches.

In the early sixteenth century, the Protestant reformers Luther, Calvin, and Zwingli, citing the Old Testament prohibition of images, rejected Erasmus's moderate proposal for the reformation of religious iconography and urged the removal of all images from churches. Opposition to what was perceived as a cult or theology of images that profaned the sacred, attributed miraculous powers to particular images, and encouraged the adoration of inanimate objects was fierce and often violent. In Basel, iconoclasts began attacking images in 1525, and in 1529 rampaging mobs stormed the churches and destroyed whatever sacred art remained.

After the schism between Catholic and Protestant churches, the Catholic reformers addressed the question of sacred art during the Council of Trent (Twenty-Fifth Session) in 1563. The council reaffirmed the decrees of the previous councils, especially of the Second Council of Nicaea, against the opponents of images, and decreed "that the images of Christ, of the Virgin Mother of God, and of the other saints are to be placed and retained especially in the churches" for veneration. The council's decree codified Erasmus's pre-schism definition of the use and purpose of religious art and his proposal for its reformation. The purpose of holy images was to put "salutary examples before the eyes of the faithful" in order to "cultivate piety." Accordingly, "all superstition" was to be removed, "the filthy quest for gain eliminated, and all lasciviousness avoided so that images shall not be painted and adorned with a seductive charm." Bishops were instructed to teach the proper use of images and to ensure that "nothing may appear that is disorderly or unbecoming and confusedly arranged, nothing disrespectful, since holiness becometh the house of God."

Post-Reformation images of the Virgin Mary reflect a new naturalism. The highly idealized figures and glittering splendor of high Renaissance paintings are replaced by a more austere realism. Mary is no longer depicted as a patrician matron, but as a warm, loving, and compassionate mother, and soaring themes are for the most part abandoned for more quiet and intimate scenes of the Virgin Mary with the Christ-child, St. John the Baptist, and other saints, frequently depicted in a landscape. [43, 49, 65, 66, 83, 86] Seventeenth-century Mannerist images of the Virgin Mary are often more animated than those of other styles. These artists, rebelling against the formalism of high Renaissance art, produced artworks in which figures are elongated and oblique, with scale and spatial relationships deliberately confused. [42, 68, 69, 77, 96, 97]

Baroque artists, during the middle to late seventeenth century and into the eighteenth, restored order and unity to their compositions, which bristle with energy, drama, and movement of forms. A new use of light, shadow, and deep space creates illusionary effects that suggests the supernatural. For the first time since antiquity, the production of secular art for secular spaces found a market. If baroque secular art tends to be monumental, baroque images of the Virgin Mary continue to emphasize her human and maternal qualities, and often her form rather substantially, while the compositions remain quietly intimate. [65, 66, 81, 82] An interesting example of how intimacy is sustained in large religious paintings may be found in Sebastiano Ricci's *Marriage Feast at Cana* [85] by comparing the detail reproduced and the reproduction of the entire painting.

Just as religious art began to disappear in Protestant countries, a new market for religious art emerged in the Americas. The conquistadors brought priests, images of the Virgin Mary, and artists to the New World. Conquest and conversion were synonymous, and, as has been noted earlier, veneration of the Virgin Mary was the principle means of achieving both. The influence of the Spanish Baroque on native artists is evident in seventeenth- and eighteenth-century paintings of the Virgin Mary produced in Mexico, Bolivia, and Peru.

The earliest images of the Virgin Mary in Latin America were carved stone figures within an arc, which associated Mary with mother-goddesses of the mountains. After the conquest, under the direction of Spanish artists, Peruvian artists in Cuzco, the site of the Incan Temple of the Sun, painted statuesque, mountain-shaped representations of the Virgin. These were depicted wearing elaborately detailed and gilded robes in the colors of the Spanish Baroque palette. Festooned with feathers, flowers, and jewels, symbols associated with the Incan religion, the virgins of Cuzco are rooted in their picture space, rising out of their firmly-anchored skirts, radiantly poised, and immovable. Their expressions, whether gently smiling or austere, are enigmatic. Unlike their more naturalistic Spanish sisters, the Peruvian madonnas are highly symbolic, almost doll-like figures. Some are fair-skinned, others are as dark as the earth.

The Black Madonna has a long history, which may have begun with the cult of Cybele, an ancient goddess native to Asia Minor. Cybele, the Mountain Mother, was worshipped in both Greece and Rome, and aspects of her cult may have been incorporated into early Christianity. The Black Madonnas of Sicily and other parts of Southern Italy, and the Black Madonna of Czestochowa in Poland, reflect the continued association of the Virgin Mary with ancient pagan earth-goddesses. The Black Madonnas of the New World, while incorporating aspects of the white European Mother of God, remain true to native traditions in art and religion. The twentieth-century Haitian Black Madonnas bear no trace of European influence at all.

Most of the paintings reproduced here are from the sacred art that American collectors and philanthropists have donated to public collections. The Samuel H. Kress Collection, for example, a priceless legacy primarily of Renaissance art, has been distributed among hundreds of museums, large and small, across the country. Other generous patrons have donated European artworks to American museums, where they have found an appreciative audience.

HER FACE is intended to be something of a pilgrimage, following the life of the Virgin Mary in art. It is not a history of Marian art as such, but an anthology that portrays the aesthetic tensions (between the spiritual and the physical, and between the symbolic and the naturalistic) that characterize not only sacred images, but all fine figurative art.

BIBLIOGRAPHIC NOTE:

The following books and articles were most helpful in the preparation of this essay:

Damian, Carol. *Virgin of the Andes: Art and Ritual in Colonial Cuzco.* Grassfield Press, 1995.

Graef, Hilda. *Mary: A History of Doctrine and Devotion.* 2 volumes; Sheed and Ward, 1963-65.

Kline, Fred. "The Lost Virgin of the New World: The Discovery of a Marian Sculpture of First Contact." Unpublished article, 1998; used with permission of the author.

Sill, Gertrude. *A Handbook of Symbols in Christain Art.* Collier Books, 1975.

Tavard, George. *The Thousand Faces of the Virgin Mary.* Liturgical Press, 1996.

Warner, Maria. *Alone of All her Sex: The Myth and Cult of the Virgin Mary.* Alfred A. Knopf, 1976.

HER YOUTH

And her months were fulfilled, and in the ninth month,
Anna brought forth....And when the days were fulfilled, Anna
purified herself and gave such to the child and called her name
Mary....And the child became three years old, and Joachim said:
Call for the daughters of the Hebrews that are undefiled, and
let them take every one a lamp, and let them be burning, that
the child turn not backward and her heart be taken captive
away from the temple of the Lord. And they did so until they
were gone up into the temple of the Lord.

And the priest received her and kissed her and blessed her and
said: "The Lord hath magnified thy name among all generations:
in thee in the latter days shall the Lord make manifest his
redemption unto the children of Israel." And he made her sit
upon the third step of the altar. And the Lord put grace upon
her and she danced with her feet and all the house of Israel loved
her....And Mary was in the temple of the Lord as a dove that is
nurtured: and she received food from the hand of an angel.

—PROTOGOSPEL OF JAMES

Andrea del Sarto, *Head of the Madonna*

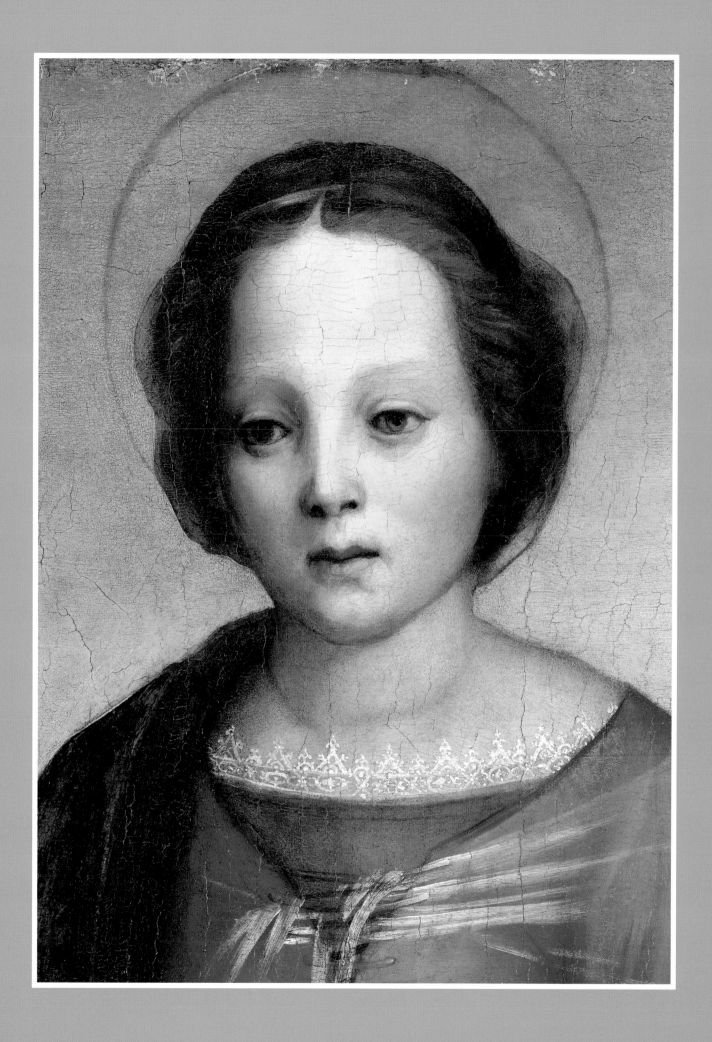

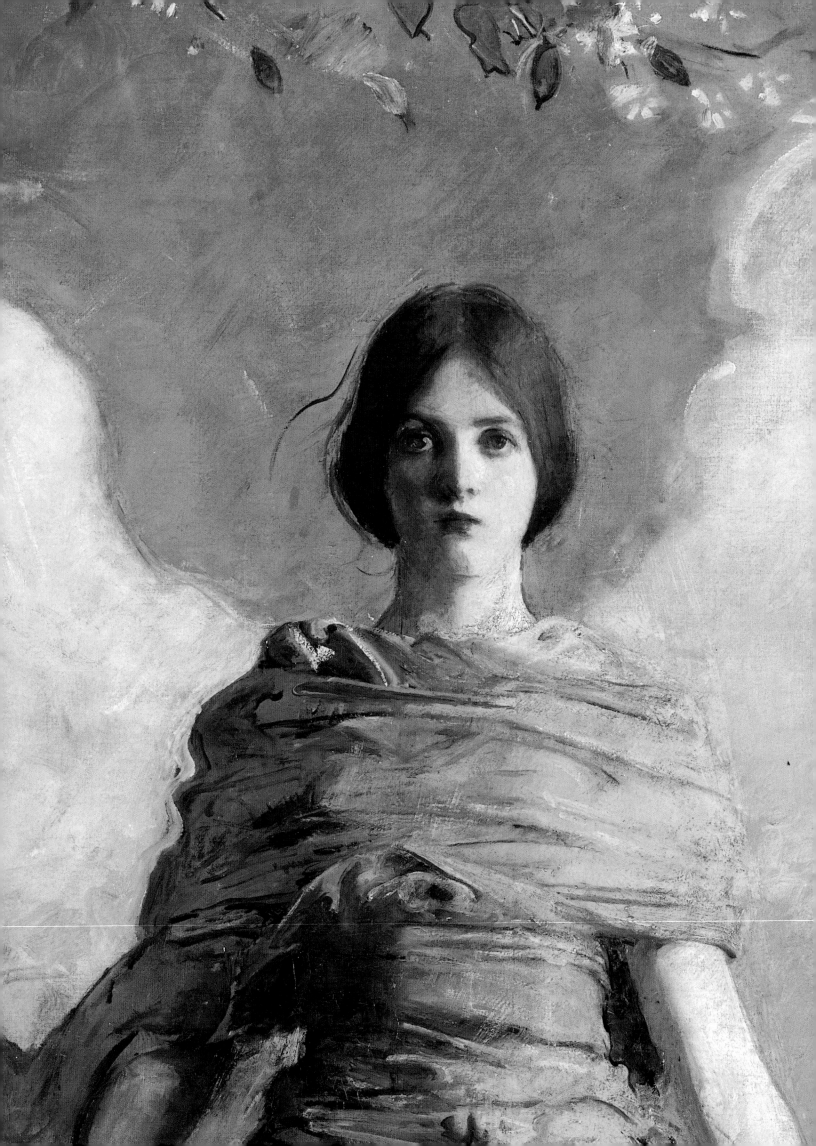

And when she was twelve years old, a council of the priests said: "Behold Mary has become twelve years old in the temple of the Lord. What then shall we do with her lest she pollute the sanctuary of the Lord?" And they said unto the high priest: "Thou standest over the altar of the Lord. Enter in and pray concerning her: And whatsoever the Lord shall reveal to thee, that let us do."

And the high priest took the vestment with the twelve bells and went in unto the Holy of Holies and prayed concerning her. And lo, an angel of the Lord appeared, saying unto him: "Zacharias, Zacharias, go forth and assemble them that are widowers of the people, and let them bring every man a rod, and to whomsoever the Lord shall show a sign, his wife shall she be." And the heralds went forth over all the country round about Judaea, and the trumpet of the Lord sounded, and all men ran thereto....

And Joseph cast down his adze and ran to meet them, and when they were gathered together they went to the high priest and took their rods with them. And he took the rods of them all and went into the temple and prayed. And when he had finished the prayer he took the rods and went forth and gave them back to them: and there was no sign upon them. But Joseph received the last rod: and lo, a dove came forth of the rod and flew upon the head of Joseph.

—PROTOGOSPEL OF JAMES

Abbott Handerson Thayer, *Virgin*

This is the blessed Mary pre-elect

God's virgin. Gone is a great while, and she

Dwelt young in Nazareth of Galilee.

Unto God's will she brought devout respect

Profound simplicity of intellect.

And supreme patience. From her mother's knee

Faithful and hopeful; wise in charity;

Strong in grave peace; in pity circumspect.

So held she through her girlhood; as it were

An angel-watered lily, that near God

Grows and is quiet. Till, one day at home

She woke in her white bed, and had no fear

At all—yet wept till sunshine, and felt awed:

Because the fulness of the time was come.

—Dante Gabriel Rossetti, *Mary's Girlhood*

Hail to thy blessed name, O Mary.

Thy name which is sweeter than all perfumes.

—Zerea Jacob, King of Abyssinia, *Hymn to Mary*

Vittore Carpaccio, *The Virgin Reading*

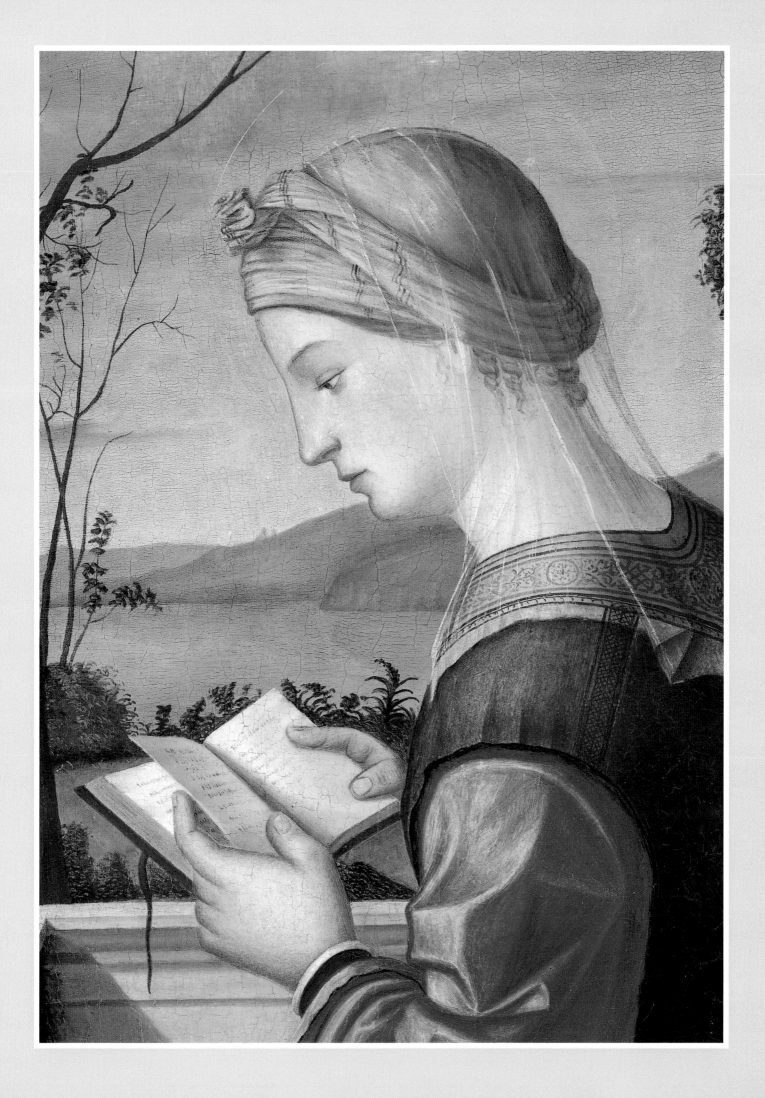

And the priest said unto Joseph: "Unto thee hath it fallen to take

the virgin of the Lord and keep her for thyself...." And Joseph said unto

Mary: "Lo, I have received thee out of the temple of the Lord: and now

do I leave thee in my house...and I will come again unto thee.

The Lord shall watch over thee."

Now there was a council of the priests, and they said: "Let us make

a veil for the temple of the Lord." And the priest said: "Call unto me pure

virgins of the tribe of David." And the officers departed and sought and

found seven virgins. And the priests called to mind the child Mary, that

she was of the tribe of David and was undefiled before God: and the

officers went and fetched her. And they brought them into the temple

of the Lord and the priest said: "Cast me lots, which of you shall weave

the gold and undefiled and the fine linen and the silk and the hyacinthine,

and the scarlet and the true purple. And the lot of the true purple and the

scarlet fell unto Mary, and she took them and went unto her house.

And she made the purple and the scarlet and brought them unto the

priest. And the priest blessed her and said: "Mary, the Lord God hath

magnified thy name, and thou shalt be blessed among all generations

of earth."

—PROTOGOSPEL OF JAMES

Luis Juárez, *The Marriage of the Virgin*

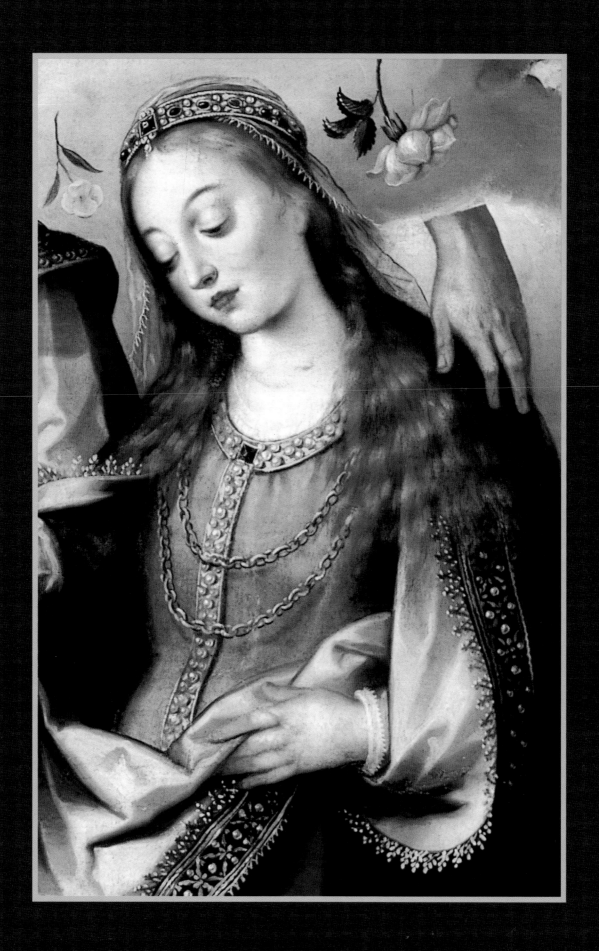

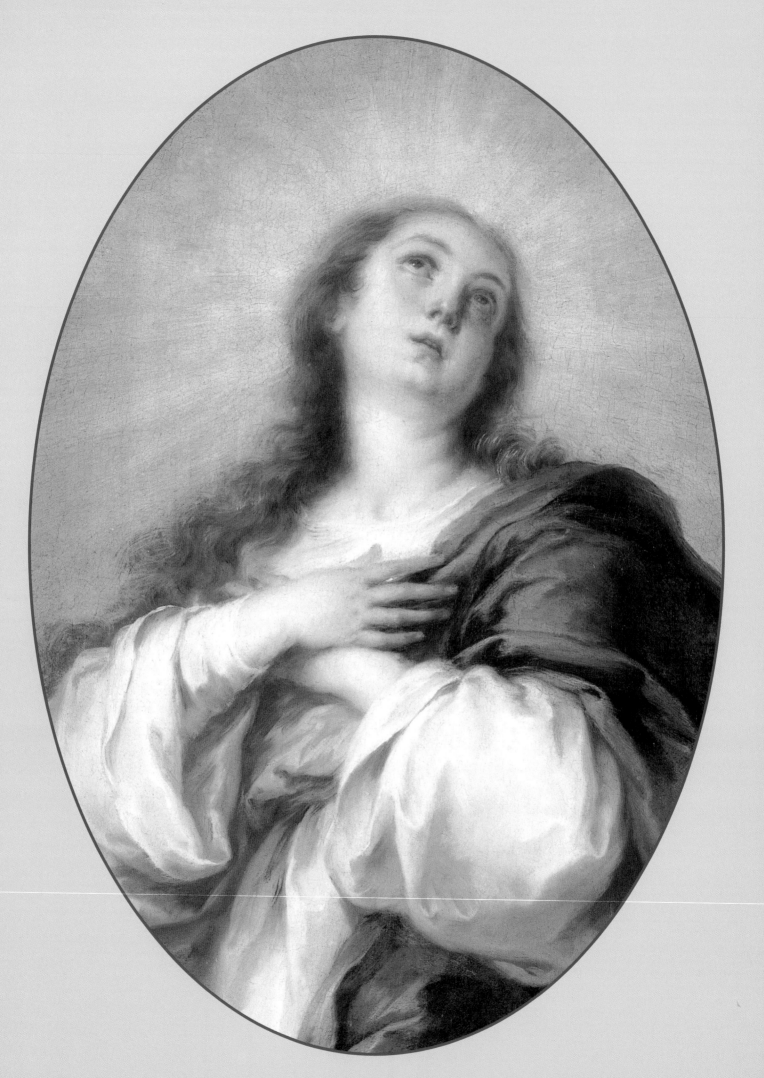

Omoon, O symbol of our Lady's whiteness;

O snow, O symbol of our Lady's heart

O night, chaste night, bejewelled with argent brightness,

How sweet, how bright, how loving, kind thou art!

O miracle; tomorrow and tomorrow,

In tender reverence, shall no praise abate

For from all seasons shall we new jewels borrow

To deck the Mother born Immaculate.

—MAURICE FRANCIS EGAN, *The Virgin of the Immaculate Conception*

And there appeared a great wonder in heaven;

a woman clothed with the sun,

and the moon under her feet,

and upon her head

a crown of twelve stars.

—REVELATION 12:1

Bartolomé Estebán Murillo, *The Immaculate Conception*

HER JOY

And behold an angel of the Lord stood before her saying:

"Fear not, Mary, for thou hast found grace before the Lord of all

things, and thou shalt conceive of his word." And she, when she

heard it, questioned in herself, saying: "Shall I verily conceive

of the living God, and bring forth after the manner of all women?"

And the angel of the Lord said: "Not so, Mary, for a power of the

Lord shall overshadow thee: wherefore also that holy thing

which shall be born of thee shall be called the Son of the Highest.

And thou shalt call his name Jesus: for he shall save his people

from their sins." And Mary said: "Behold the handmaid of the

Lord is before him: be it unto me according to thy word."

—PROTOGOSPEL OF JAMES

From Jesse's Root behold a branch arise,

Whose sacred flower with fragrance fills the skies;

Th'eternal Spirit o'er its leaves all move,

And on the top descends the mystic Dove.

—ALEXANDER POPE, *The Messiah*

Jean Hey (Master of the Moulins), *The Annunciation*

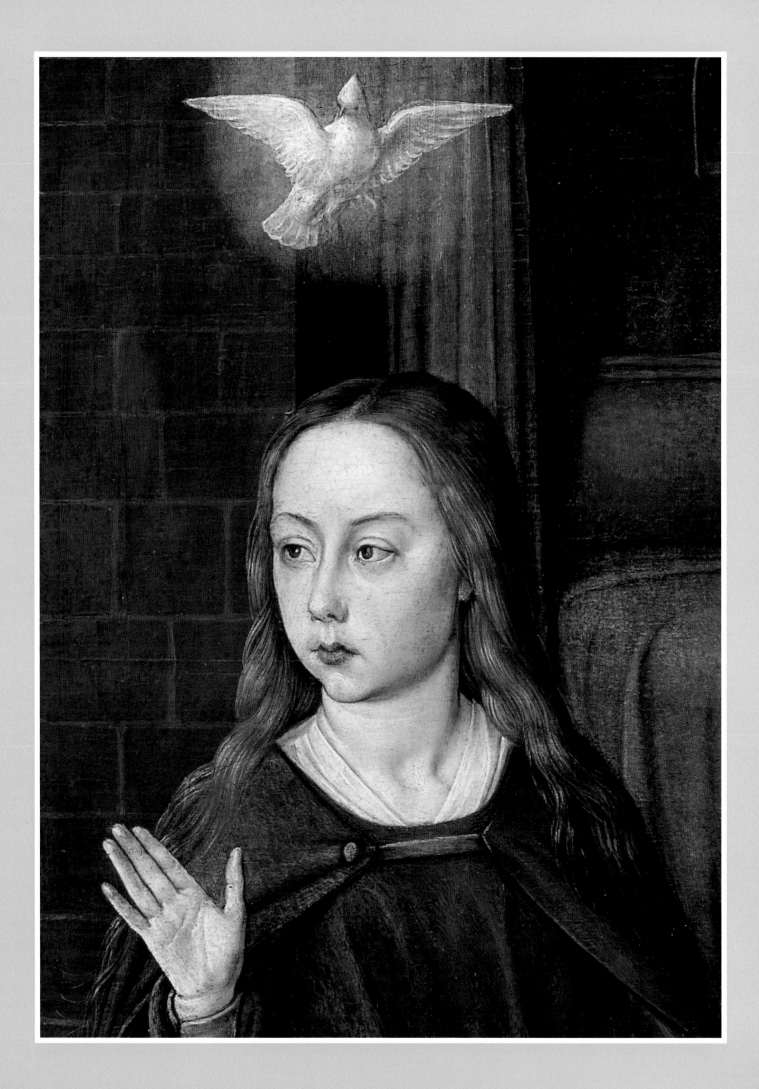

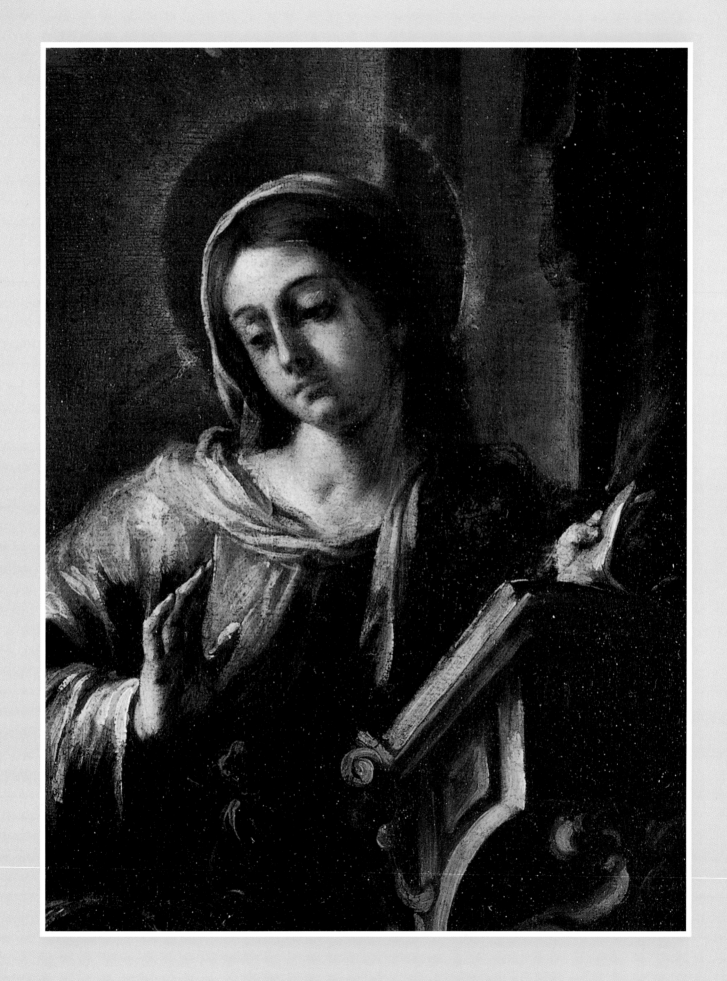

(above) Juan de Valdés Leal, *The Annunciation*
(opposite) Peruvian, Cuzco School, *The Annunciation*

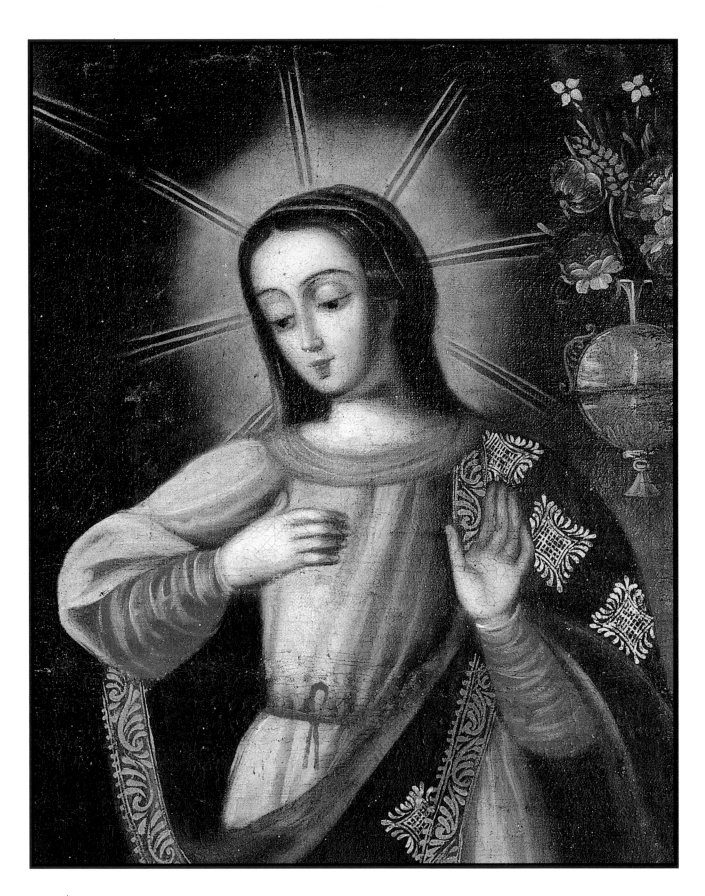

Ave Maria! blessed be the hour!
The time, the clime, the spot, where I so oft
Have felt that moment in its fullest power
Sink o'er the earth so beautiful and soft:
While swung the deep bell in the distant
 tower,

Or the faint dying day-hymn stole aloft,
And not a breath crept through the rosy air,
And yet the forest leaves seem'd stir'd with
 prayer.

—GEORGE GORDON BYRON, *DON JUAN*

(opposite) Agostino Masucci, *The Annunciation*
(above) Paolo Veronese, *The Annunciation*

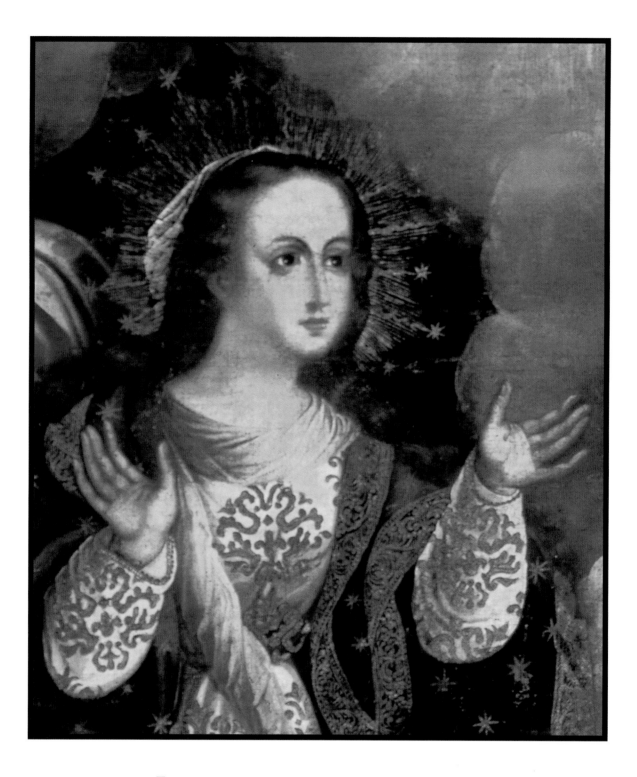

It wasn't an angel entering—recognize—
that frightened her....
No, not his entering; but he so inclined,
the angel, a youth's face to hers, that it combined
with the gaze with which she looked up, and the two
struck together, as though all outside suddenly
were empty.

—RAINER MARIA RILKE, *Annunciation to Mary*

(above) Basilio Santa Cruz Pumacallao, *The Annunciation*
(opposite) Workshop of Agnolo Gaddi, *The Annunciation*

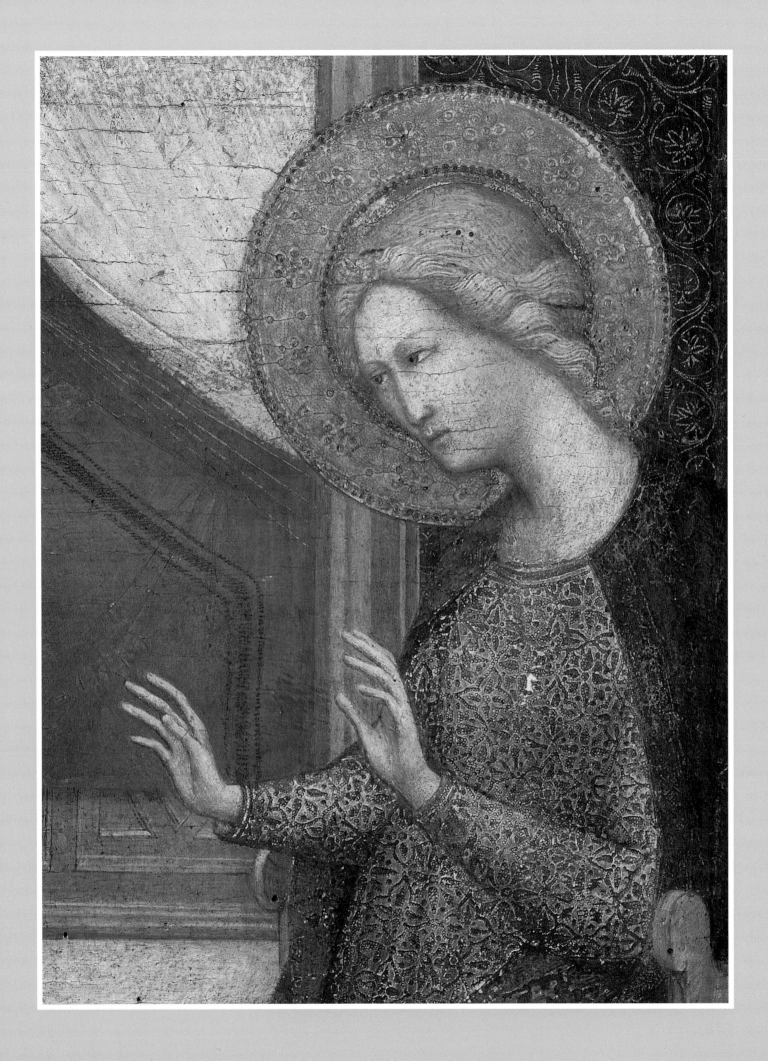

*M*y soul doth magnify the Lord,

> And my spirit hath rejoiced in God my Saviour.

For he hath regarded the lowliness of his handmaiden:

> For behold, from henceforth all generations shall call me blessed.

> For he that is might hath magnified me:

>> And holy is his name.

And his mercy is on them that fear him through-out all generations.

He hath showed strength with his arm,

He hath scattered the proud in the imagination of their hearts.

He hath put down the mighty from their seat:

> And hath exalted the humble and meek.

He hath filled the hungry with good things:

> And the rich he hath sent away empty.

He remembering his mercy, hath holpen his servant Israel:

> As he promised to our forefathers, Abraham and his seed, for ever.

—*Magnificat*, BOOK OF COMMON PRAYER, 1549

Guercino (Giovanni Francesco Barbieri), *The Annunciation*

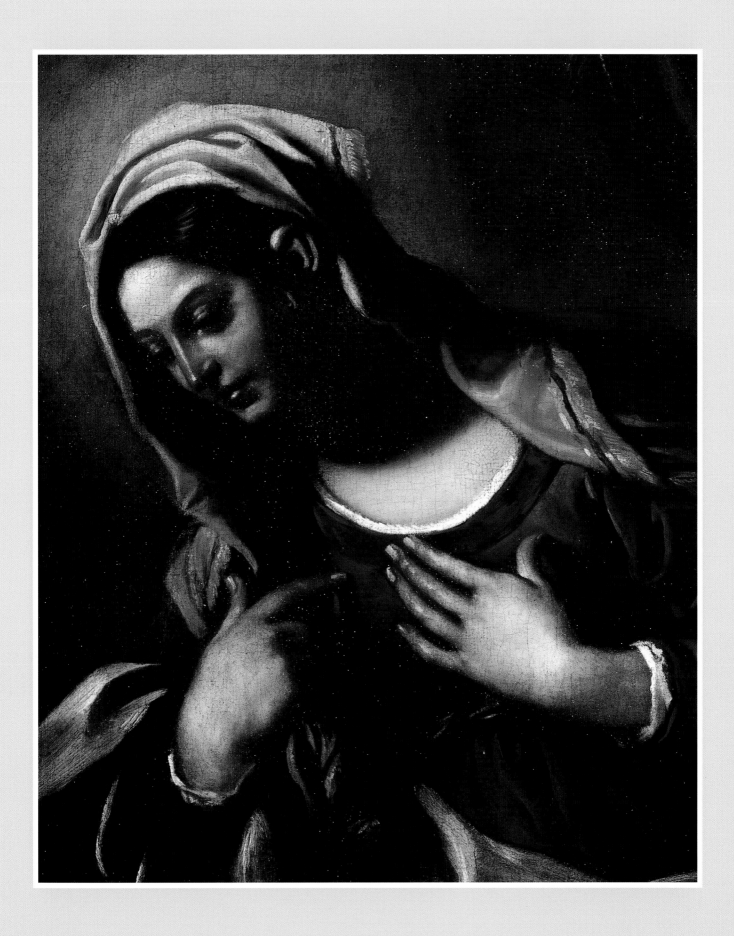

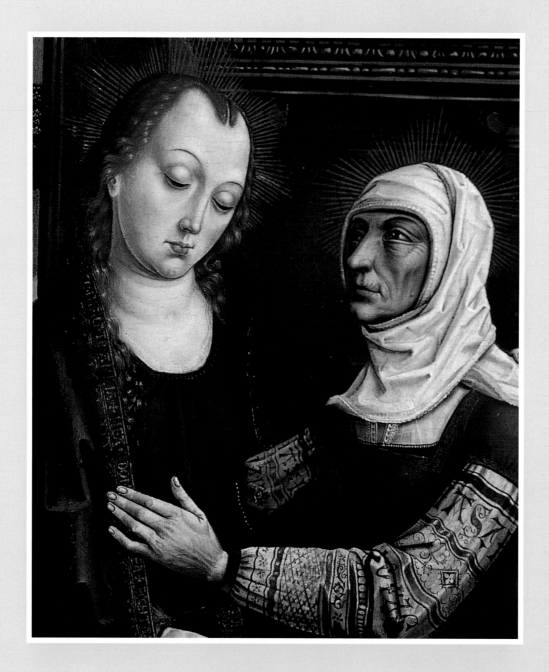

And Mary arose in those days, and went into the hill country with haste, into a city of Juda; and entered into the house of Zacharias, and saluted Elizabeth. And it came to pass, that when Elizabeth heard the salutation of Mary, the babe leaped in her womb; and Elizabeth was filled with the Holy Ghost: And she spake out with a loud voice, and said, "Blessed art thou among women, and blessed is the fruit of thy womb."

—LUKE 1:39-42

Master of the Retablo of the Reyes Catolicos, *The Visitation*

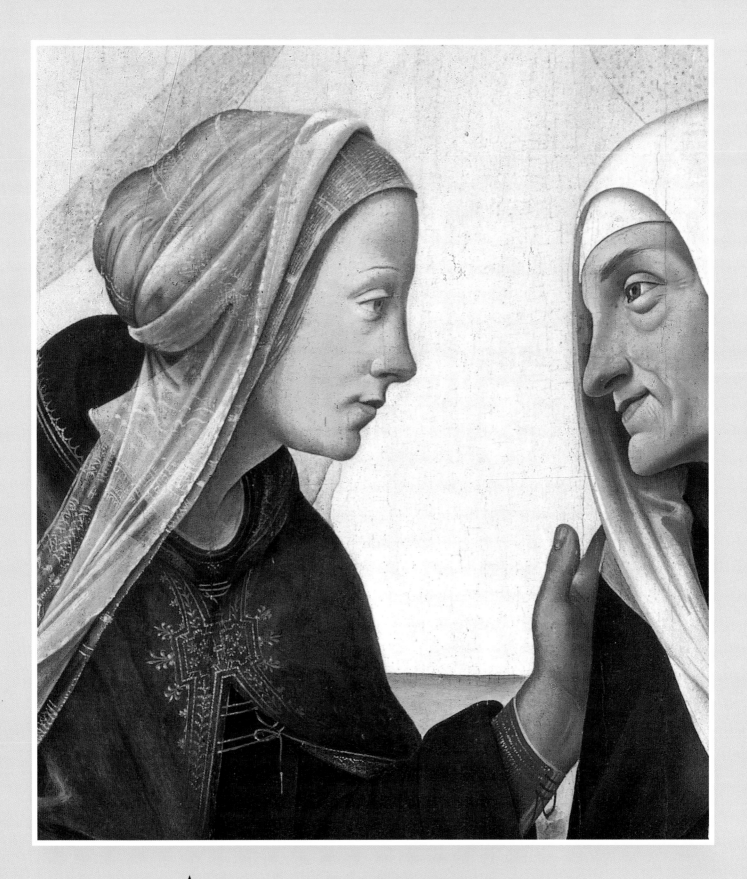

And the need pressed on her now to lay her hand
on the other body, which had gone on further.
And the women leaned to one another, and
they touched each other on the dress and hair.

—Rainer Maria Rilke, *Visitation of the Virgin*

Piero di Cosimo, *The Visitation with Saint Nicholas and Saint Anthony Abbot*

At the end of this third month after the Annunciation,

which is June,

The woman who is God's mother has heard the tune

Of heartbeats under hers and felt the movement of her

Son.

Within the sinless Virgin's womb commences a new era.

The Child who is before all time assumes time in his

Mother of his Mother,

And in the primal Mover man's breathing is begun!

She moves not, speaks not a word. She adores.

She withdraws from the world. For her, God is not outdoors:

He is her work, her Son, her Baby borne as her All!

—PAUL CLAUDEL, *Hymn of the Sacred Heart*

Then Joseph, who never knew the Virgin, stopped,

stunned by her glory,

And, gazing on the brilliance of her form, said:

"O shining one, I see that a flame and hot coals encircle

you.

It frightens me, Mary. Protect me, do not consume me!

Your spotless womb has suddenly become a fiery furnace.

Let it not melt me, I beg you. Spare me."

—ROMANUS MELODUS

Joseph Stella, *The Virgin*

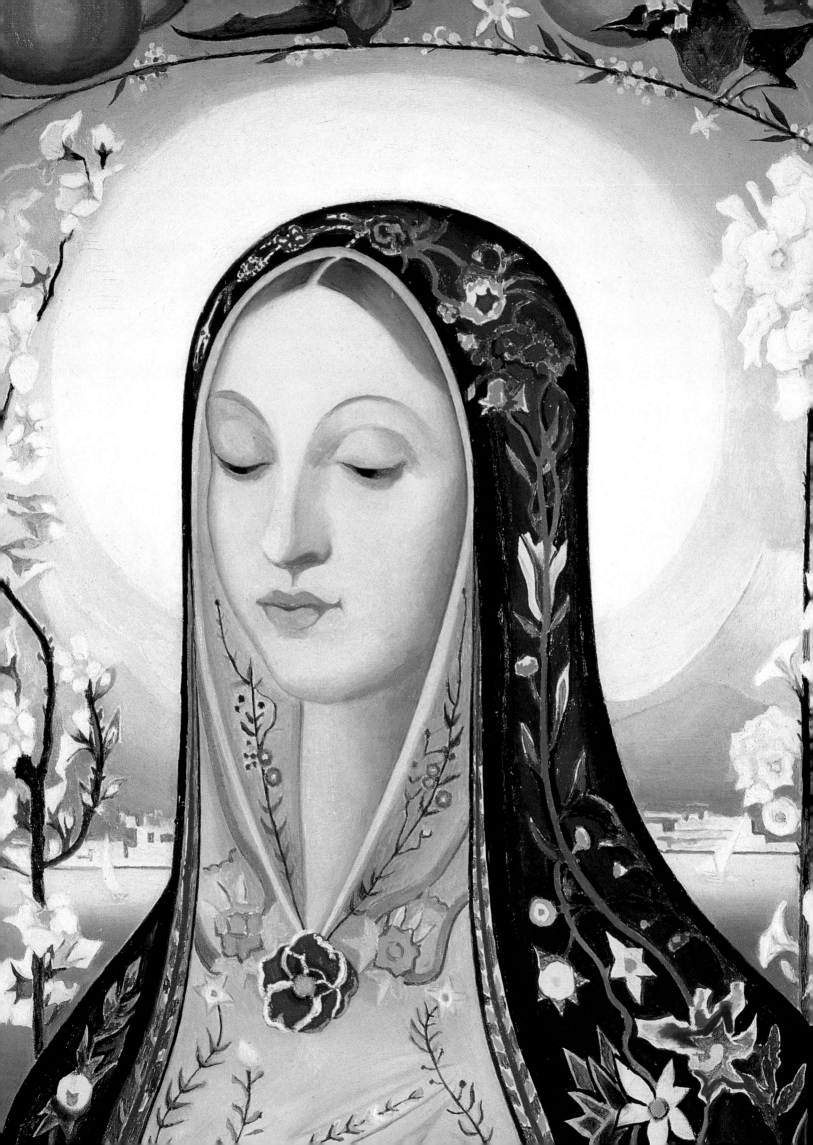

*N*ow as concerning the manner in which I brought forth Jesus Christ. A star from out of the East appeared unto me, and in its great light was hidden the light of all the other stars. Now I was abiding in my house and I was afraid of everything, and there was none to minister unto me.

I was a virgin, and I knew nothing whatsoever, and was the first born of my mother. I had never at any time dwelt with women who had given birth to children except Elizabeth, the barren woman, who when she nigh to bring forth had everything which was necessary made ready for her by her neighbors. As for me, I had not clothing, and I sought therefore, but found nothing except swathings of sackcloth, and in these swathings I wrapped His Holy Body.

Nigh at hand was a stable wherein they fed the oxen, and herein was laid my pillow, and I laid the Child to sleep therein. And there were there an ass and an ox which bowed down in homage unto Him and they kept him warm with their breath, for at that season the days were cold and behold, the angels, and the archangels, and the Seraphim and the Cherubim came in their companies, and they bowed down in adoration before Him.

—The Miracles of the Blessed Virgin Mary

*T*his is the month, and this the happy morn,
Wherein the Son of Heaven's eternal King,
Of wedded Maid and Virgin Mother born,
Our great redemption from above did bring;
For so the holy sages once did sing,
 That he our deadly forfeit should release,
And with his Father work us a perpetual peace.

—John Milton, *On the Morning of Christ's Nativity*

Lorenzo Lotto, *The Nativity*

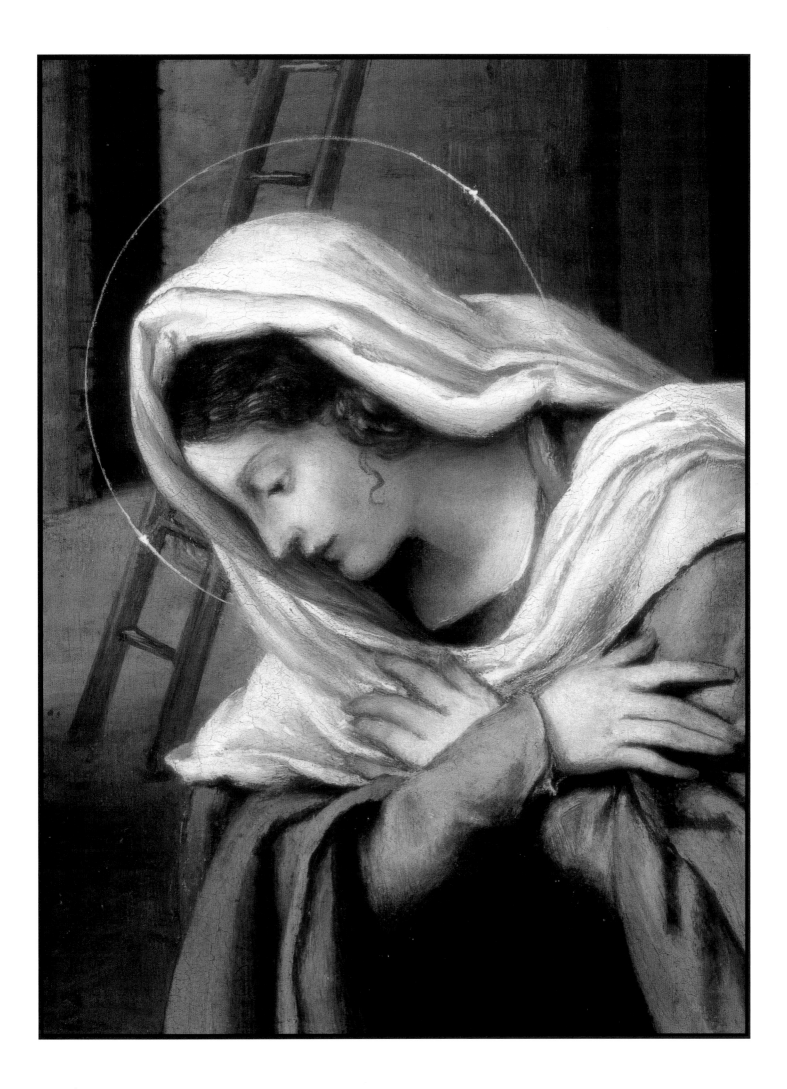

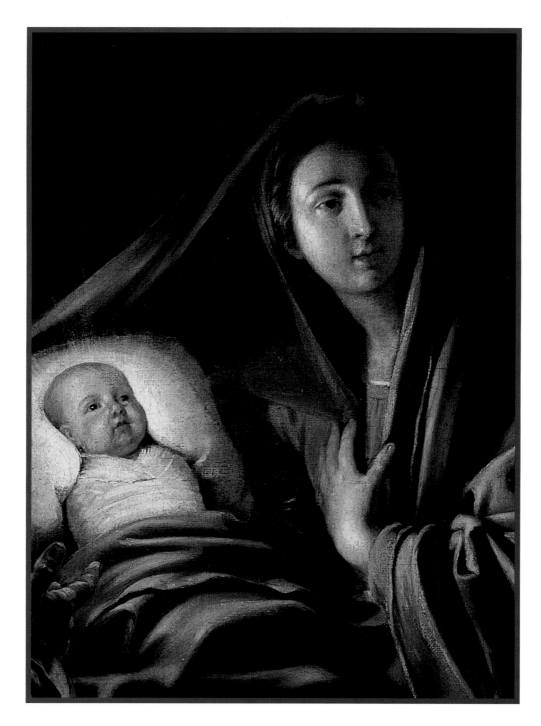

As through the palms ye wander
O Angels of the Blest,
Bend down the branches yonder
To shield my Darling's rest.

O palm-trees stirred and shaken
By every breath that blows,
Lest Bethlehem awaken,
Sway lightly for repose.
Soft sleep serenely squander.

—Lope de Vega Carpio, *The Lullaby*

(above) Phillippe de Champaigne, *Adoration of the Shepherds* (opposite) Giovanni Girolamo Savoldo, *The Adoration of the Shepherds*

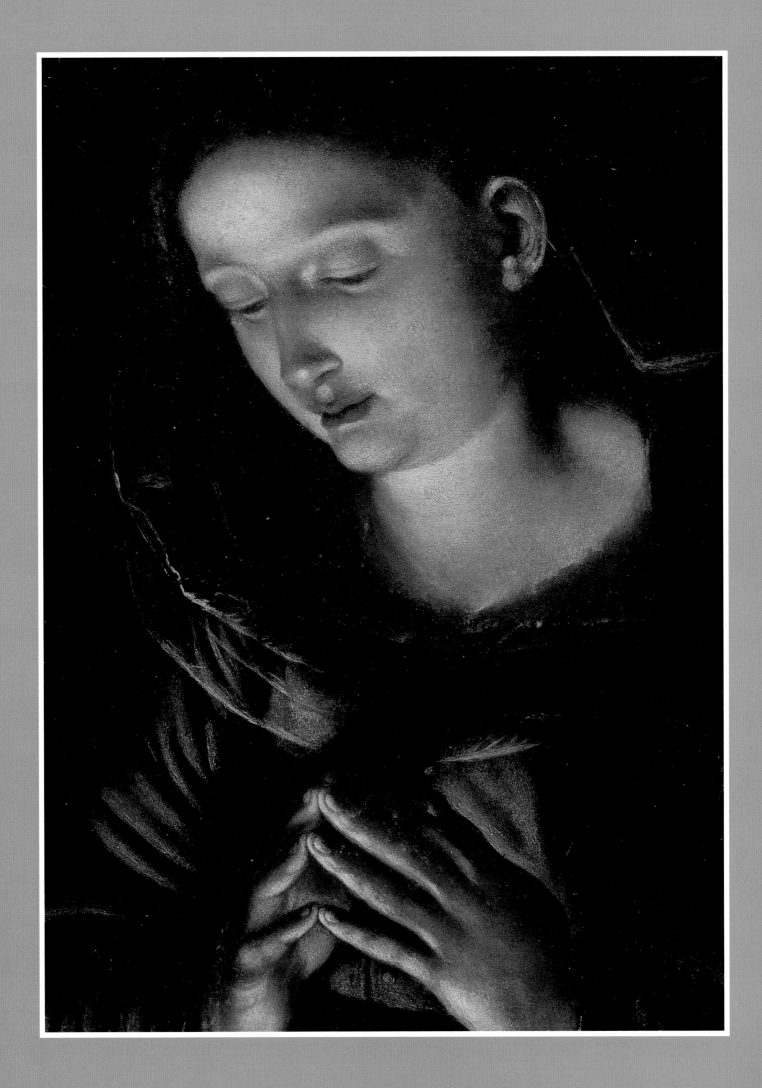

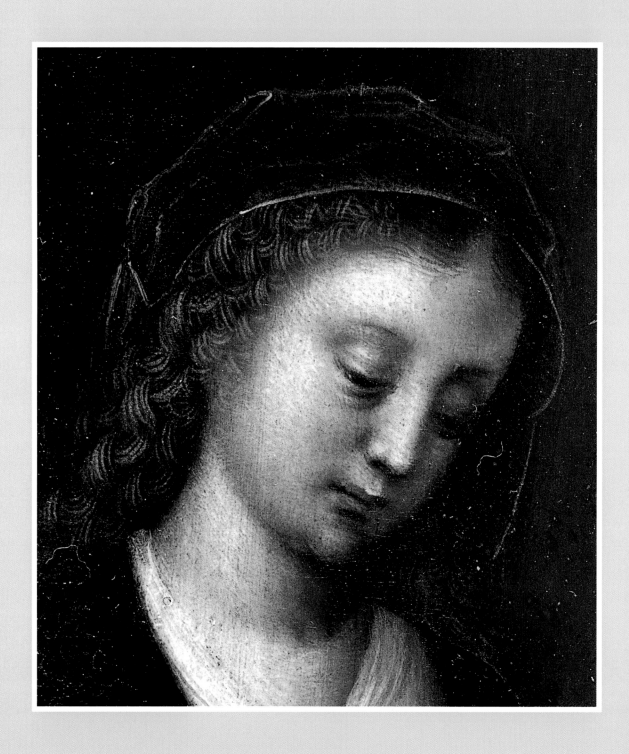

Today from the Aurora's bosom
A pink has fallen—a crimson blossom;
And oh, how glorious rests the hay
On which the fallen blossom lay
When silence gently had unfurled
Her mantle over all below,

And crowned with winter's frost and snow,
Night swayed the sceptre of the world,
Amid the gloom descending slow
Upon the monarch's frozen bosom
A pink has fallen—a crimson blossom.

School of Adriaen Isenbrandt, *Madonna & Child in Interior*

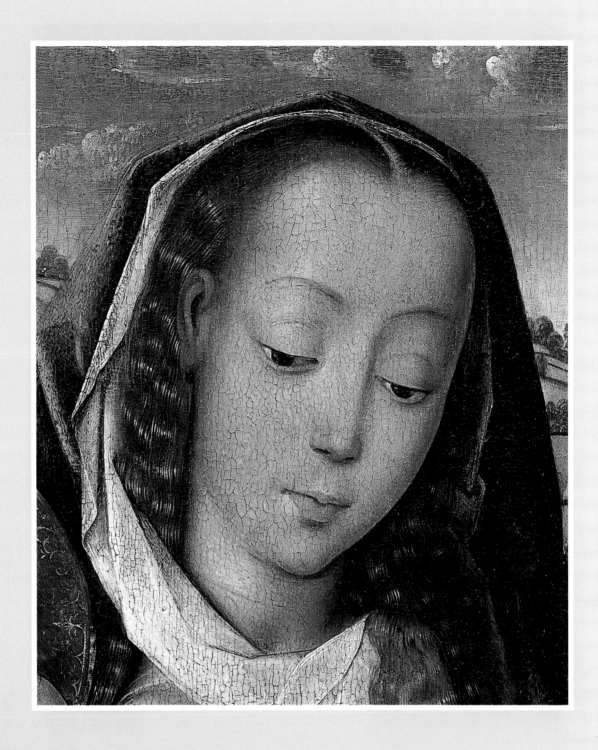

The only flower the Virgin bore
(Aurora fair) within her breast,
She gave to earth, yet still possessed
Her virgin blossom as before;
That hay that colored drop caressed,
 Received upon its faithful bosom
 That single flower—a crimson blossom.

The manger, unto which 'twas given,
Even amid wintry snows and cold,
Within its fostering arms to fold
 The blushing flower that fell from heaven,
Was as a canopy of gold.
 A downy couch, where on its bosom
 That flower had fallen—that crimson blossom.

—LUIS GONGORA, *The Nativity of Christ*

Master of the Legend of Saint Lucy, *Virgin & Child in a Landscape*

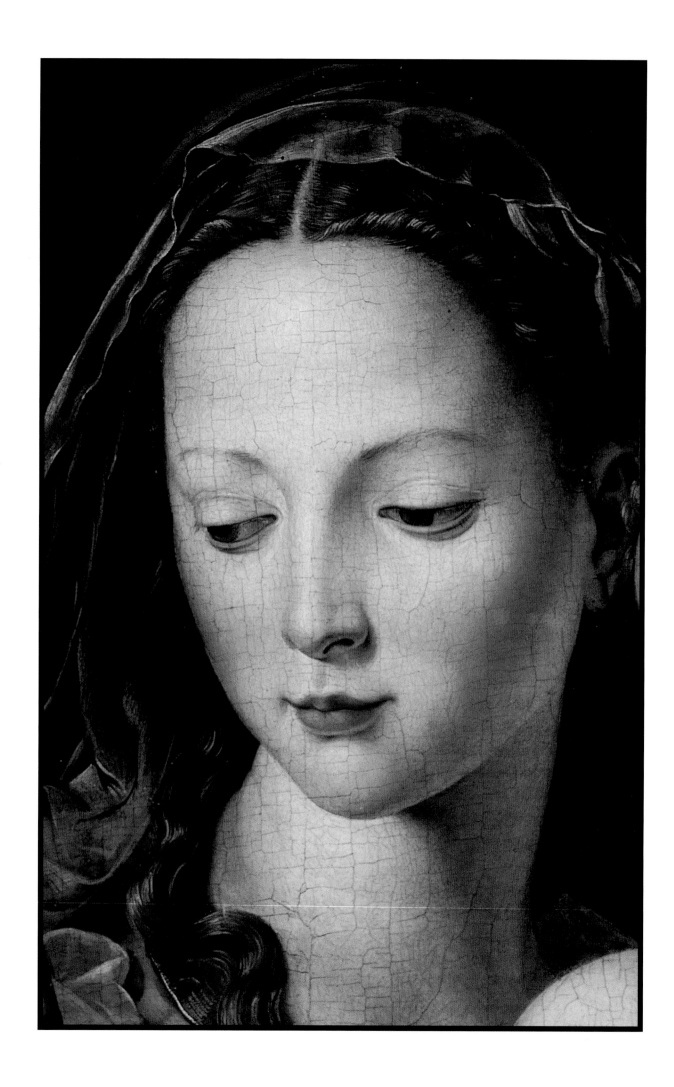

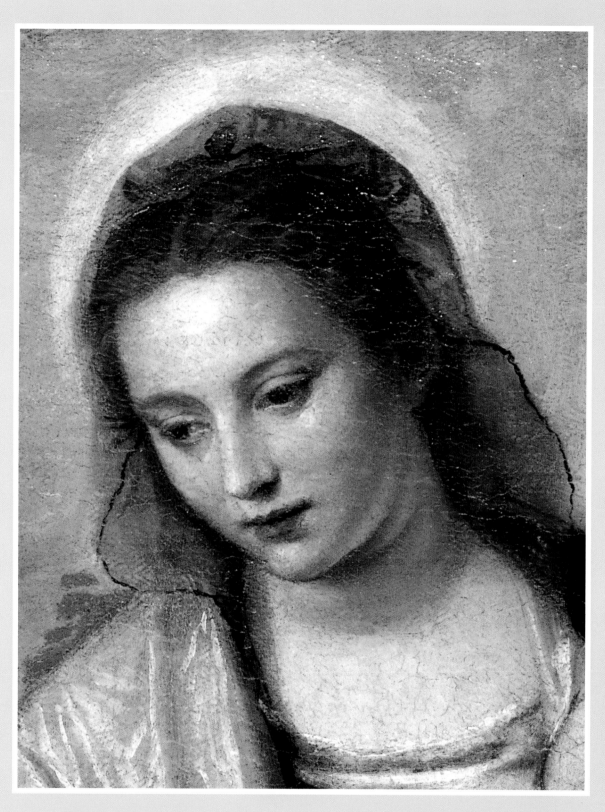

Stood the lovely Mother smiling
By the Manger where beguiling
Lay her little one at rest;

All her soul its gladness voicing,
As the gleam of her rejoicing
Swept across her gentle breast.

—Stabat Mater Speciosa

(opposite) Agnolo Bronzino, *The Holy Family*
(above) Paolo Veronese, *Madonna & Child with St. Elisabeth, the Infant St. John the Baptist, & St. Catherine*

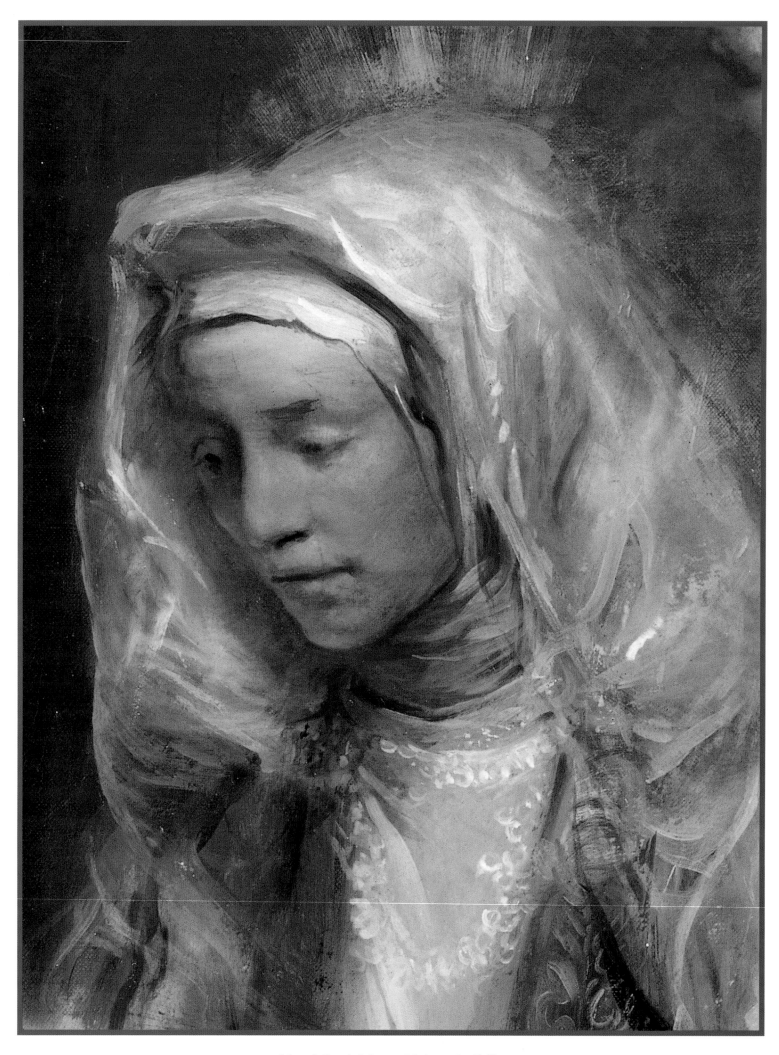

(above) Frank Mason, *Madonna & Child*
(opposite) George Hitchcock, *Madonna & Child*

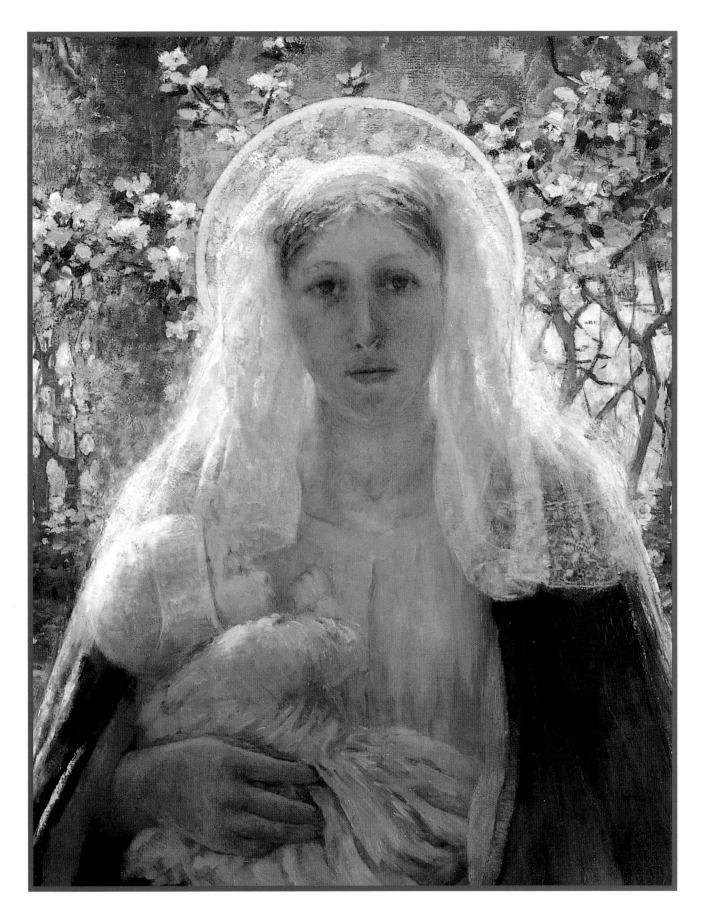

But see! The star has tarried, Mary holds her God within her
 arms!
It is too late now to think of darkness and mysterious alarms.
We have but to open our eyes and brush the mist away:
The Son of God is born to us—and this is the twelfth day!

—PAUL CLAUDEL, *Hymn for Epiphany*

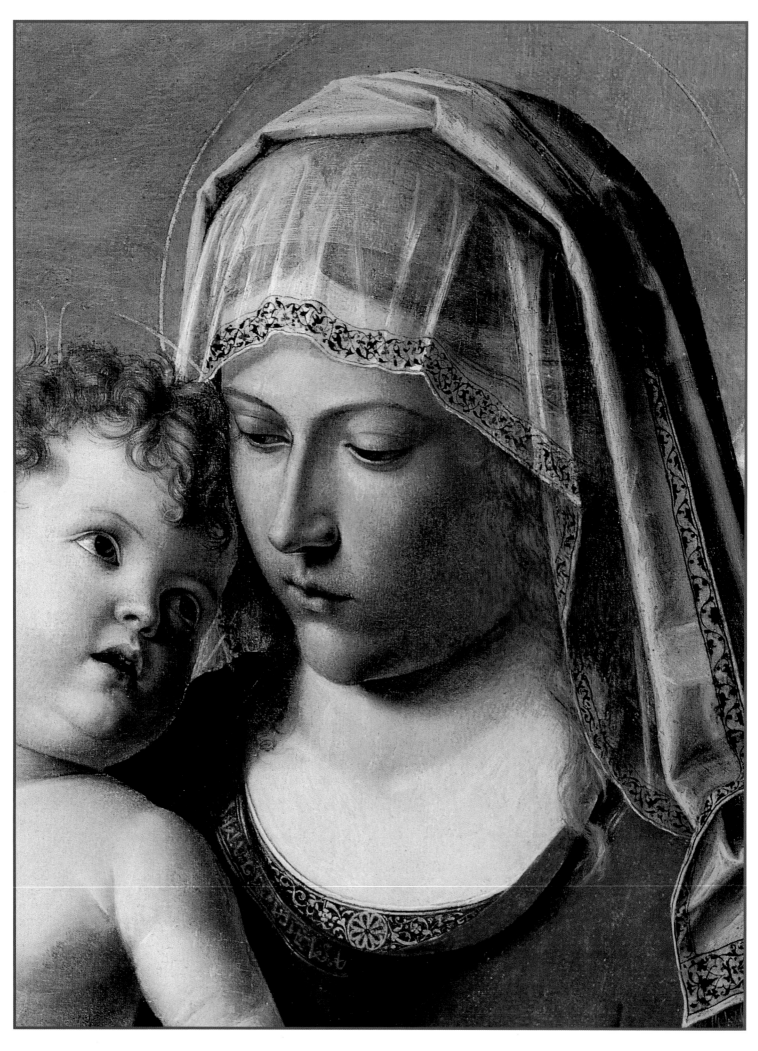

46

(above) Giovanni Battista Cima da Conegliano, *Madonna & Child in a Landscape*
(Opposite) Sandro Botticelli, *Madonna & Child with an Angel*

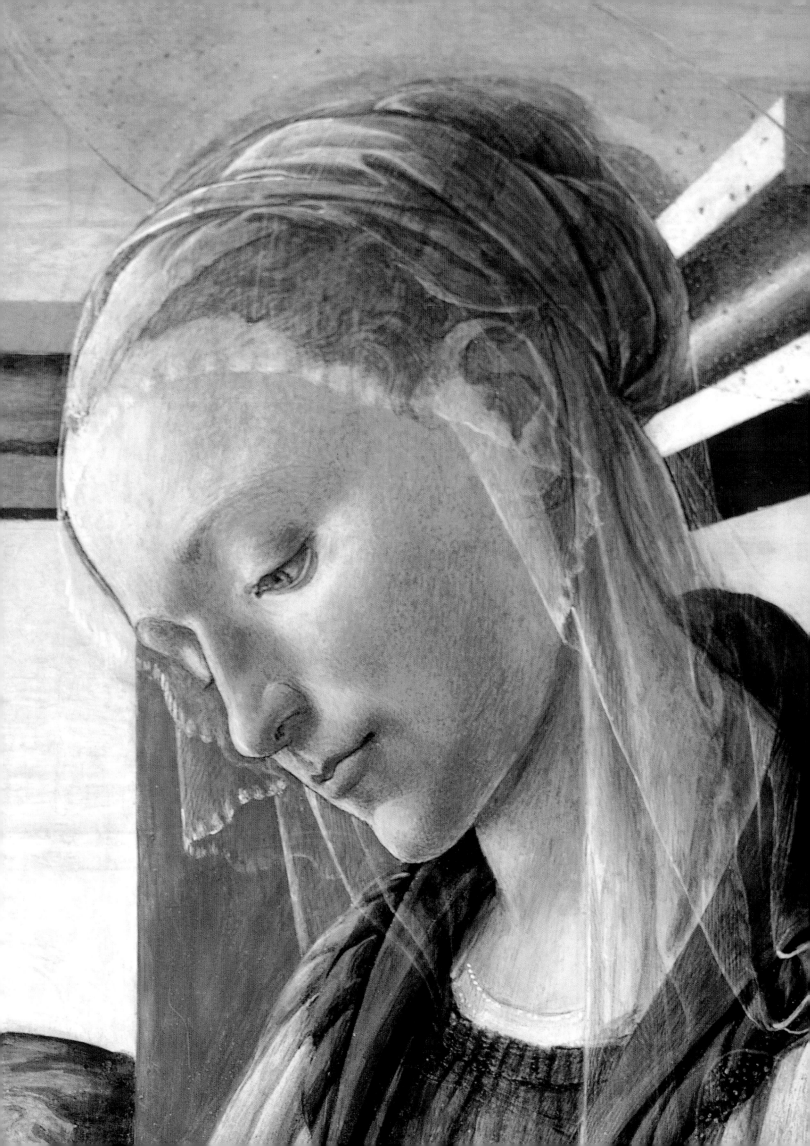

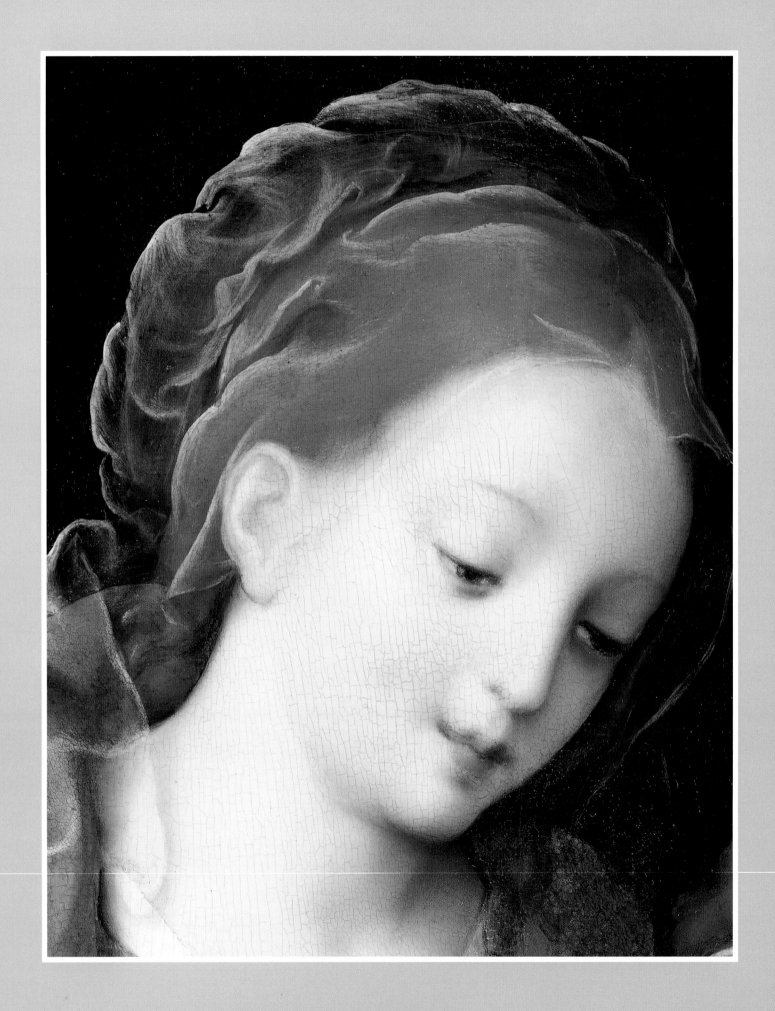

Cornelis van Cleve, *Madonna & Child*

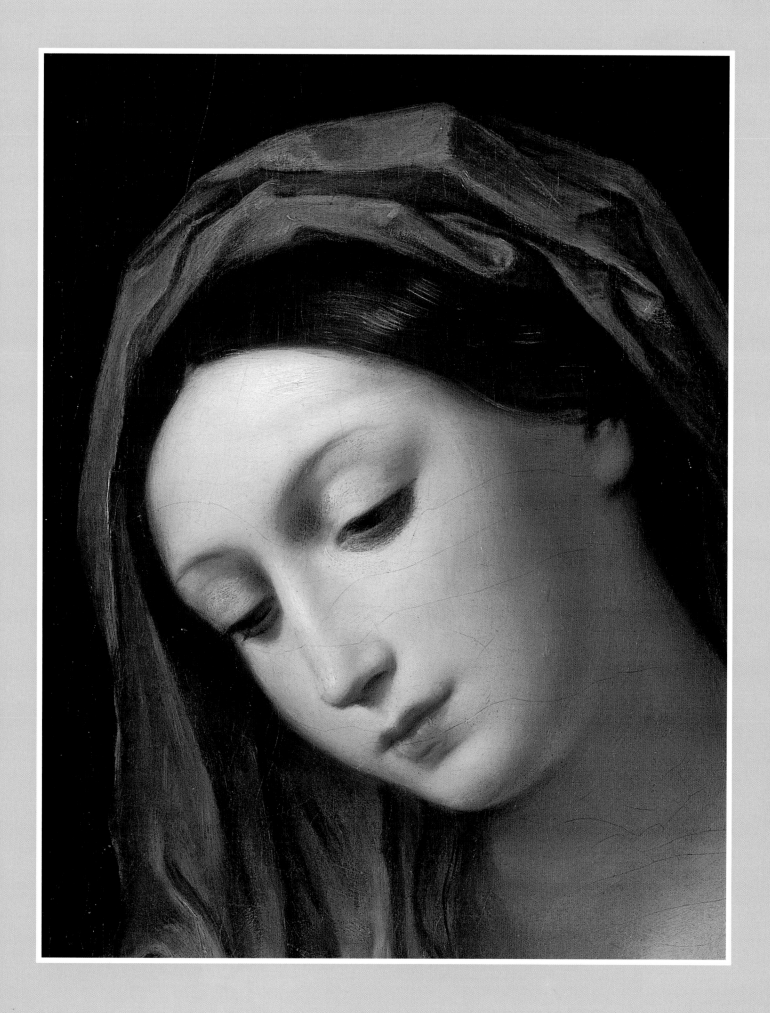

Guido Reni, *Madonna & Child*

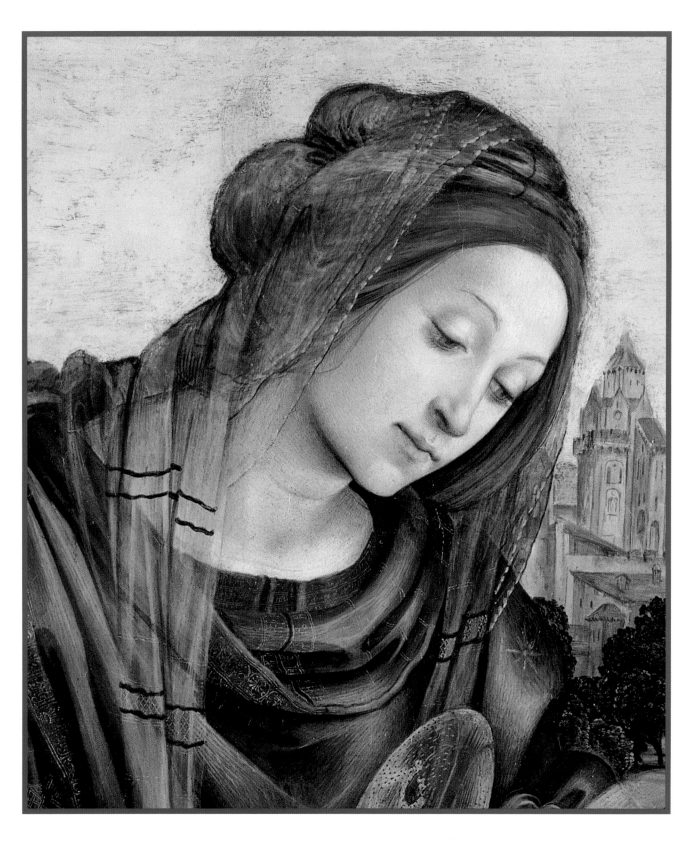

The Saviour of the newborn lay newly born in a manger.

When his mother looked down at him, she said:

"My Son, how was your seed sown in me, how did it grow within me!"

—ROMANUS MELODOS, *The Nativity I*

(above) Filippino Lippi, *The Holy Family with John the Baptist & St. Margaret*
(opposite) Giovanni Bellini, *Madonna & Child*

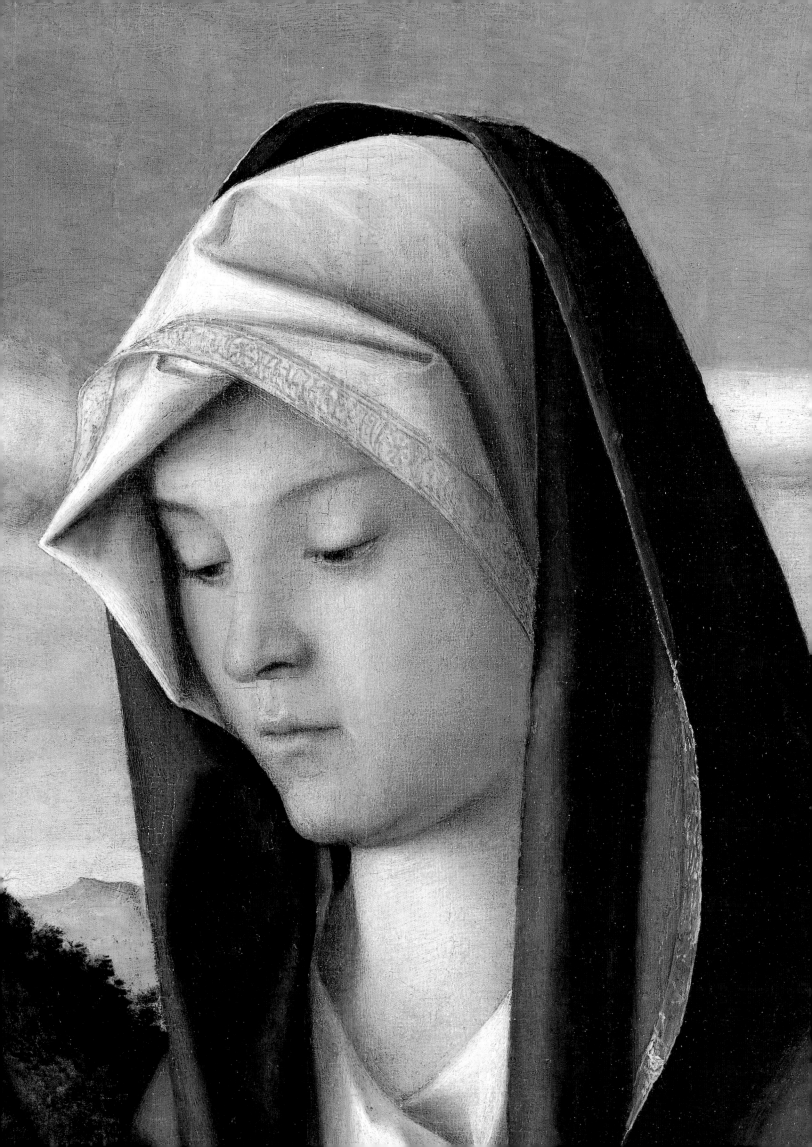

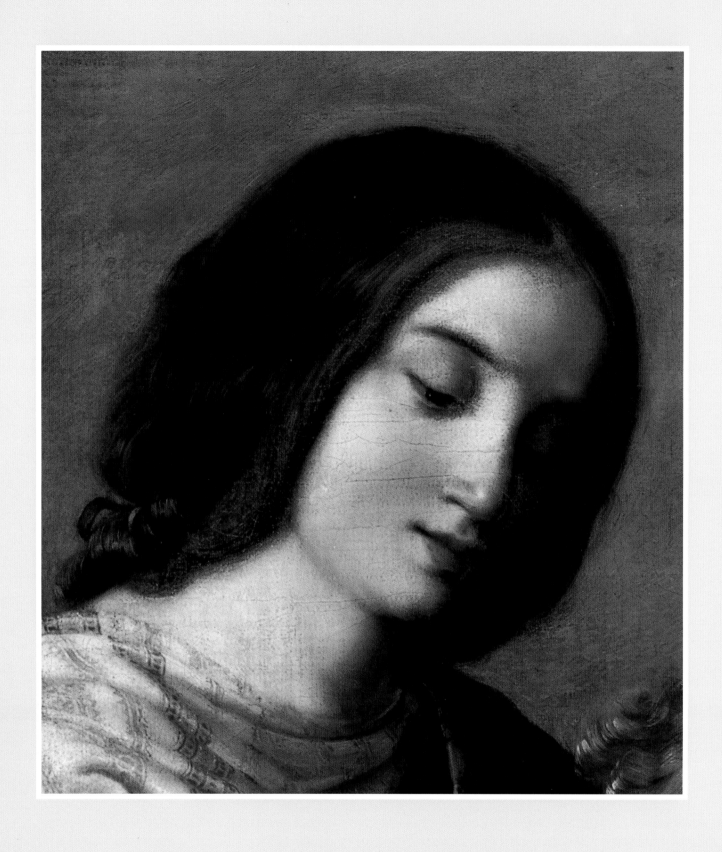

I gaze at you, Lord of mercy, and I am thunderstruck;
though never a bride, I have become your nurse.

—ROMANUS MELODOS, *The Nativity I*

Francisco de Zurbarán, *Madonna & Child with the Infant St. John*
Lorenzo di Credi, *Madonna & Child with the Infant St. John*

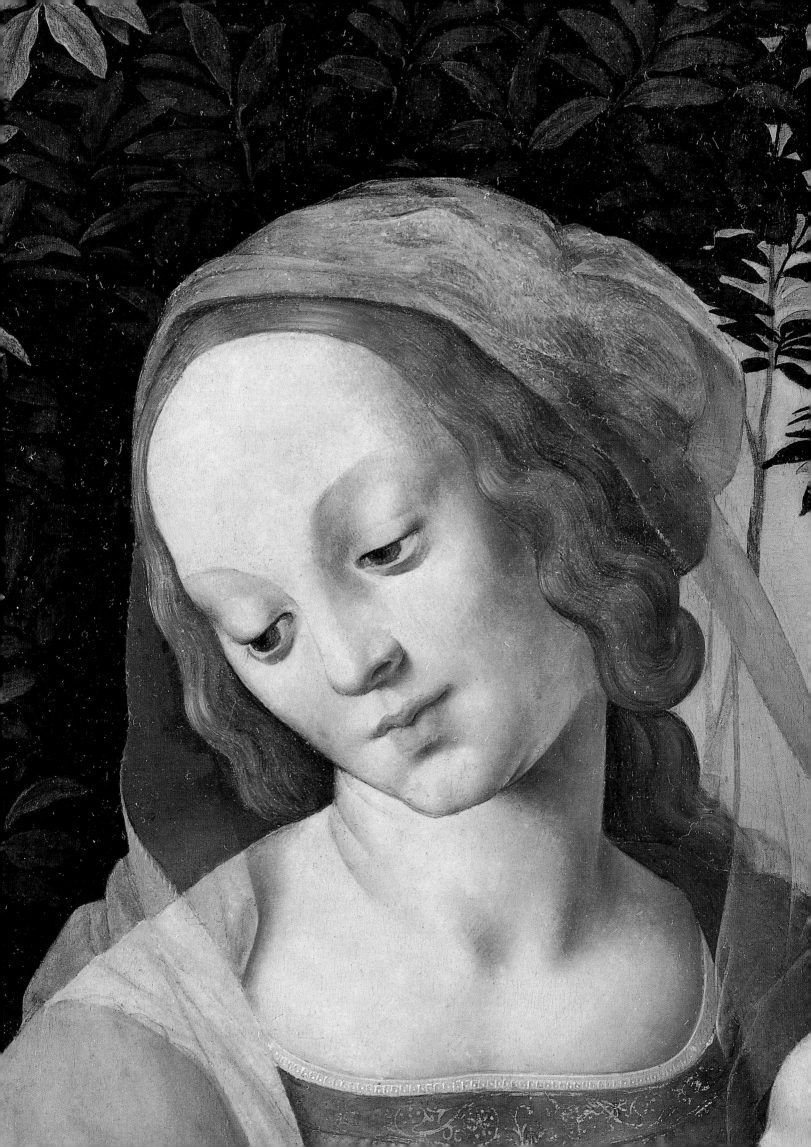

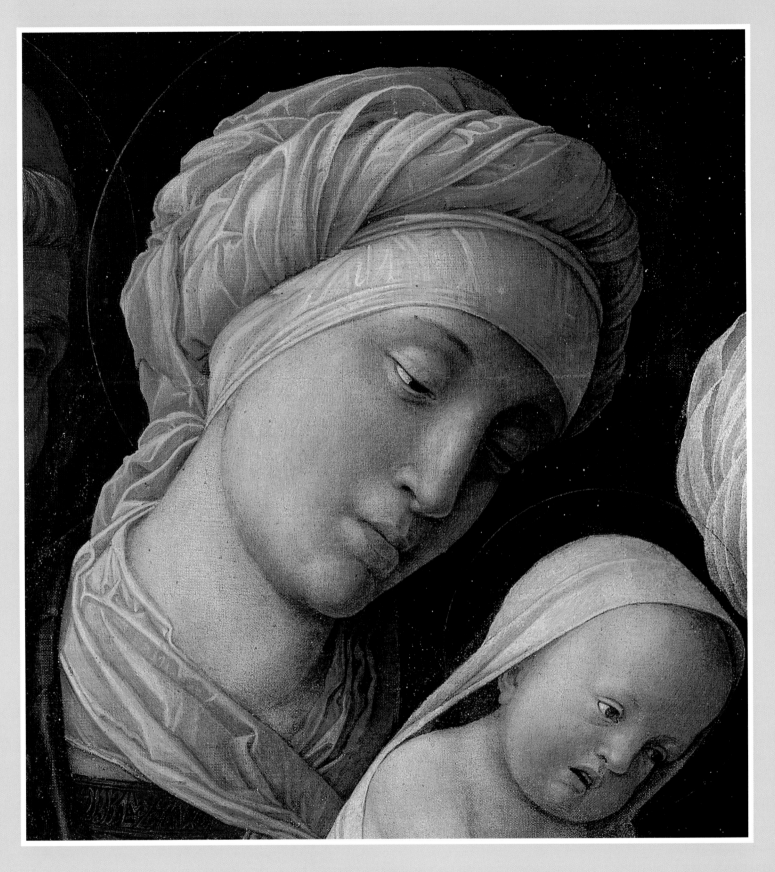

*A*nd in those days there came certain men who were Magians from the country of the East....And when they had entered into the stable they saw the child in my arms, and they worshipped Him, and with joy and gladness they brought forth gifts of gold, frankincense, and myrrh; and they cried out, "Blessed be the great King Who shall destroy the kingdoms of the earth...." And that night they slept there thinking that on the morrow they would go to Herod and tell him that they had found the Child and his mother. But the angel of the Lord appeared and said unto them, "Get ye to your own country in peace": and they went there according as the angel of God had said unto them.

—The Miracles of the Blessed Virgin Mary

(above) Andrea Mantegna, *Adoration of the Magi*
(opposite) Lucas Cranach the Elder, *Madonna & Child with Grapes*

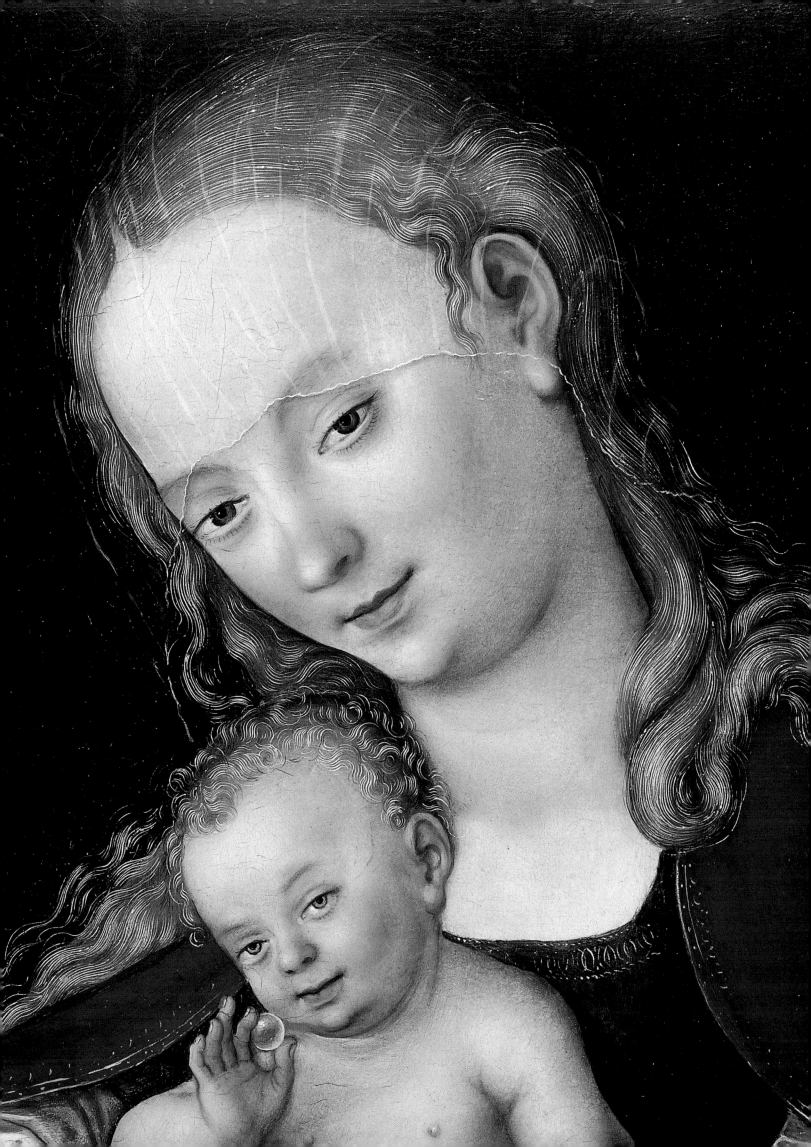

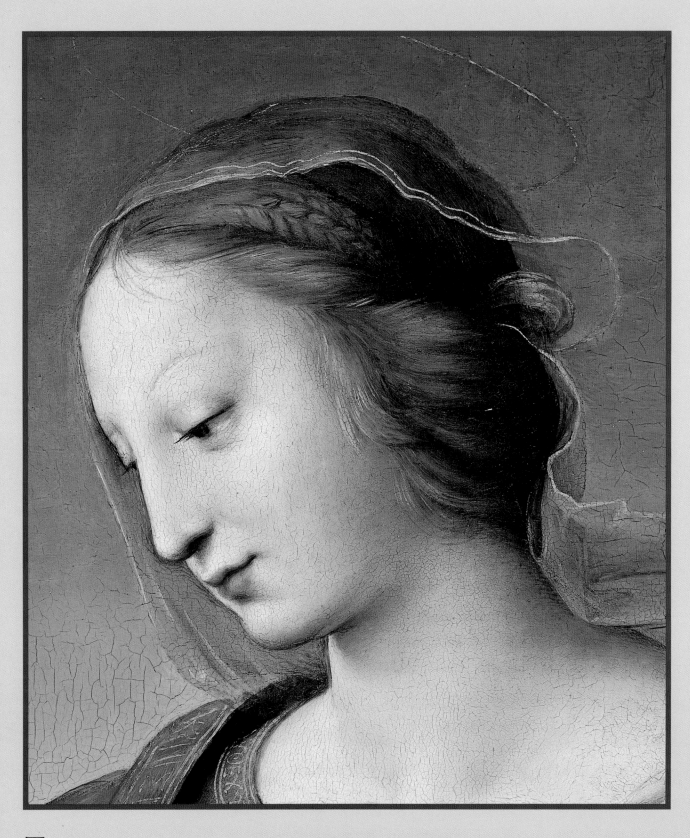

The virgin, Astraea, returns; the Saturnian age of peace is renewed,

For a new order of generation is sent down from the high heavens

Thou, chaste Lucina, be propitious to the boy new-born,

Through whom the Iron Age will reach its end

And the Golden Age will spread over the entire world;

So may the reign of Apollo begin!

—Virgil, *Fourth Eclogue*, The Sibylline Prophecy

(above) Raphael, *The Niccolini-Cowper Madonna*
(opposite) Pietro Perugino, *Madonna & Child*

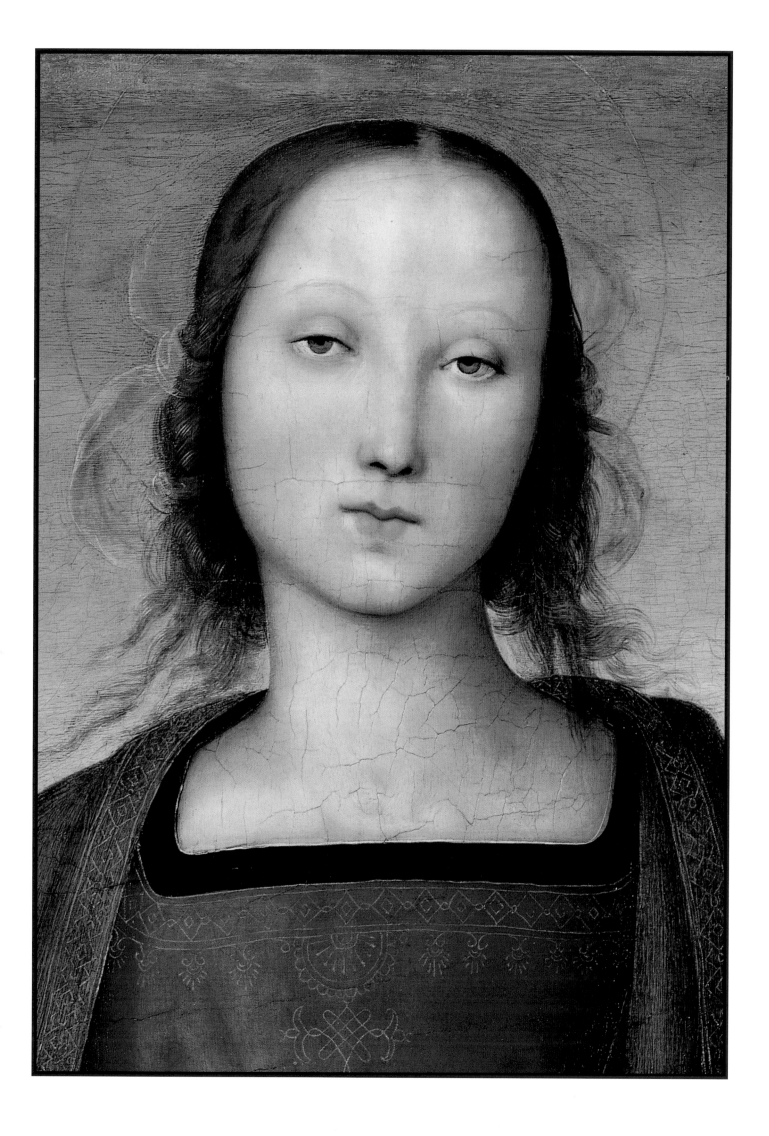

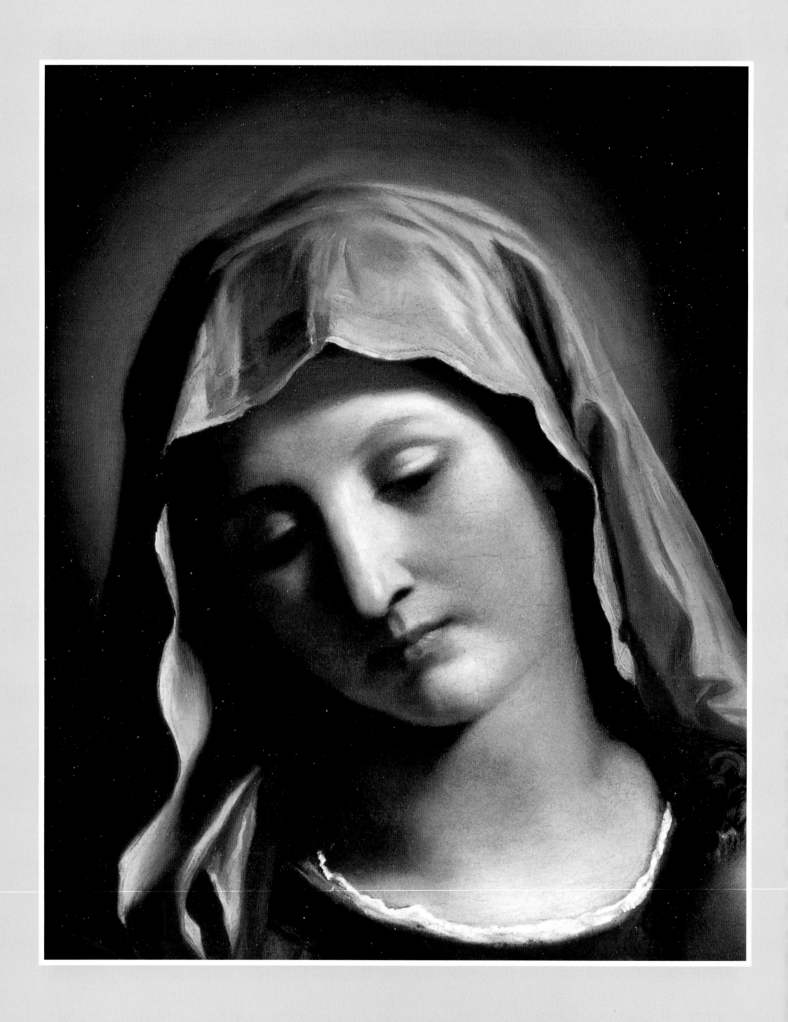

(above) Guercino (Giovanni Francesco Barbieri), *Madonna & Child*
(opposite) Andrea Mantegna, *The Holy Family with Saint Elizabeth & the Infant Saint John the Baptist*

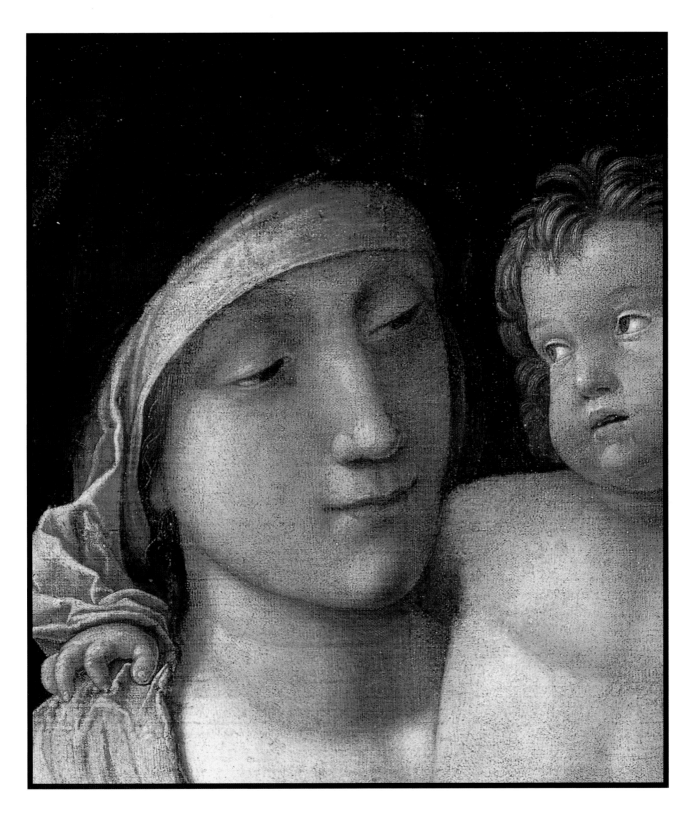

Hail, woman who kneels in the splendor, first-born of every
 creature!
Abysses were not as yet and thou wert already conceived!
It is thou who hast made a light unfailing to rise in Heaven!
When He made a cross over chaos, the Omnipotent had thy face
 before Him,
As I have it now in my heart, O great Lily-flower, pure Virgin!

—PAUL CLAUDEL, *Marching Song for Christmas*

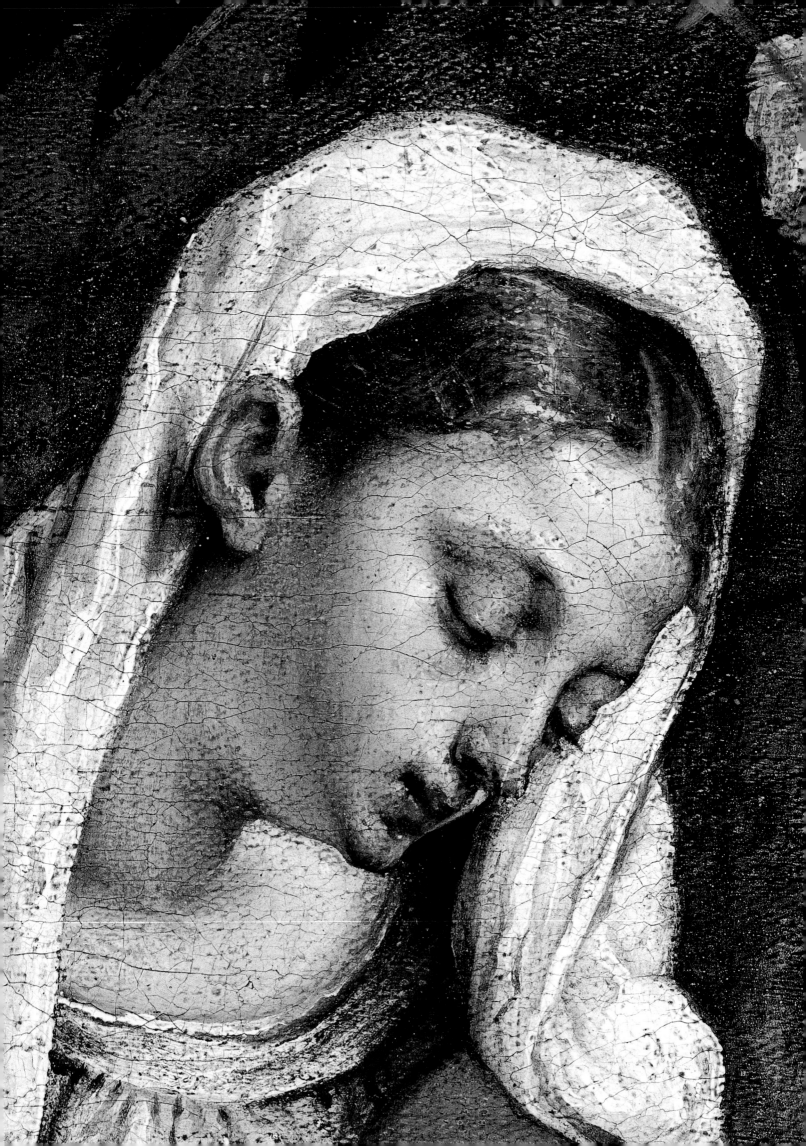

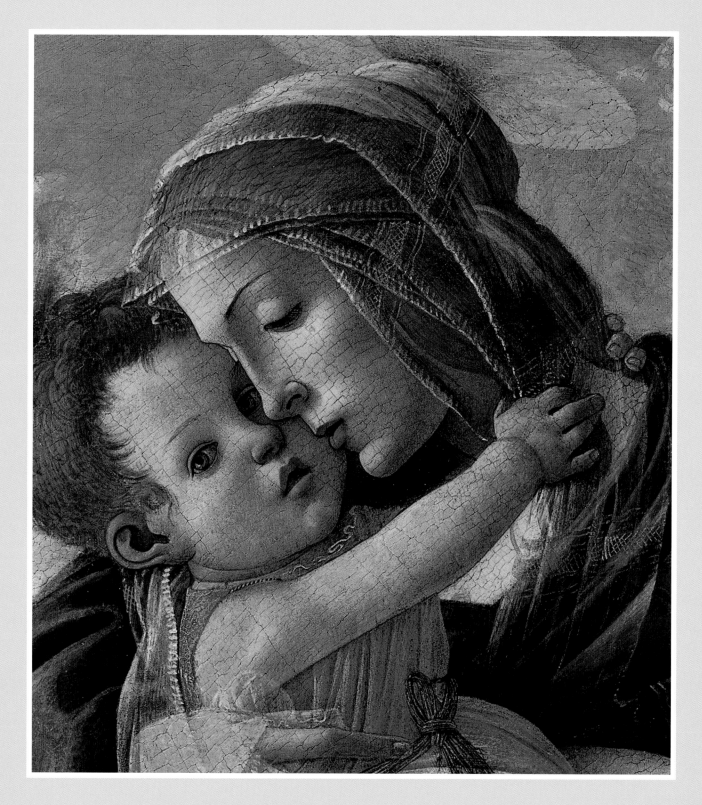

*N*ow on that day the angel of God appeared unto Joseph, and said unto him, "Rise up, and take the Child and his
mother; and depart unto the country of Egypt...for Herod seeketh the Child to slay Him." Then straightway
we rose up and departed unto the country of Egypt...

And I carried my Child sometimes on my shoulders, and sometimes on my back, and sometimes in my
arms....Then, sometimes I set Him down upon the ground that He might follow me, even as do women when
they teach their children to walk...and He would walk along a little way at a time, holding on to the hem of
my skirt, and then, like all children who cry out to their mothers to carry them He expected me to carry Him,
and I did so immediately on my back. Then I would embrace Him and would rejoice in His walking.

—THE MIRACLES OF THE BLESSED VIRGIN MARY

(opposite) Bassano (Jacopo da Ponte), *The Flight into Egypt*
(above) Sandro Botticelli, (Alessandro di Mariano Filipepi) and Studio, *Virgin & Child with Saint John the Baptist*

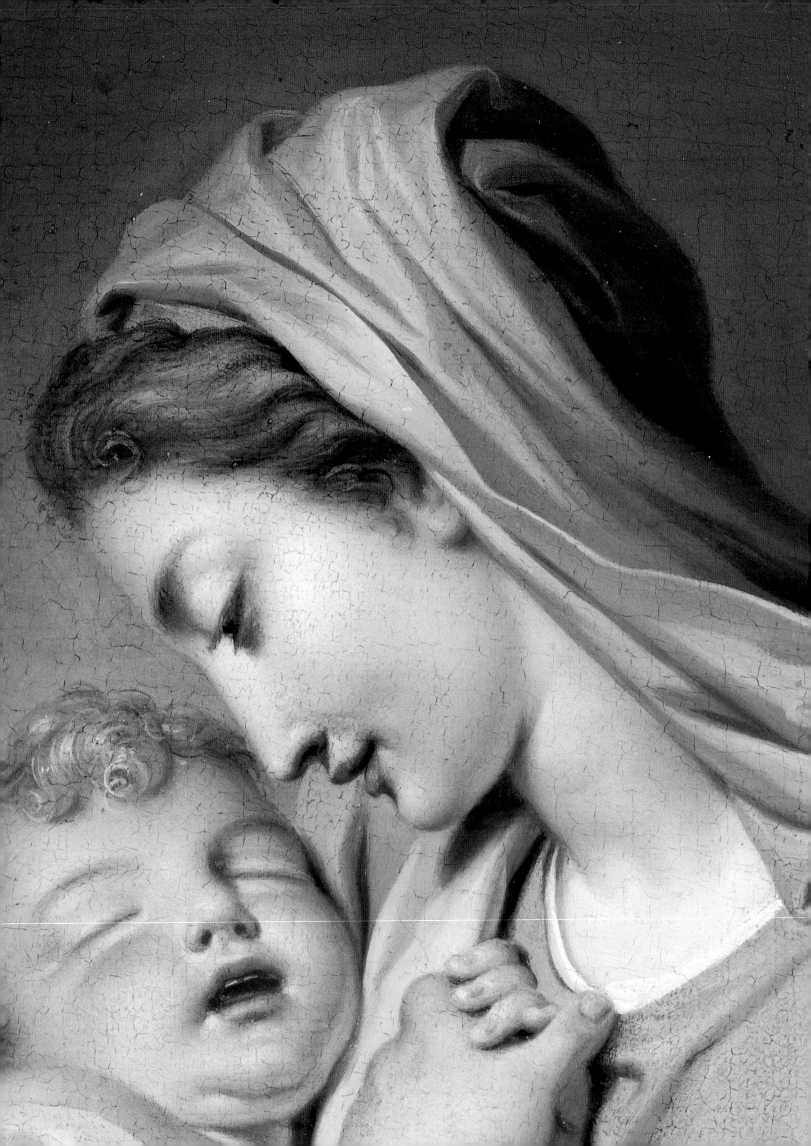

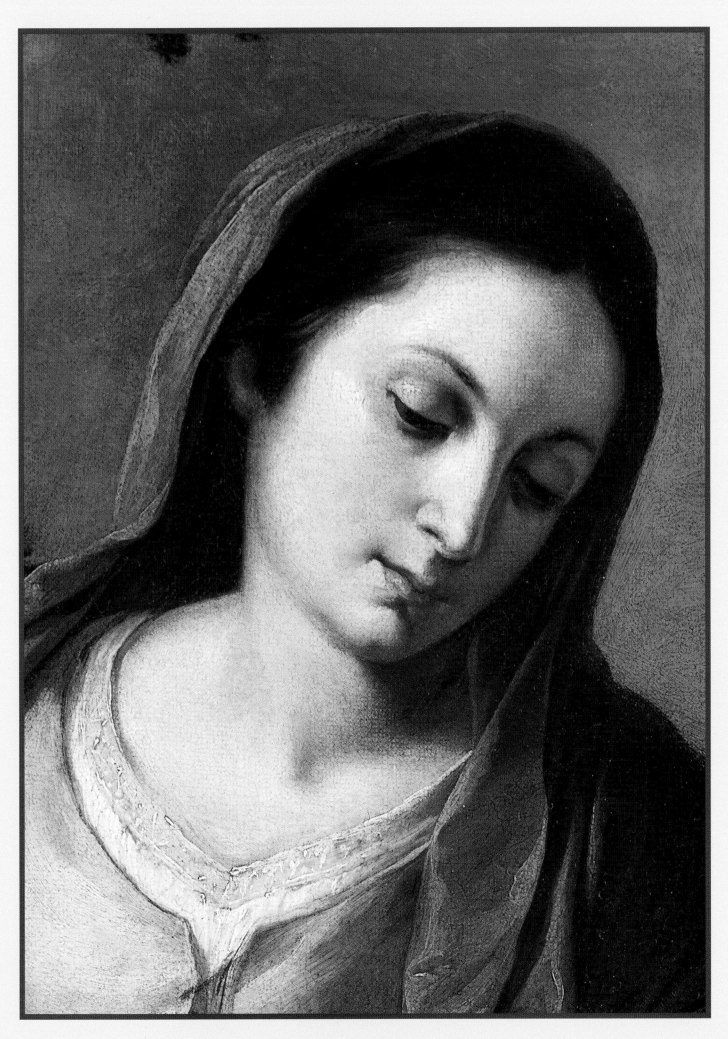

(opposite) Domenico Corvi, *Virgin & Child*
(above) Bartolomé Esteban Murillo, *The Flight into Egypt*

63

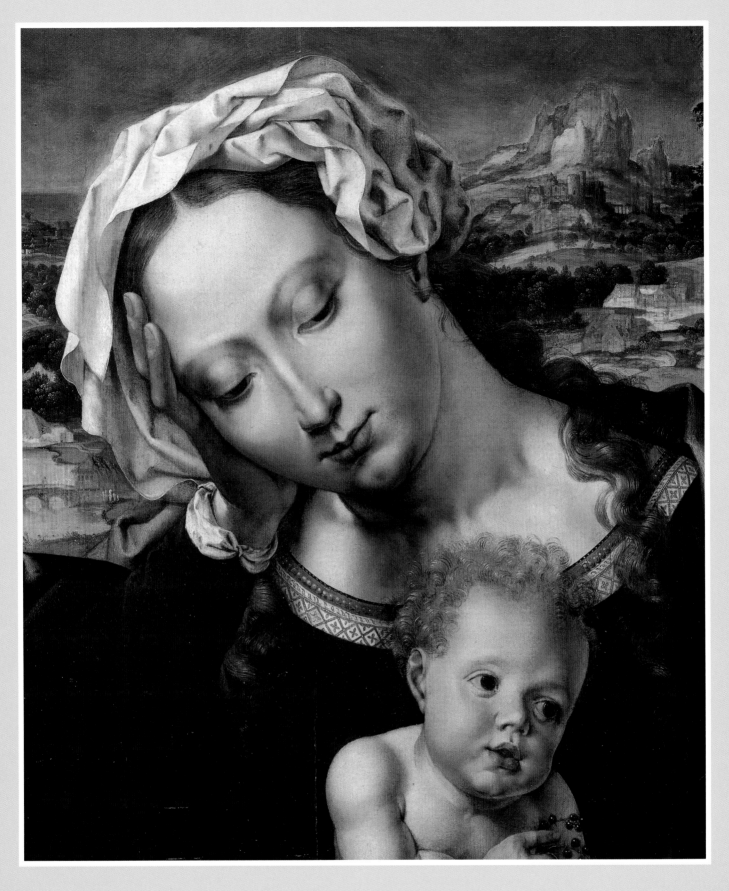

Jan Gossaert (Joannes Malbodius), *Virgin & Child*

Only for a moment while everything stands still.
Noon! To be with you, Mary, in this place where you are.
To say nothing, to look at your face,
Letting the choir sing in its own language,
To say nothing, merely to sing because one's heart
 is too full, like the blackbird following his
 idea in these improvised couplets.

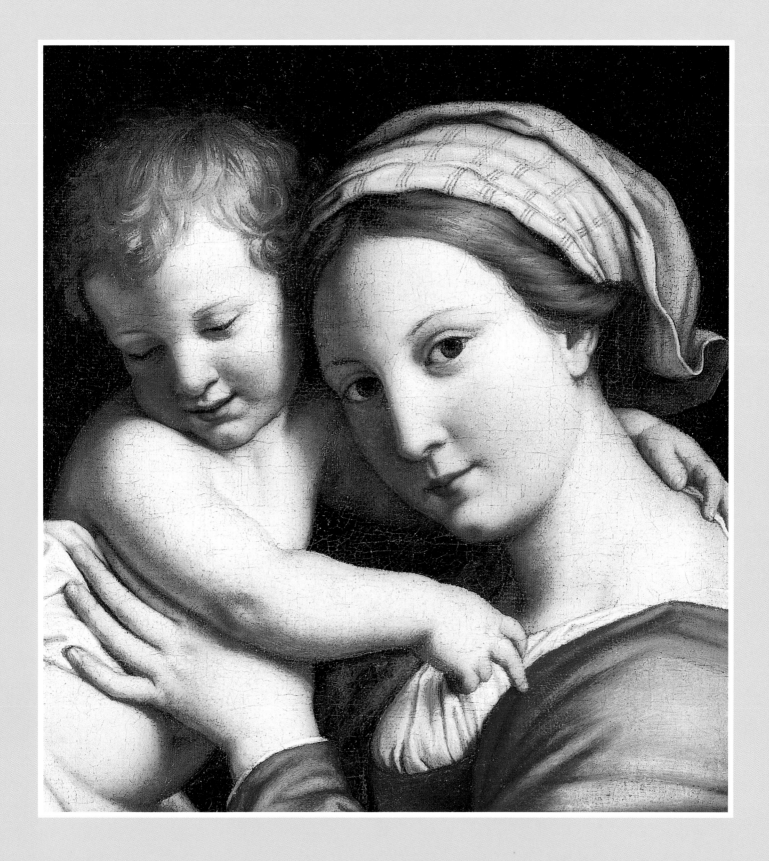

Sassoferrato, *Madonna & Child*

Because you are beautiful, because you are immaculate…

Ineffably intact because you are the Mother of Jesus Christ,

Who is the truth in your arms, and the only hope

 and the only fruit.…

 Because it is noon, because we are living in this day

 Because you are always there, simply because you are

 Mary, simply for existing,

 Mother of Jesus, let me thank you.

—PAUL CLAUDEL, *The Virgin at Noon*

65

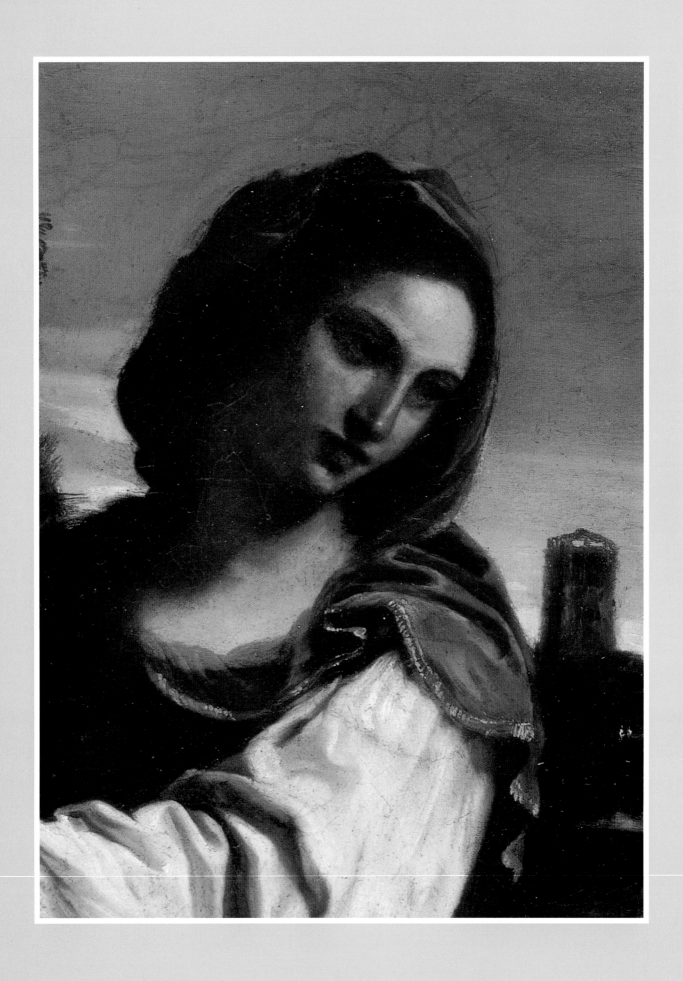

Guercino (Giovanni Francesco Barbieri), *Rest on the Flight into Egypt*

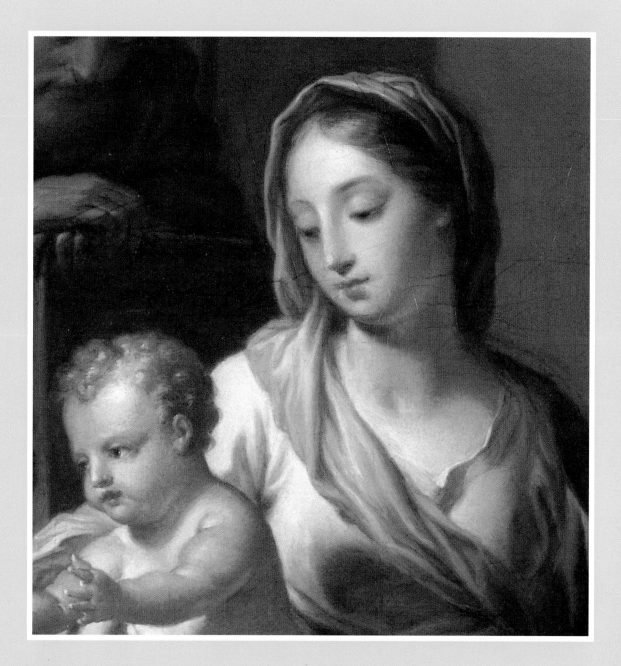

*A*nd Herod continued to wait two years for the Magians to return unto him. . .and Herod was greatly moved, and he and all his servants were afraid. Then Satan appeared unto him by night in the form of a wise man, and said unto him, "Wherefore remainest thou thus idle? For thou and all thy kingdom shall be destroyed." And Herod answered and said, "What shall I do?" Then Satan said unto him, "On the morrow, in the morning, send thy servants and command them not to leave alive in Bethlehem any which is two years old and under, and let them slay them; and as the Child Jesus shall be found among those who shall be slain He shall not grow up and shall not take thy kingdom from thee."

—*Miracles of the Virgin Mary*

Francesco, Trevisani, *The Holy Family with St. Anne, Joachim & John the Baptist*

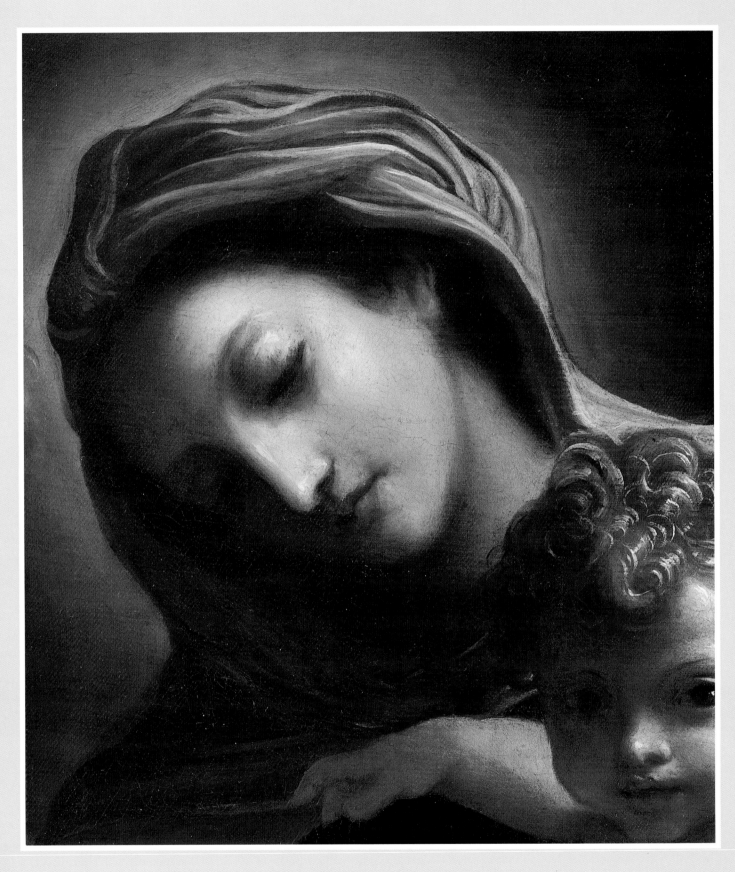

T he Mother with the Child
Whose tender winning arts,

Have to His little arms beguiled
So many hearts.

—MATTHEW ARNOLD

(above) Lodovico Carracci, *The Dream of Saint Catherine of Alexandria*
(opposite) Giulio Cesare Procaccini, *Holy Family with the Infant Saint John & an Angel*

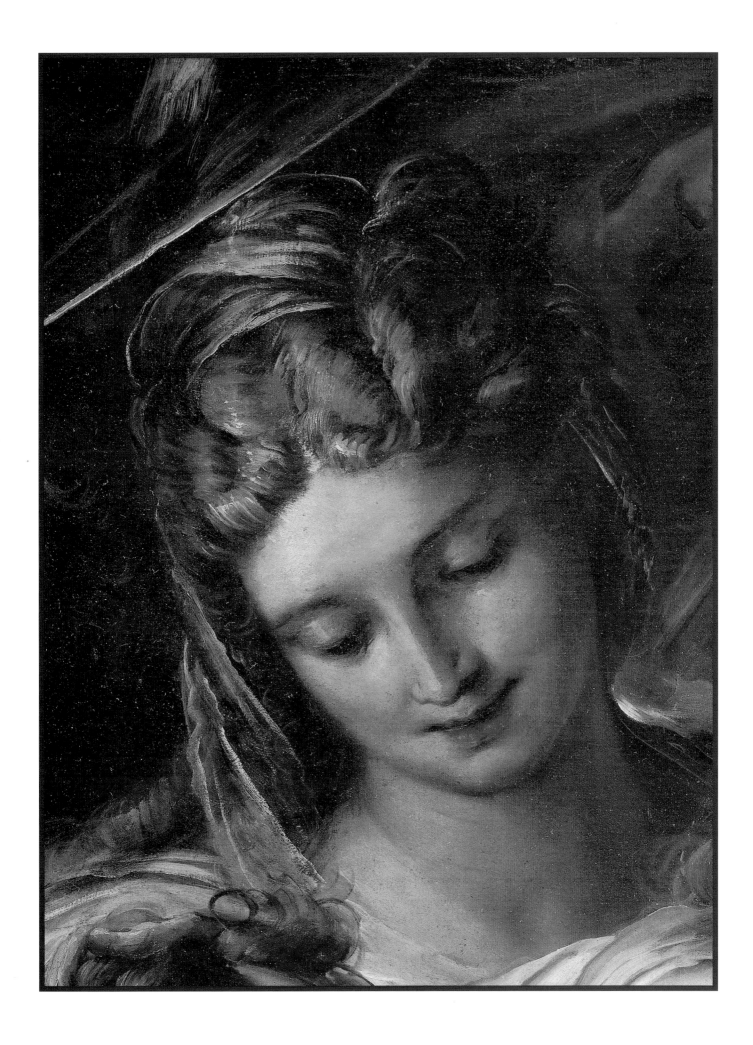

Mother! Whose virgin bosom was uncrost

 With the least shade of thought to sin allied;

 Woman! Above all women glorified,

Our tainted nature's solitary boast;

Purer than foam on central ocean tost;

 Brighter than eastern skies at daybreak strewn

 With fancied roses, than the unblemished moon

 Before her wane begins on heaven's blue coast;

Thy image falls to earth. Yet some, I ween,

 Not unforgiven, the suppliant knee might bend

 As to a visible power, in which did blend

 All that was mixed and reconciled in thee

 Of mother's love with maiden purity,

Of high with low, celestial with terrene.

—WILLIAM WORDSWORTH, *The Virgin*

Correggio (Antonio Allegri), *Virgin & Child with the Young Saint John the Baptist*

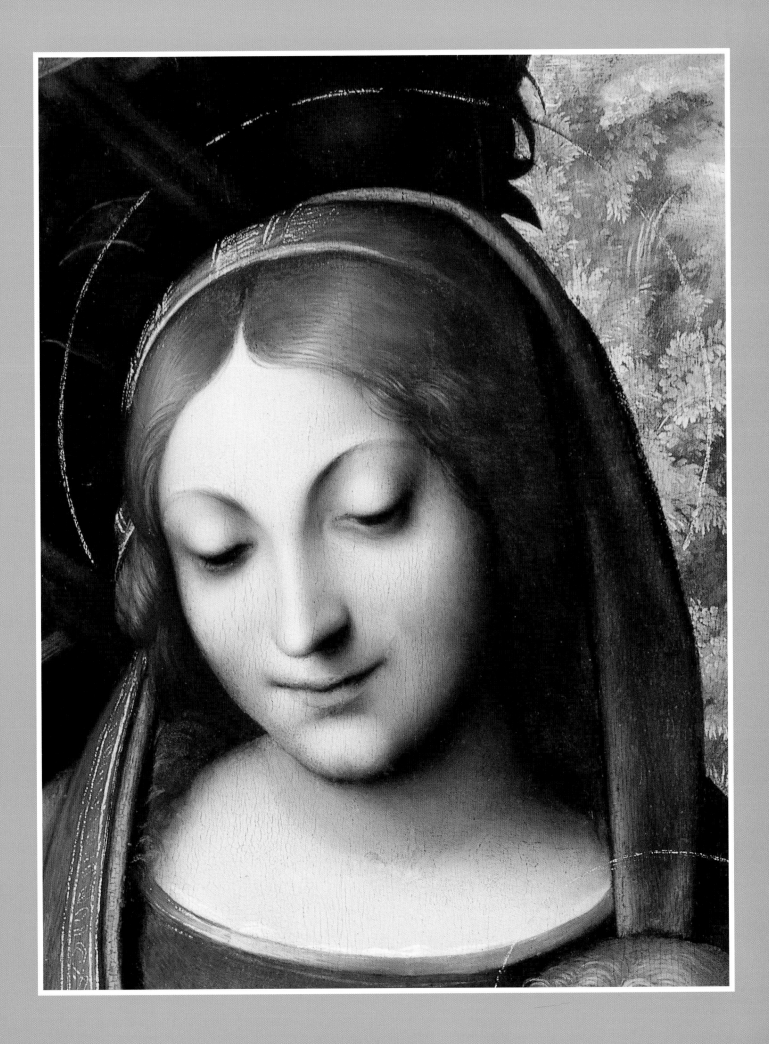

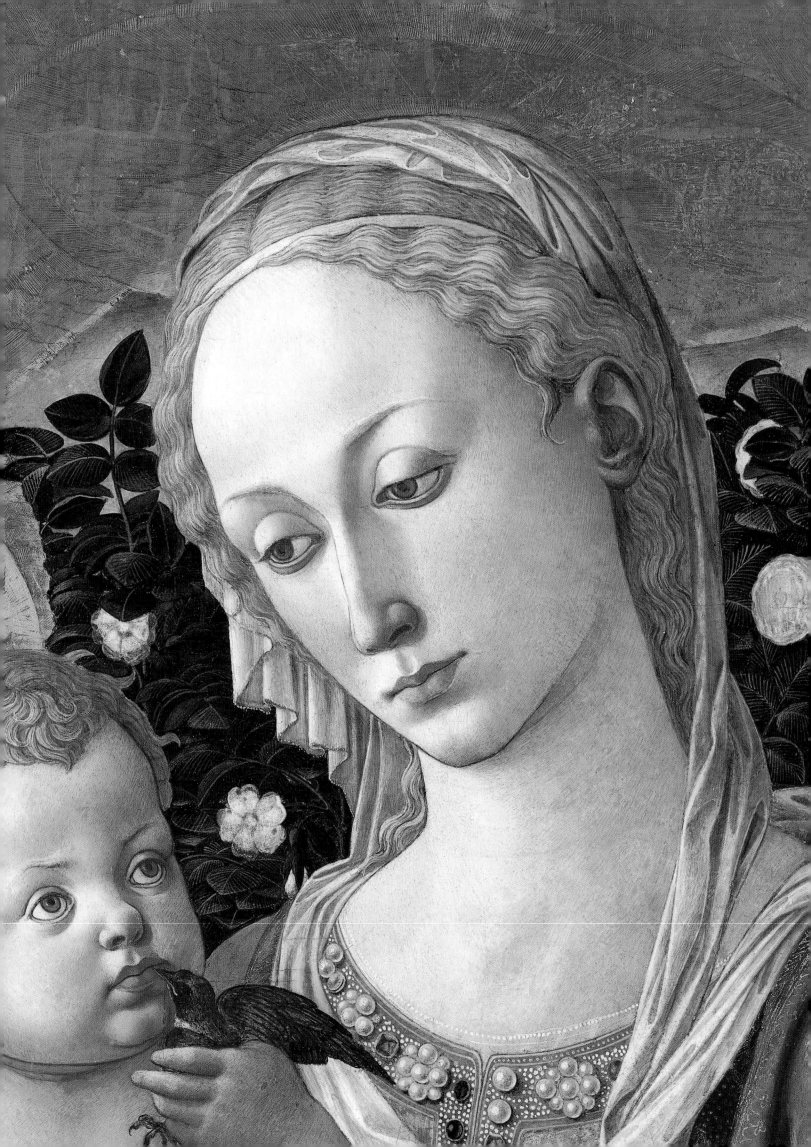

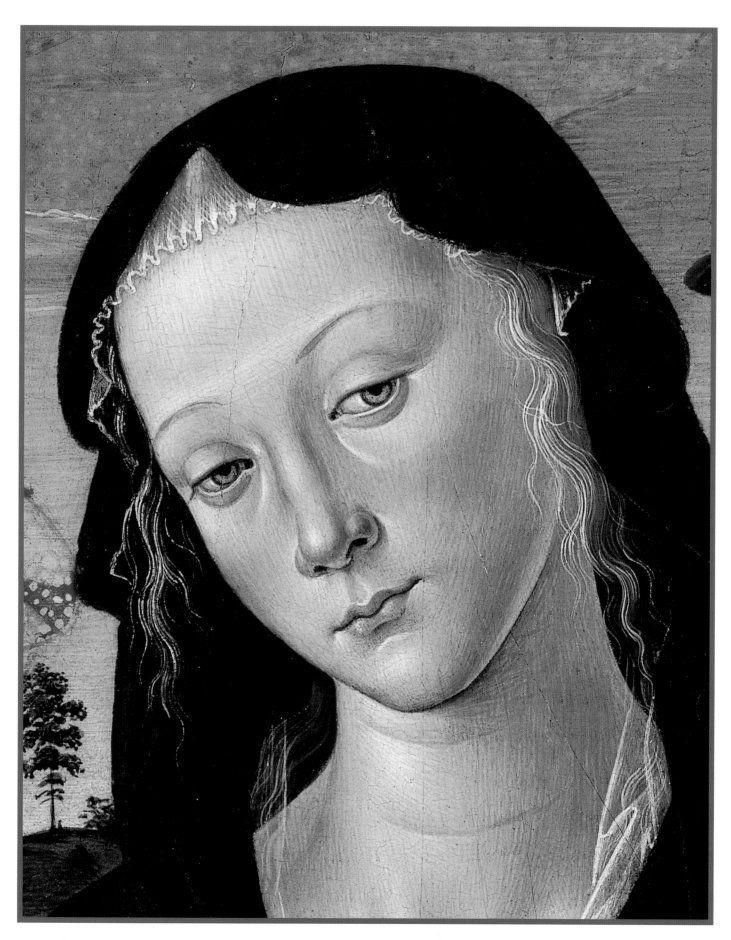

O shut your bright eyes that mine must endanger
With their watchfulness; protected by its shade
Escape from my care: what can you discover

From my tender look but how to be afraid?
Love can but confirm the more it would deny.
Close your bright eye.

—W.H. AUDEN, *At the Manger Mary Sings*

(opposite) Francesco di Stefano Pesellino, *Madonna & Child with Saint John*
(above) Pintoricchio (Bernardino di Betto), *Virgin & Child with Saint Jerome*

73

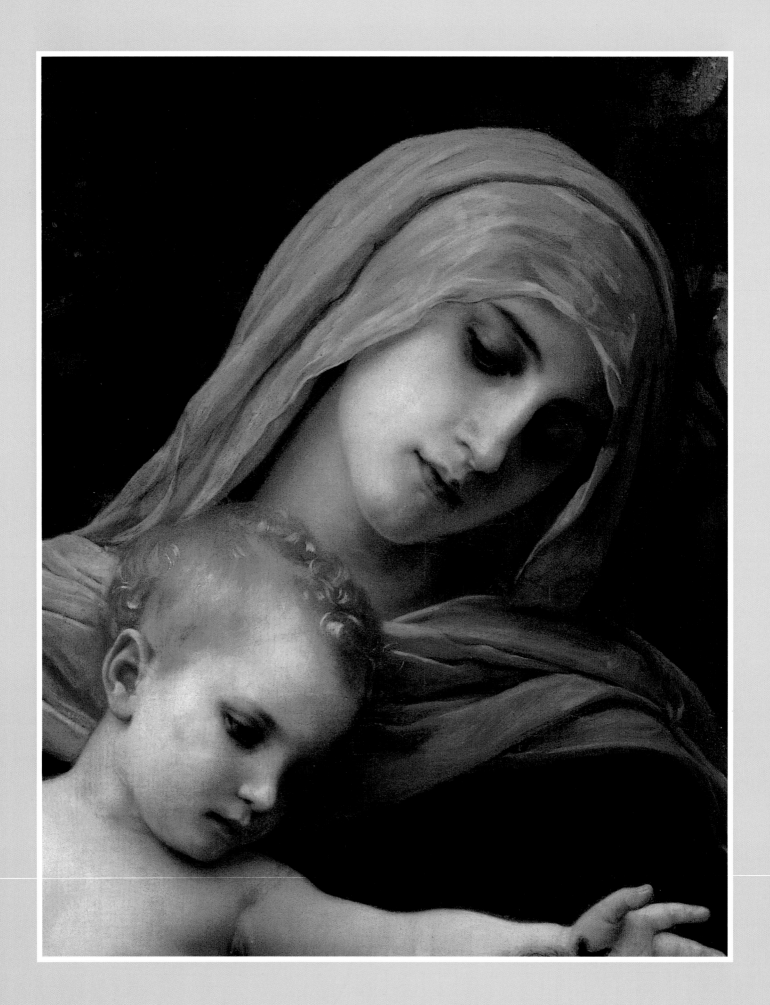

Adolphe William Bouguereau, *Madonna & Child with Saint John*
Pintoricchio (Bernardino di Betto), *Virgin & Child with Saint Jerome*

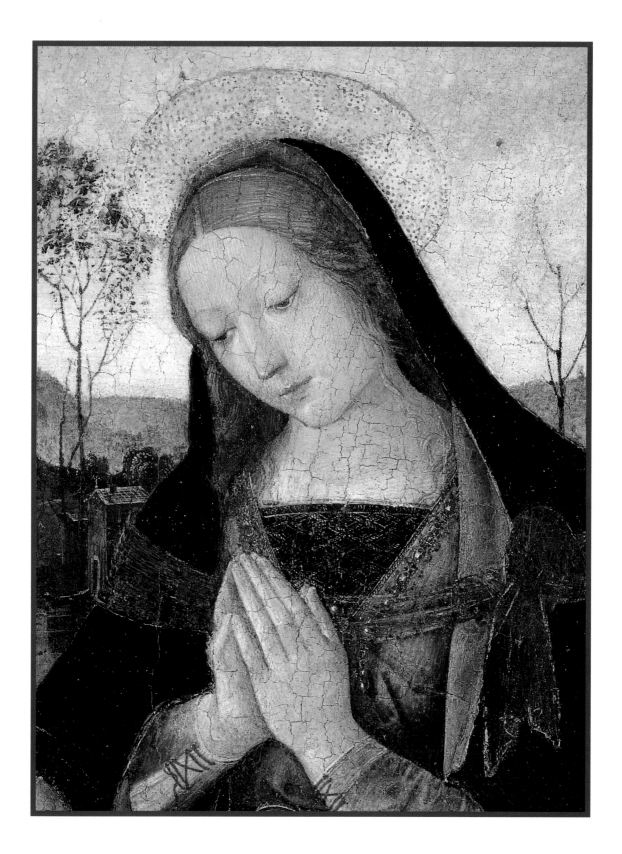

Sleep. What have you learned from the womb that bore you
But an anxiety your Father cannot feel? Sleep.
What will the flesh that I gave do for you,
Or my mother love, but tempt you from His will?
Why was I chosen to teach His Son to weep?
 Little One, sleep.

 —W. H. AUDEN, *At the Manger Mary Sings*

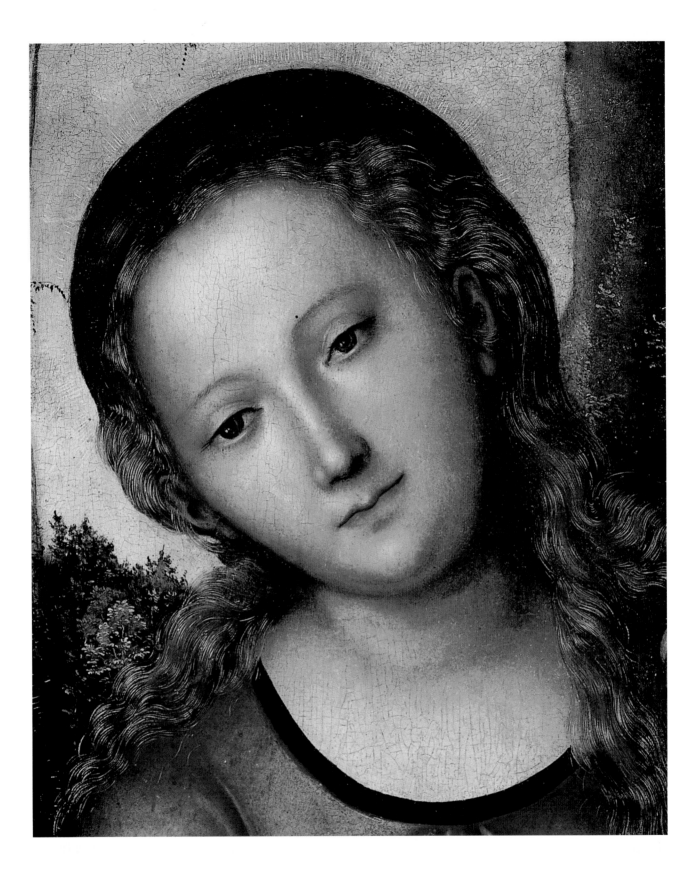

Dream. In human dreams earth ascends to Heaven
Where no one need pray nor ever feel alone.
In your first few hours of life here,
O have you Chosen already what death must be your own?
How soon will you start on the Sorrowful Way?
 Dream while you may.

—W. H. AUDEN, *At the Manger Mary Sings*

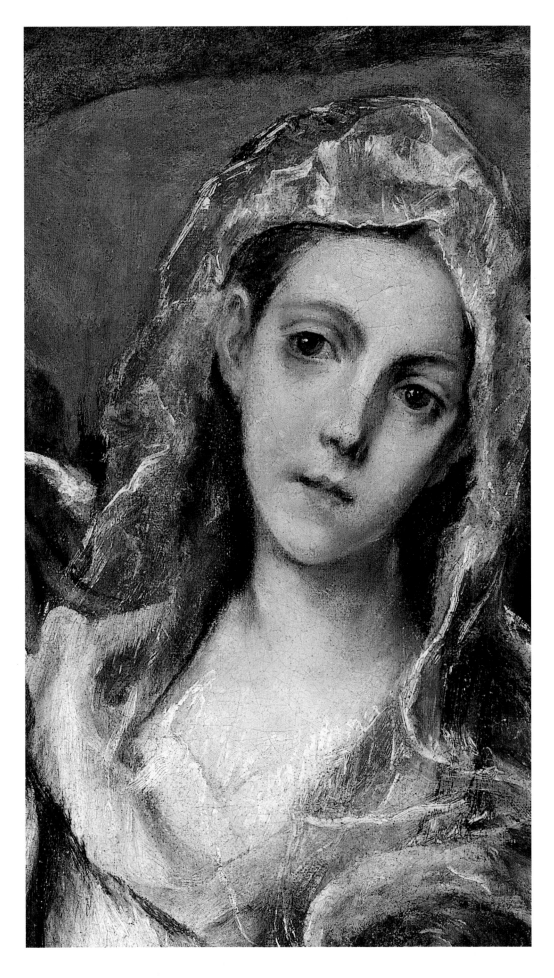

(opposite) Lucas Cranach the Elder, *Madonna & Child with St. Catherine*
(above) El Greco, *The Holy Family with Mary Magdalen*

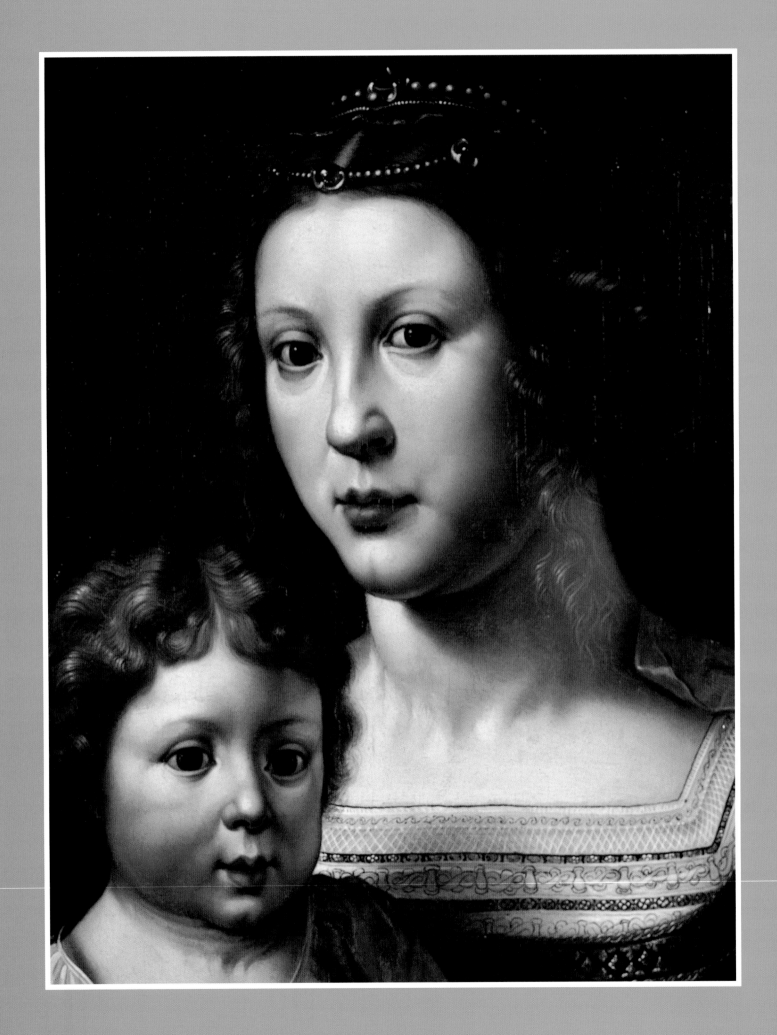

(above) Jan Gossart (Mabuse), *Madonna & Child*
(opposite) Workshop of Andrea del Sarto, *Madonna & Child & Infant Saint John*

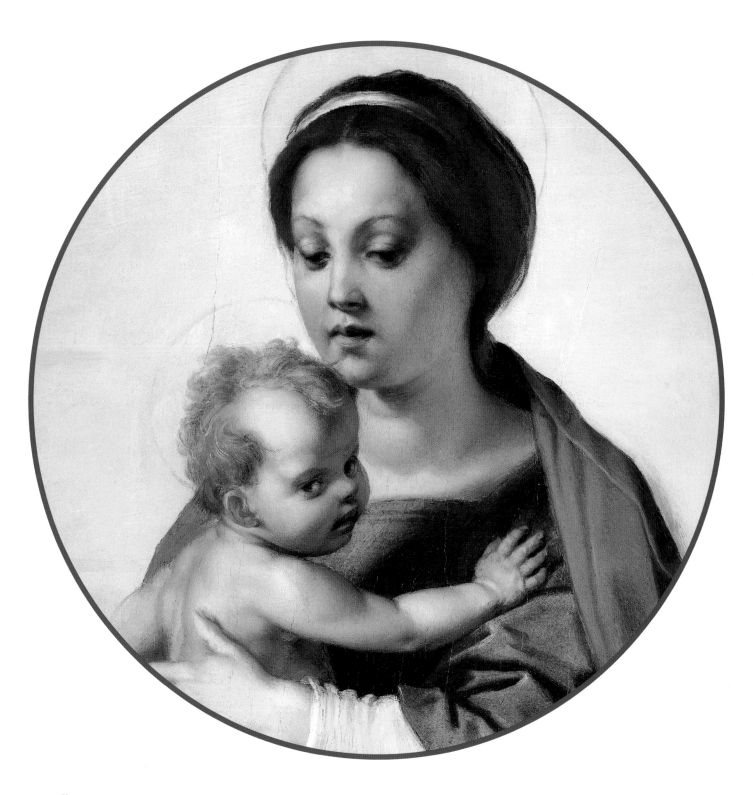

"Mother, mother, Mary, most holy,
 where did you spend last night?"
"I spent last night in Jerusalem,
 in God's church near His altar:
My sleep was restless and I dreamed,
 a dream most strange, my son.
I gave birth to a son, Christ, the king,
 and wrapped him in swaddling clothes."

Jesus, the Christ, said to holy Mary:
 "O mother, mother! Do not tell me more.
I know what this dream means—
 I will interpret it for you.
By the Jordan river grew a sacred tree,
 a cypress, and it became the Cross,
Life-giving and wondrous Cross of Christ.
 On that Cross I shall die . . ."

—ANONYMOUS, THE DREAM OF MARY

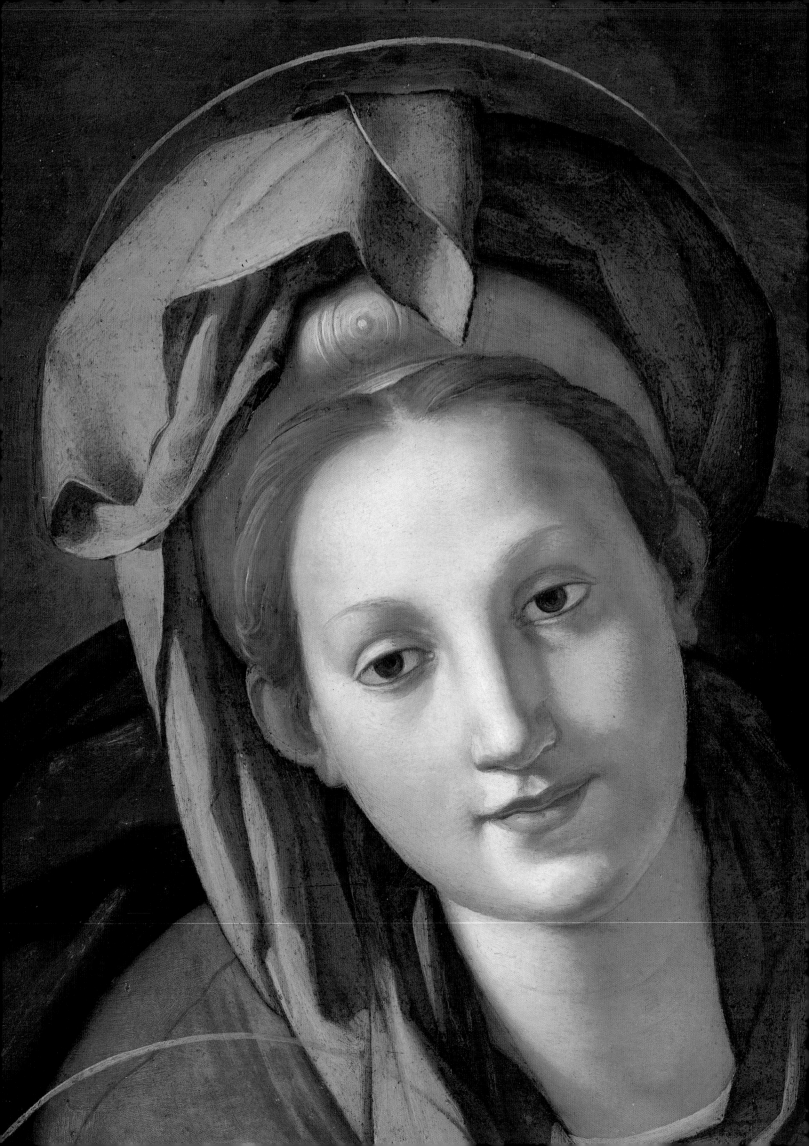

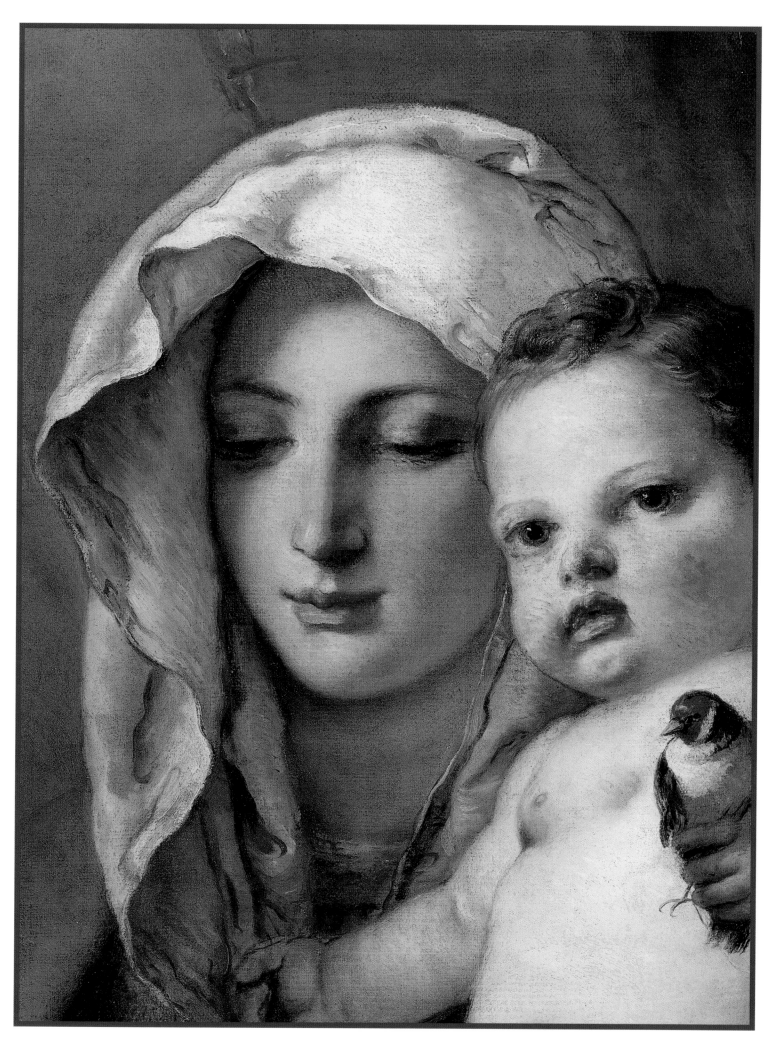

(opposite) Agnolo Bronzino, *The Holy Family*

(above) Giovanni Battista Tiepolo, *Madonna of the Goldfinch*

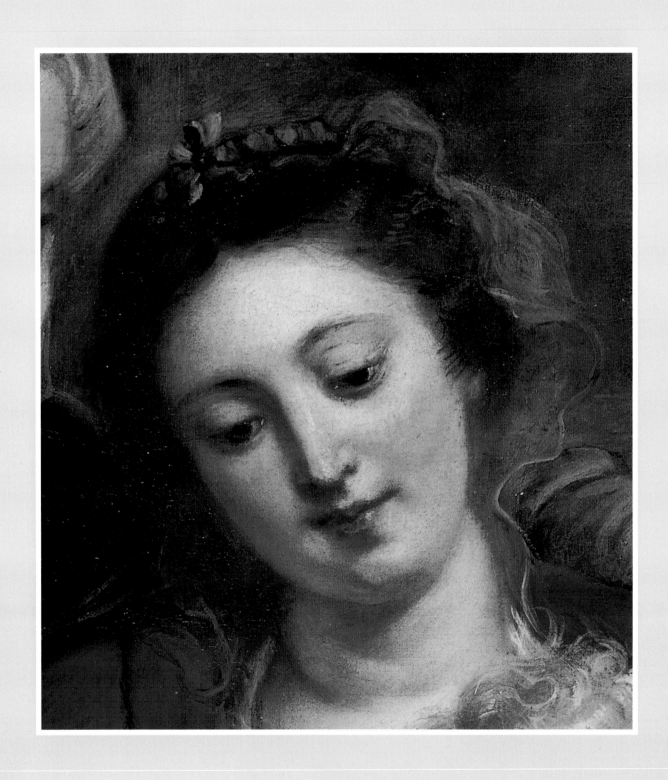

Mother and Maiden
Was never none but she;
Well may such a lady
God's mother be.

—OLD ENGLISH CAROL

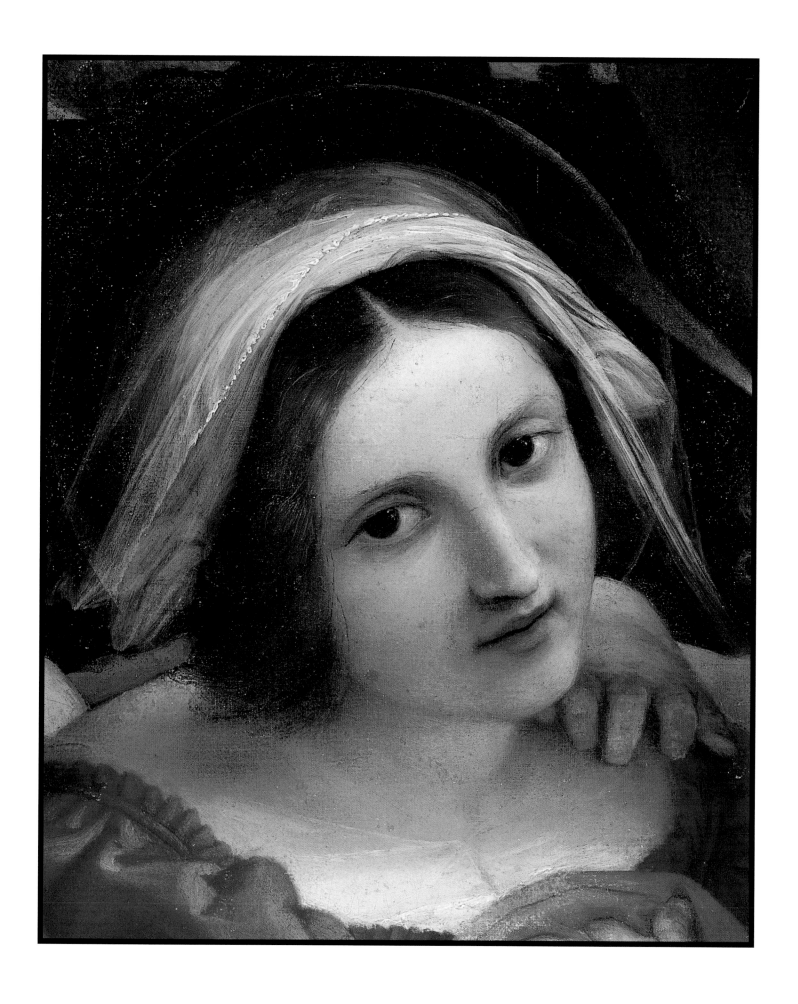

(opposite) Peter Paul Rubens, *The Holy Family*
(above) Lorenzo Lotto, *Virgin & Child with Saints Jerome & Anthony*

And the third day there was a marriage in Cana of Gallilee; and the mother of Jesus was there: And both Jesus was called, and his disciples, to the marriage. And when they wanted wine, the mother of Jesus saith unto him, "They have no wine." And Jesus saith unto her, "Woman, what have I to do with thee? Mine hour is not yet come." His mother saith unto the servants, "Whatsoever he saith unto you, do it." And there were set there six water pots of stone, after the manner of the purifying of the Jews, containing two or three firkins apiece. Jesus said unto them, "Draw out now, and bear unto the governor of the feast. And they bare it. . . . The governor of the feast called the bridegroom, And saith unto him, "Every man at the beginning doth set forth good wine; and when men have well drunk, then that which is worse: but thou hast kept the good wine until now."

—JOHN 2:1-11

The third mystery truly is at Gallilee's wedding repast

(For the first time that we see Thee, it is not as Host, but as

Guest)

When Thou dost change unto wine, on Thy Mother's whispered

word,

The secret water there in the ten stone wine-jars stored,

The bridgroom lowers his eyes. He is poor and oppressed

with woe:

For cistern water is hardly drink for a marriage, you

know,

Such as it is in August when the reservoirs are low,

All filled with impurities and with insects, not fit to show.

—PAUL CLAUDEL, *Hymn For Epiphany*

Sebastiano Ricci, *The Marriage Feast of Cana*

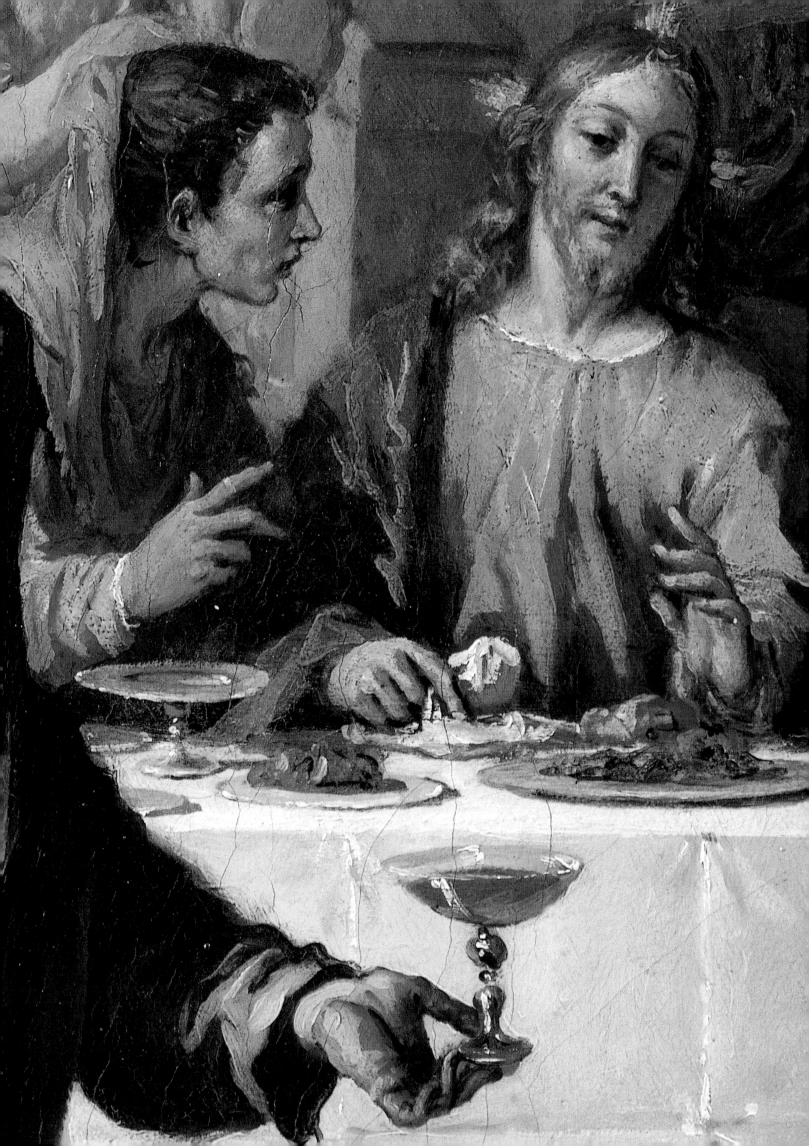

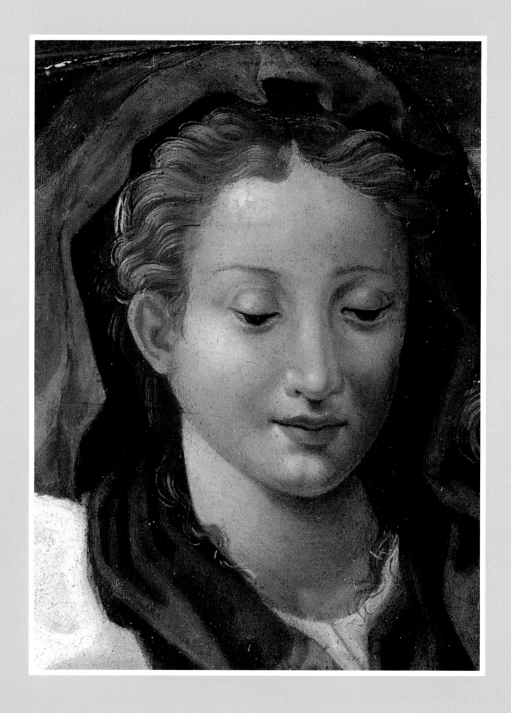

Oh, if you had willed this, you never should

have sprung out of the body of a woman.

Men should quarry saviours from a mountain

where they hew the hard out of the hard.

—RAINER MARIA RILKE, *Before the Passion*

(above) Constantini de Servi, *Virgin & Child*
(opposite) Francisco de Zurbaran, *Christ & the Virgin in the House of Nazareth*

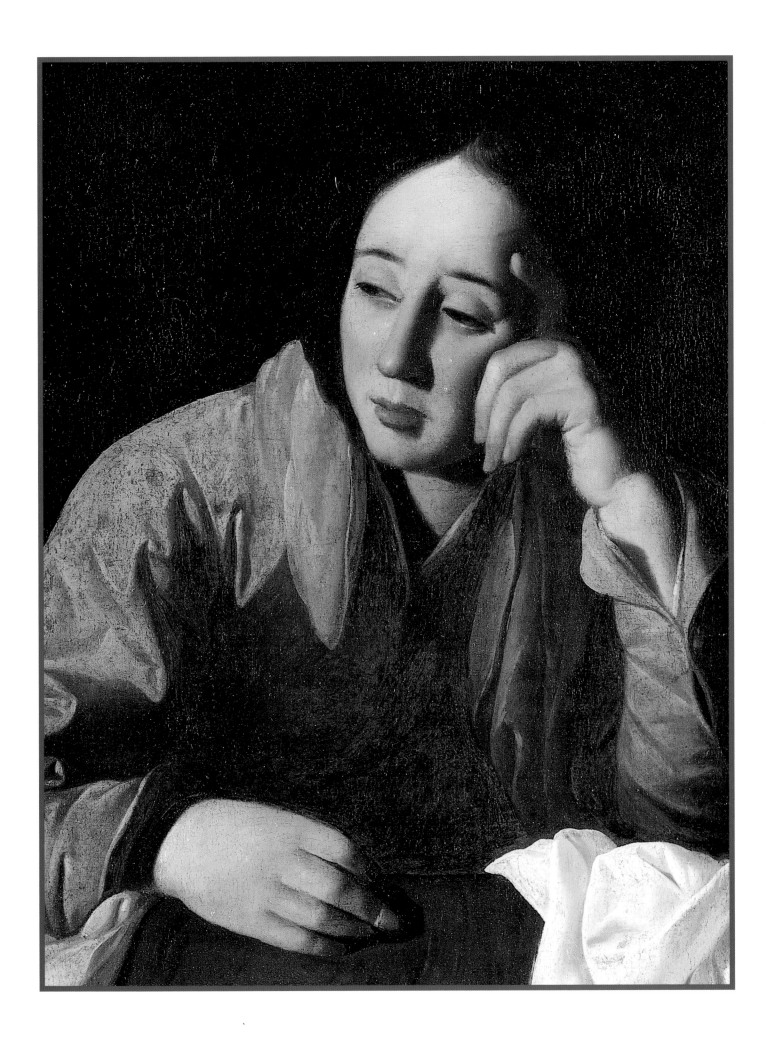

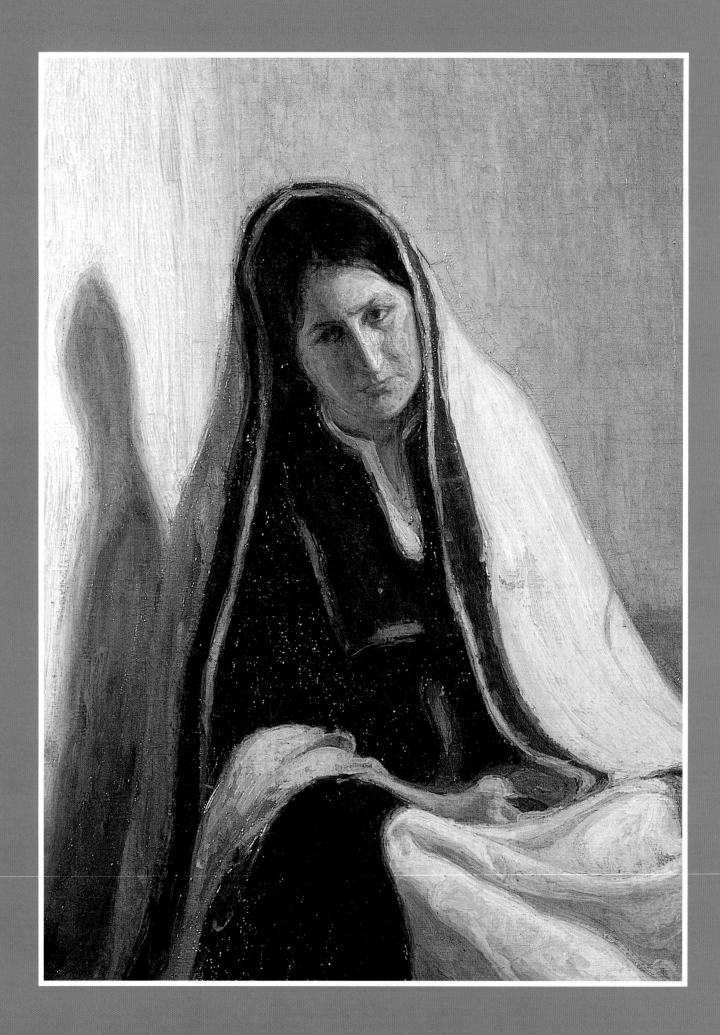

HER SORROW

1a. *Ignorant before of lamentation,*
 I am distressed and worn out
 with lamentation;
 I am tortured with pain.

2a. *Son, one and only delight,*
 remarkable joy,
 look at your mother weeping,
 and bring her comfort.

3a. *Flower of flowers, prince of goodness,*
 vein of forgiveness,
 how heavy against your shoulders
 is your punishment!

4a. *O how late you were surrendered,*
 how early you forsake me;
 O how nobly you were born,
 how wretchedly you die!

5a. *O holy grace of him*
 who dies thus
 O jealousy!
 O sin of envious people!

6a. *O true eloquence of just Simeon,*
 I feel the sword of grief
 which he foretold.

7a. *Spare my child, death,*
 do not spare me,
 then me alone,
 you alone, soothe.

8a. *What a crime, what sins*
 a brutal people have committed!
 Chains, rods, wounds, spit, thorns,
 other things without fault he suffers.

1b. *Judaea robs the world*
 of a ray of light
 and me of my son,
 my joy, my delight.

2b. *My heart, my mind, my eyes,*
 your wounds put to the rack.
 What a mother, what a woman,
 so fortunate, so wretched!

3b. *Woe the pain, from here*
 the color of your face flees away,
 from here it rushes down,
 from here it flows a wave of blood.

4b. *O what love*
 has despoiled your body?
 O how sweet the pledge,
 how bitter the prize!

5b. *O beastly hand*
 of the crucifier,
 O gentle mind of the one suffering
 in punishment.

6b. *Groans, sighs, and tears*
 outside are the proof
 of the wound inside.

7b. *May I be parted,*
 fortunate one, from you by death,
 provided, son,
 you are not tortured.

8b. *Spare my son, I pray, crucify the mother,*
 or fasten me on the stock of the cross
 at the same time,
 unfortunately he dies alone.

—*Planctus ante nescia*

Henry Ossawa Tanner, *Mary*

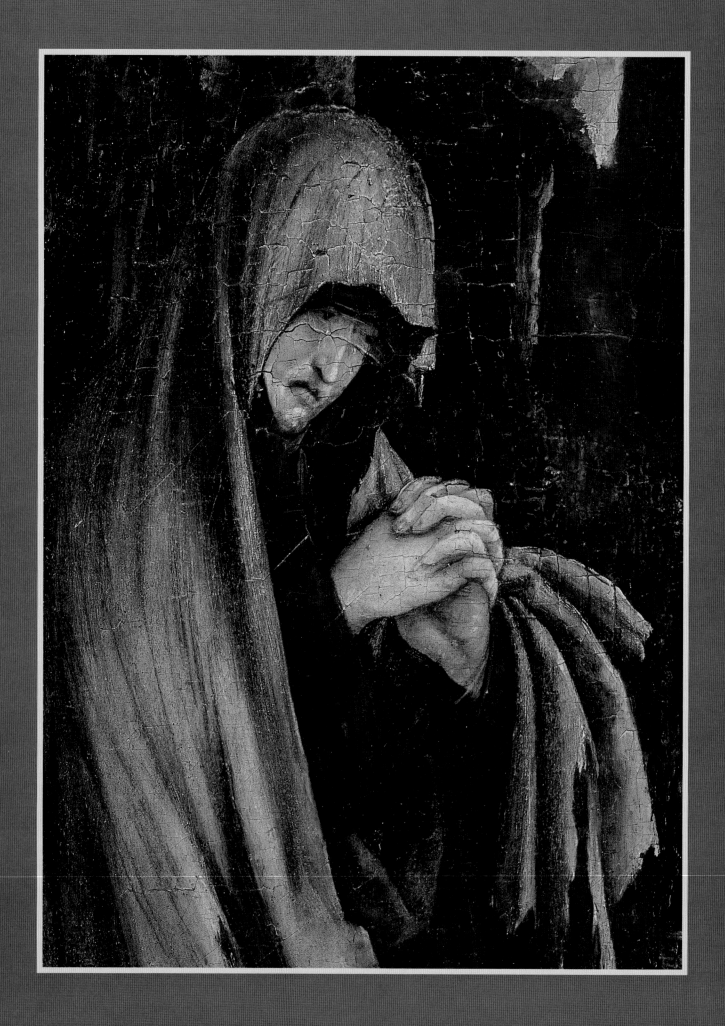

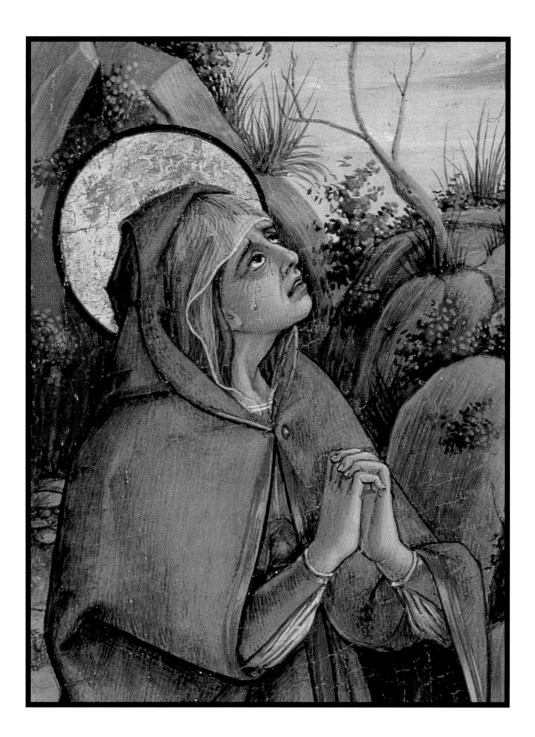

Christ:

Lady, take my broken heart
For thine own to share apart.
John, beloved as thou art,
Shalt be to thee a son.

John, my mother dear, behold;
Take her tenderly and fold
In thy pity. She is cold
And her heart undone!

Mary:

Son, Thy spirit hath gone forth!
Son of most stupendous worth!
My sight is of its vision dearth
And bloodless is my heart!

Hear me, Son most innocent,
Son of splendor over me spent,
Passing to thine element,
With darkness for my part;

Son of whiteness and of rose,
Son unrivalled as the snows,
Son my bosom held so close,—
My heart, why hast Thou gone?...

John, my nephew, look and see;
Dead thy brother now must be;
For I feel the sword through me,
As the Prophets said.

—JACOBONE DA TODI, *Christ and His Mother at the Cross*

(opposite) Matthias Grunewald, *The Small Crucifixion*
(above) Carlo Crivelli, *The Crucifixion*

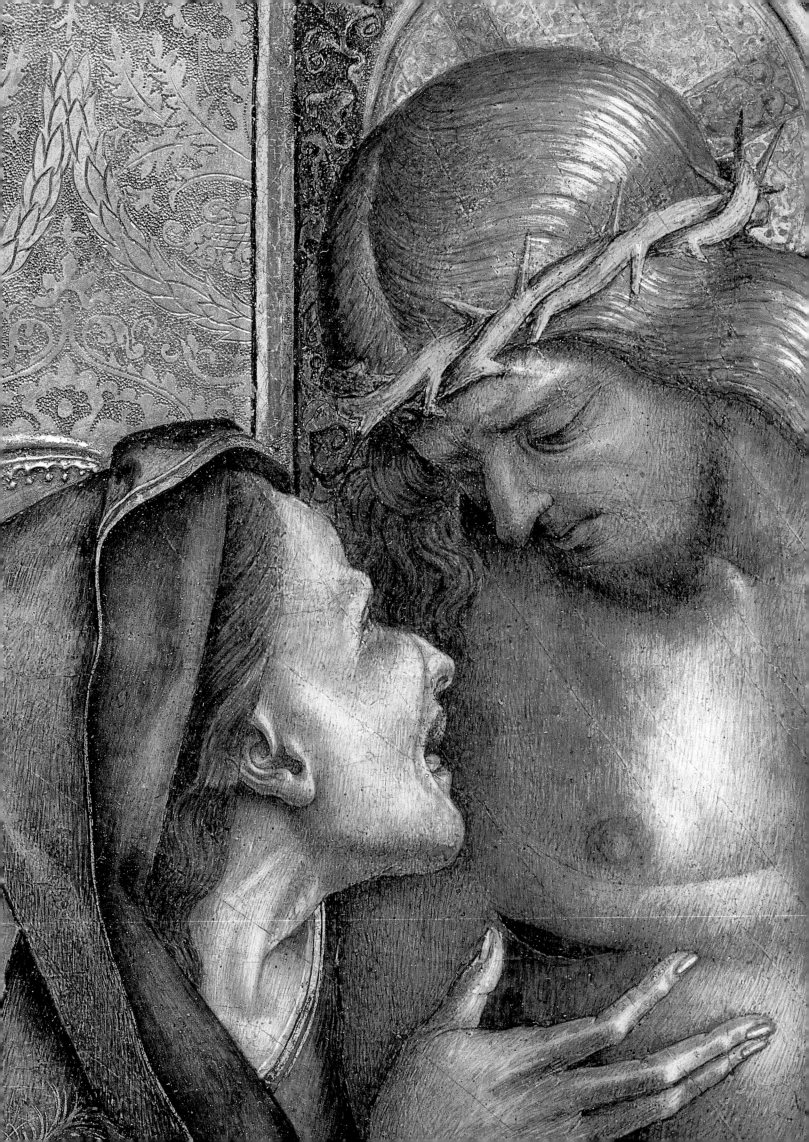

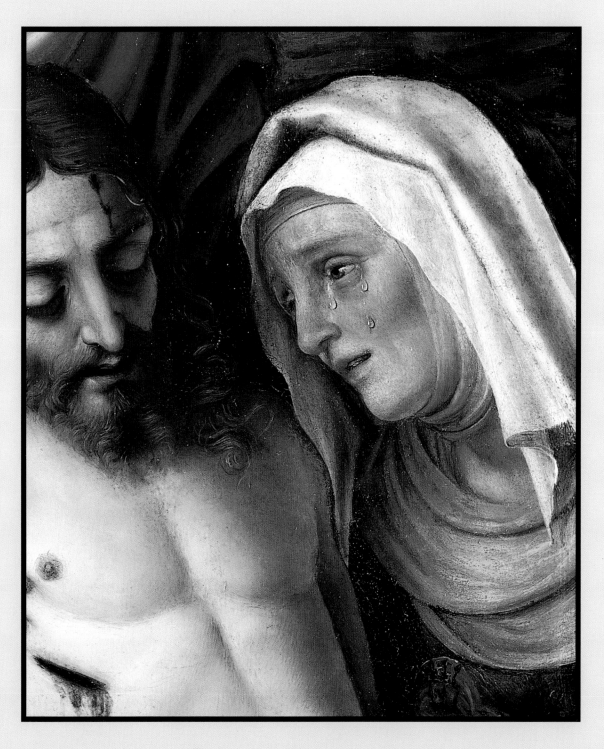

I am overwhelmed, o my son,

I am overwhelmed by love,

And I cannot endure

That I should be in the chamber

And you on the wood of the cross,

I in the house,

And you in the tomb.

—Romanus Melodos

(opposite) Carlo Crivelli, *The Crucifixion*
(above) Andrea Solario, *Pietà*

And is he gone, whom these arms held but now
 Their hope, their vow?
Did ever grief and joy in one poor heart
 So soon change part?
He's gone; the fair'st flower that ever bosom dress'd,
 My soul's sweet rest.
My womb's chaste pride is gone, my heaven-born boy:
 And where is joy?
He's gone; and his lov'd steps to wait upon
 My joy is gone.
My joys and he are gone, my grief and I
 Alone must lie.
He's gone; not leaving with me, till he come,
 One smile at home.
Oh, come then, bring Thy mother her lost joy:
 Oh come, sweet boy.
Make haste and come, or e'er my grief and I
 Make haste and die.

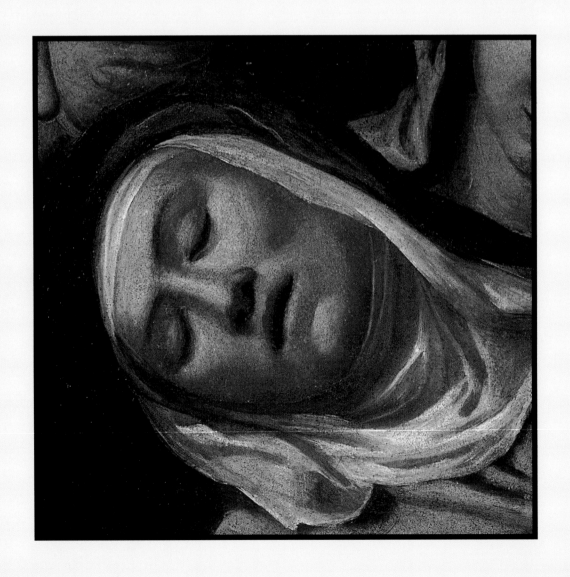

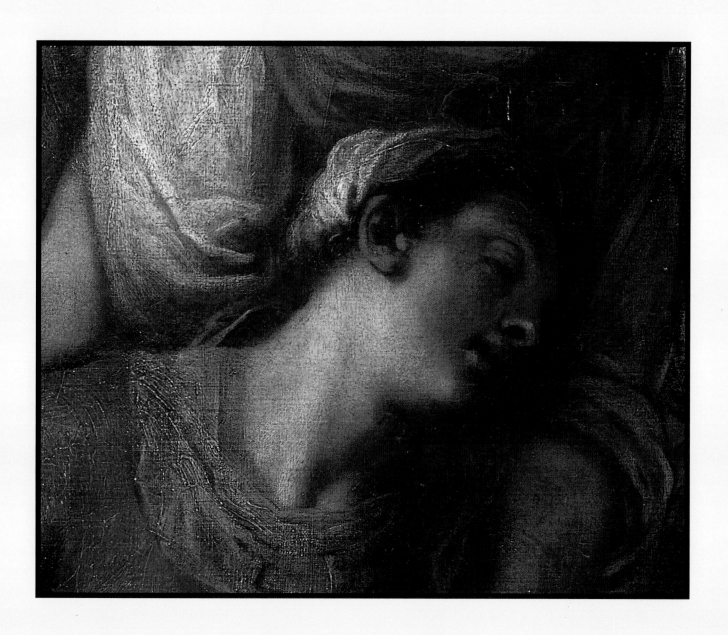

The virgin heard these words from her
innocent child: "Mother, behold, your son."
The virgin saw her son saying: "It is finished,"
and thus the sword pierced her soul.

Thus she was left in sorrow as the loving
maiden saw her son die; a vast sorrow,
a sorrow that surpassed the martyrdom
of a thousand saints maiden saw her son die.

—*Stabat iuxta Christi crucem*

(opposite) Santi di Tito Titi, *The Deposition*
(above) Jacopa Palma, *Lamentation Over the Dead Christ*

9a. *Return to the most sorrowful*
woman the body, even if
only lifeless, so that, although so
diminished the crucified man may grow
with kisses, with embraces.

1Oa. *Why are you astounded, wretched people,*
that the earth is moved,
that the stars are darkened,
that the enfeebled grieve.

11a. *You set the killer free,*
but give Jesus to punishment;
if you tolerate peace badly,
discord will come.

12a. *Blind people, wretched people,*
do penance,
while Jesus can be swayed
for you toward forgiveness.

13a. *Weep, daughters of Zion,*
such grateful gratitude
is the last office to the dead,
your distress is a pleasure to him
in return for your offenses.

9b. *Would that I so grieve*
that I may perish from grief,
for it is a more considerable thing
to die without death for grief
than to perish too quickly.

10b. *If you deprive the sun of light*
how would it shine?
If you deprive a sick man of medicine
how would he recover?

11b. *Taught by the weight of hunger,*
murder, and diseases, you will know
that Jesus is dead for you
and that Barrabas lives.

12b. *Let the rivers of the fountains*
which you have made, benefit you,
let them allay the thirst of all,
let them cleanse all crimes.

13b. *Rush into his embraces,*
while he hangs on the stock,
for mutual embraces
he prepares himself
with loving hands outstretched.

—*Planctus ante nescia*

William Adolphe Bouguereau, *Pietà*

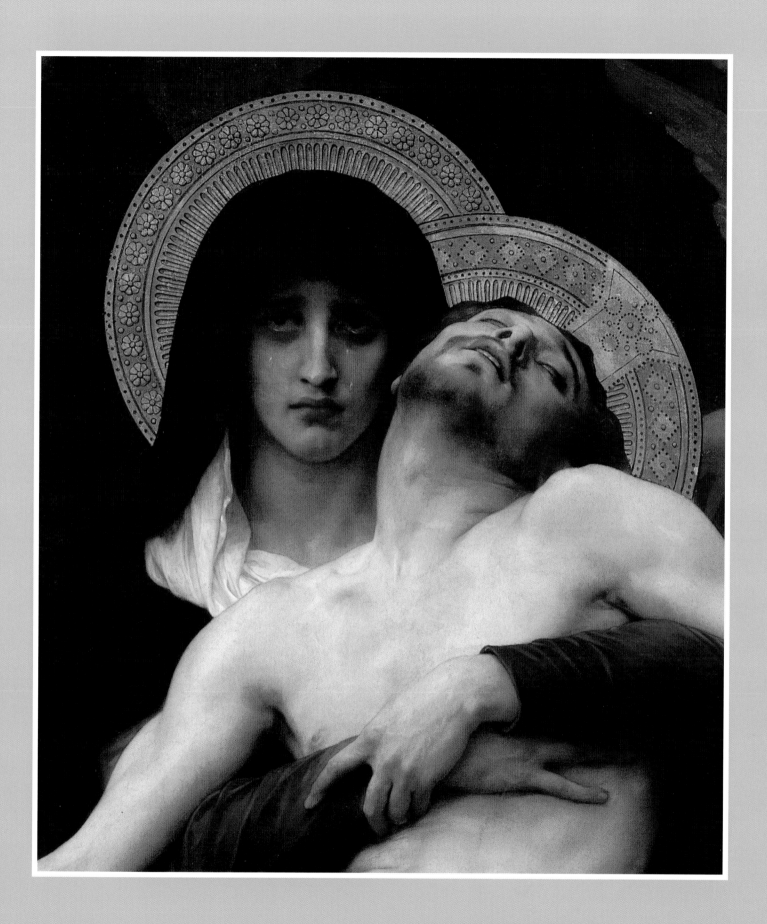

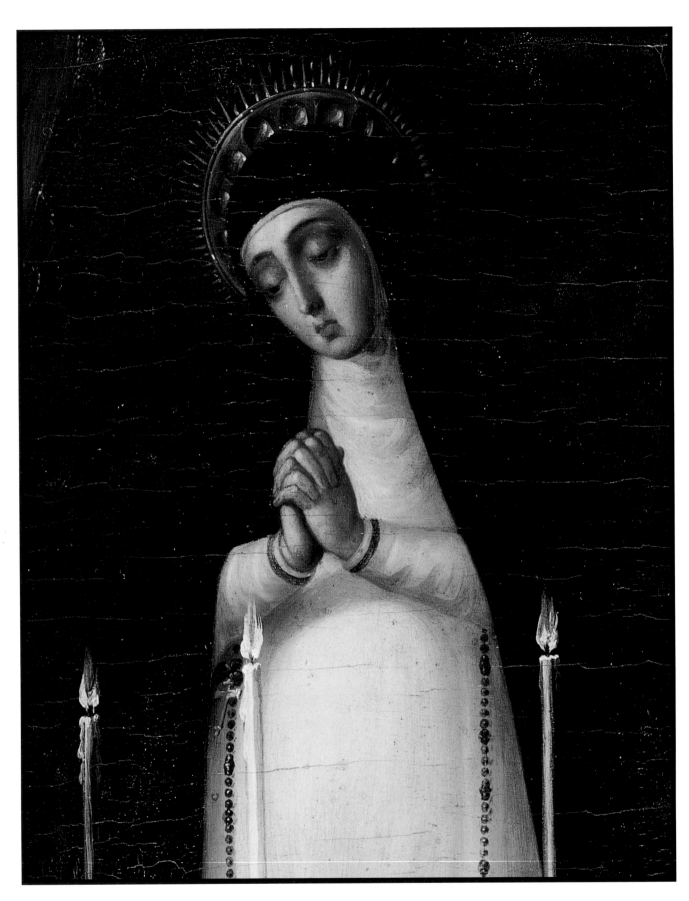

14. In this alone I rejoice,
 that I grieve on behalf of you,
 repeat your part, I pray,
 lament the loss of the mother.

—*Planctus ante nescia*

(above) Nicolas Rodriguez Juárez, *Mater Dolorosa*
(opposite) Dieric Bouts, *Mater Dolorosa (Sorrowing Madonna)*

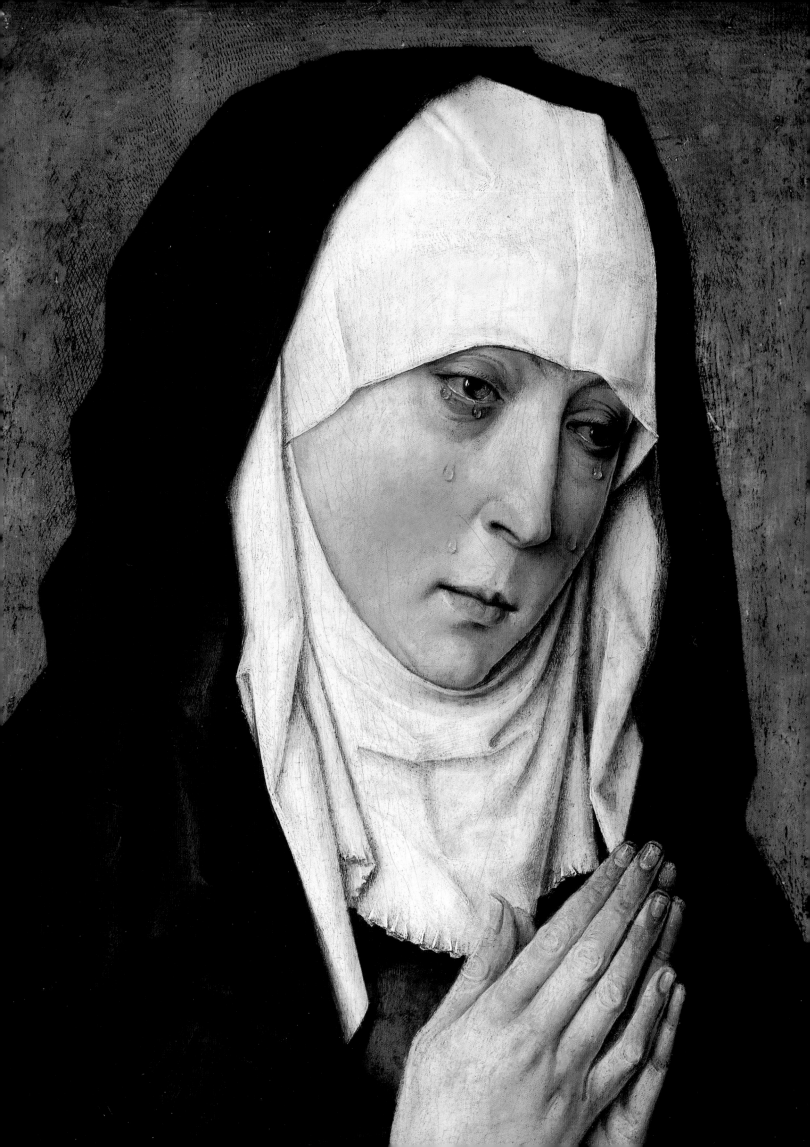

HER GLORY

Christ had already said to his dying mother,

"Come to me, that you may be crowned."

She had answered him,

"Behold, I am coming, for it is written of me

that I am to do your will, my God,

and my spirit rejoices in you, the God of my salvation."

—Voragine, *The Golden Legend*

Follower of Rogier van der Weyden, *Christ Appearing to the Virgin*

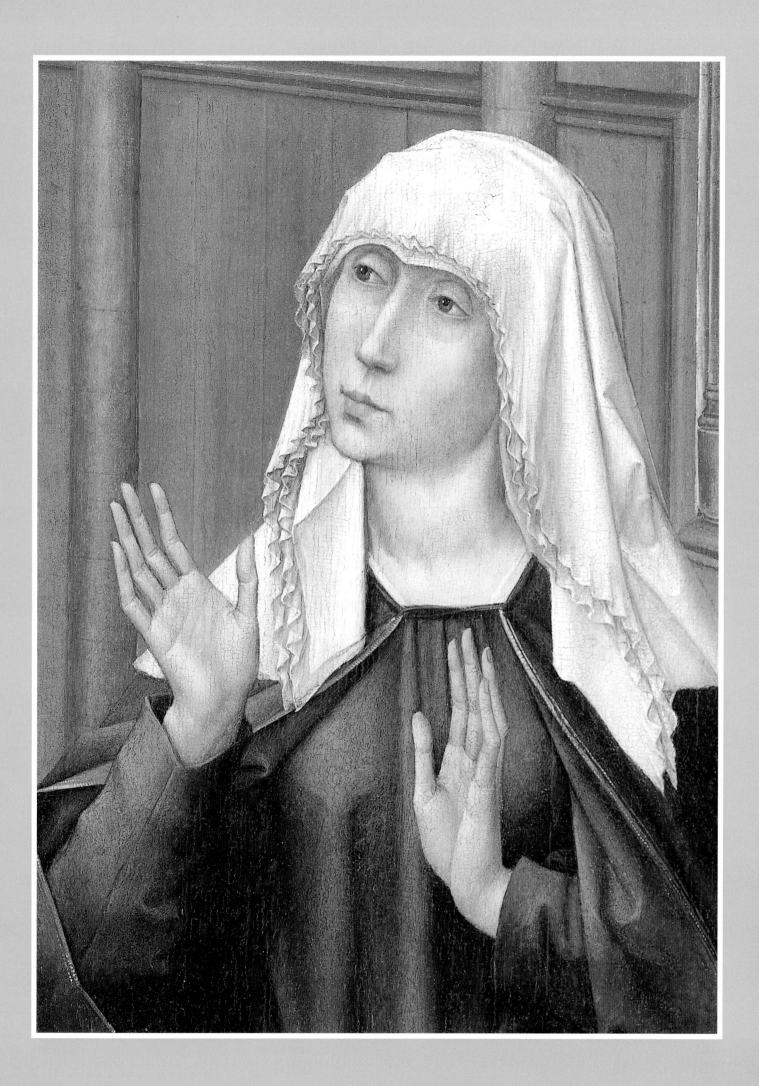

At the moment of the Ascension Jesus charged Peter, his bishop, and John to remain with Mary till her death. She was living in Jerusalem with a number of virgins. We also, the apostles Peter and John, were with her.

On the 20th of Tobi we came to her and found her amazed. She explained that that night, after she had finished the "little office," she slumbered and saw a beautiful youth about thirty years of age, and "you also standing at his right hand, with garments in your hands." She perceived that it was Jesus, and he told her that the garments were her shroud; and he vanished.

Then Mary made a long discourse on the horrors of death—the river of fire, the two powers of light and darkness, the avengers with diverse faces, the worm, the unquenchable fire which three tears will put out, the ruler of darkness. On hearing this we wept.

There was a knocking at the door. It was the virgins who had come from the Mount of Olives, with censers and lamps. They had been warned by a voice in the night to come to Mary, who was to die next day.

Mary bade us withdraw a little, and uttered a long thanksgiving to her Son, and a prayer to be delivered from the terror of the next world.

There were thunderings and lightnings. Jesus came on a chariot of light with Moses, David, the prophets, and the righteous kings, and addressed Mary: "O my beloved Mother, arise let us go hence."

He turned to the apostles—to me Peter and to John—and said that Mary should appear to them again. "There are 206 days from her death unto her holy assumption. I will bring her unto you arrayed in this body." He bade them bring garments and perfumes from the altar, which were sent from heaven. They spread them on the bed.

The Virgin arose and prayed him to receive her. She lay down on the garments, turned her face to him, and straightway commended her spirit into his hands.

He bade us prepare her for burial, and gave us three palms from paradise and three branches of the olive tree which Noah's dove brought to Noah, and we laid them on her body.... The body was to be placed in the stone coffin and watched, and in 206 days he would bring the soul to it.

He went up to heaven and presented the soul to the Father and the Holy Ghost. And the voice of the Holy Trinity was heard welcoming the soul.

—The Discourse of Theodosius

Starnina (Gherardo di Jacopo), *The Dormition of the Virgin*

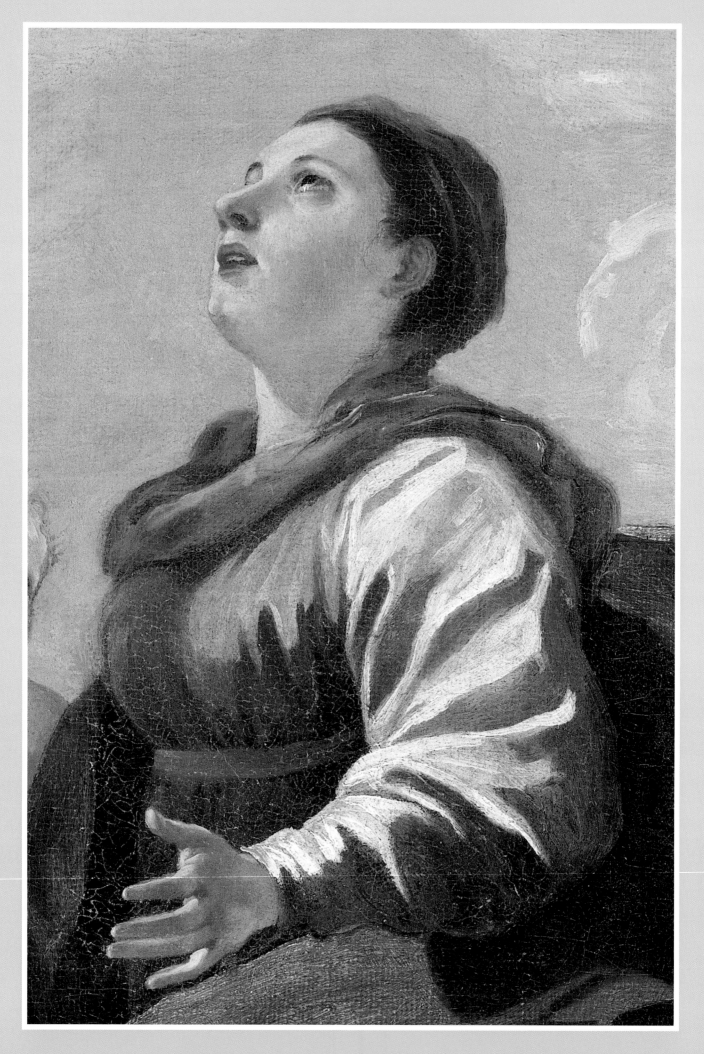

It came to pass after that we reached the 16th of Mesore, and were gathered with the apostles at the tomb. We saw lightnings and were afraid. There was a sweet odour and a sound of trumpets. The door of the tomb opened: there was a great light within. A chariot descended in fire: Jesus was in it; he greeted us.

He called into the tomb: "Mary, my mother, arise!" And we saw her in the body, as if she had never died. Jesus took her into the chariot. The angels went before them. A voice called, "Peace be to you, my brethren."

—THE DISCOURSE OF THEODOSIUS

(opposite) Nicolas Poussin, *The Assumption of the Virgin*
(above) Massimo Stanzione, *The Assumption of the Virgin*

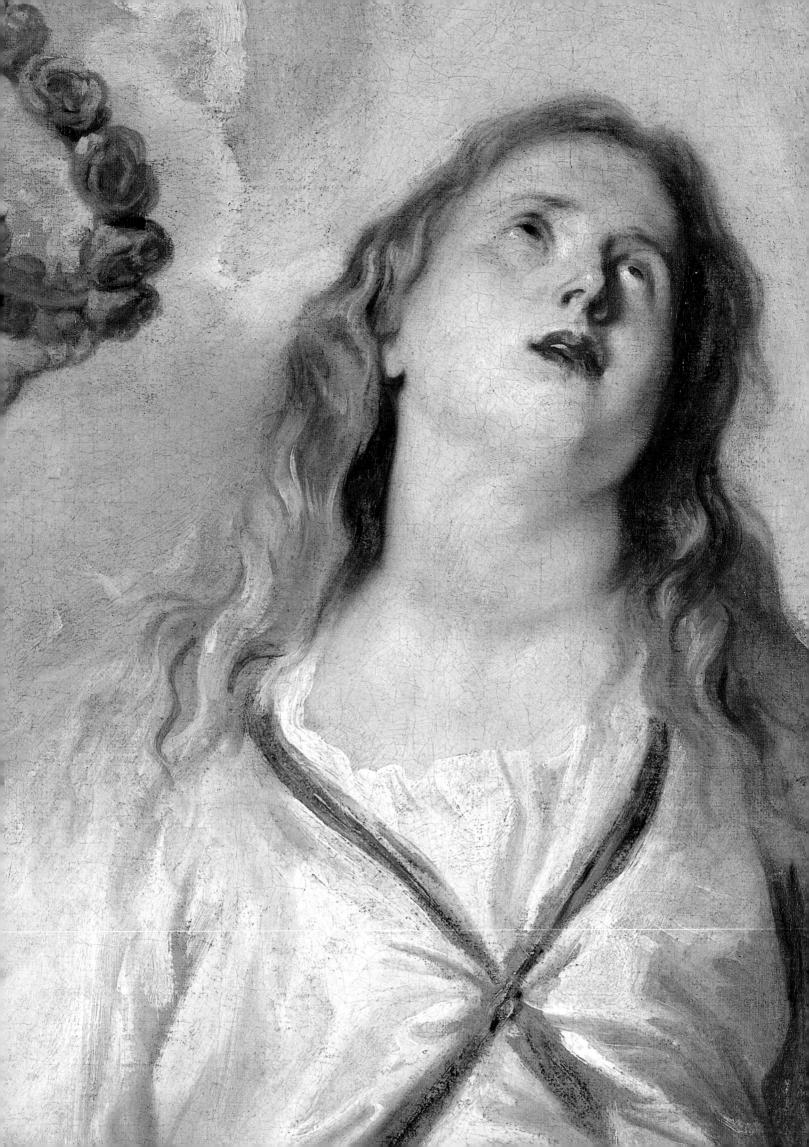

Wild air, world-mothering air,
Nestling me everywhere,
That each eyelash or hair
Girdles; goes home betwixt
The fleeciest, frailest-flixed
Snowflake; that's fairly mixed
With, riddles, and is rife
In every least thing's life;
This needful, never spent,
And nursing element;
My more than meat and drink,
My meal at every wink;
This air, which, by life's law,
My lung must draw and draw
Now but to breathe its praise,
Minds me in many ways
Of her who not only
Gave God's infinity
Dwindled to infancy
Welcome in womb and breast,
Birth, milk, and all the rest
But mothers each new grace

That does now reach our race—
Mary Immaculate,
Merely a woman, yet
Whose presence, power is
Great as no goddess's
Was deemed, dreamed; who
This one work has to do—
Let all God's glory through,
God's glory which would go
Through her and from her flow
Off, and no way but so.
I say that we are wound
With mercy round and round
As if with air: the same
Is Mary, more by name.
She, wild web, wondrous robe,
Mandes the guilty globe,
Since God has let dispense
Her prayers his providence:
Nay, more than almoner,
The sweet alms' self is her.

—GERARD MANLEY HOPKINS,
The Blessed Virgin compared to the Air we Breathe

Sir Anthony van Dyck, *The Virgin as Intercessor*

Mortals, that behold a Woman
 Rising 'twixt the Moon and Sun;
Who am I the heavens assume? an
 All am I, and I am one.

—Francis Thompson, *AssumptaMaria*

Who is she that ascends so high,
Next the Heavenly King,
Round about whom Angels fly
And her praises sing?

Who is she that, adorned with light,
Makes the sun her robe,
At whose feet the queen of night
Lays her changing globe?

To that crown direct thine eye,
Which her head attires;
There thou mayst her name descry
Writ in starry fires.

This is she in whose pure womb
Heaven's Prince remained;
Therefore in no earthly tomb
Can she be contained.

Heaven she was, which held that fire,
Whence the world took light,
And to Heaven doth now aspire
Flames with flames t'unite.

—John Beaumont, *The Assumption*

El Greco (Domenico Theotokópoulos), *The Assumption of the Virgin*

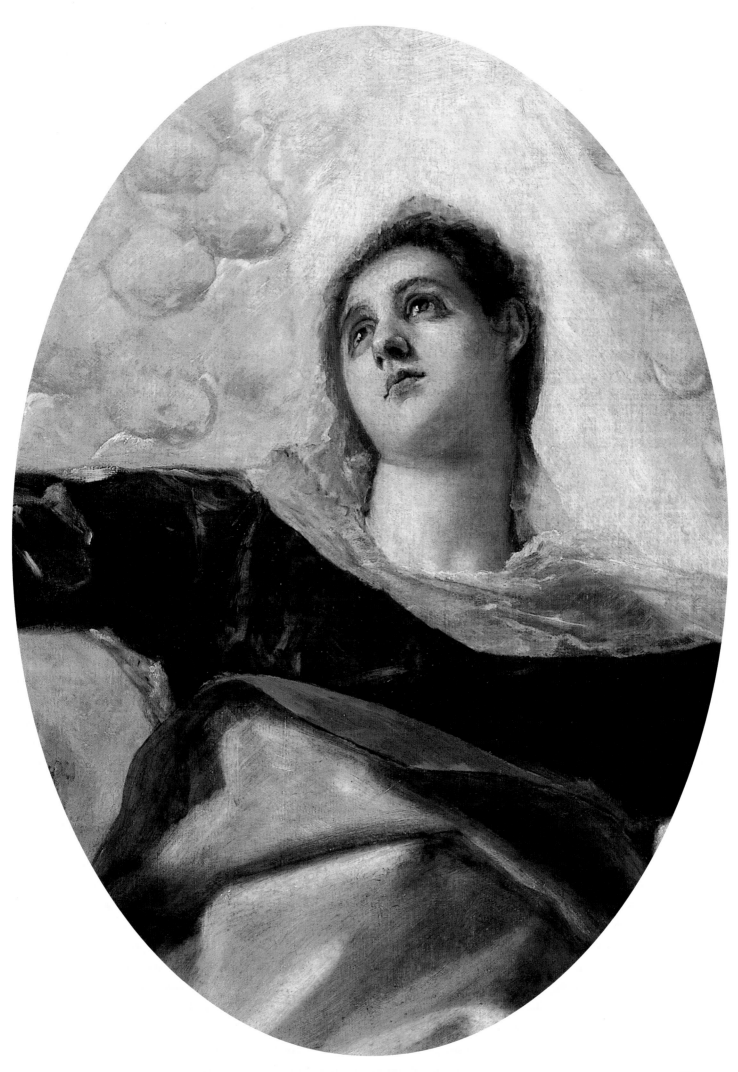

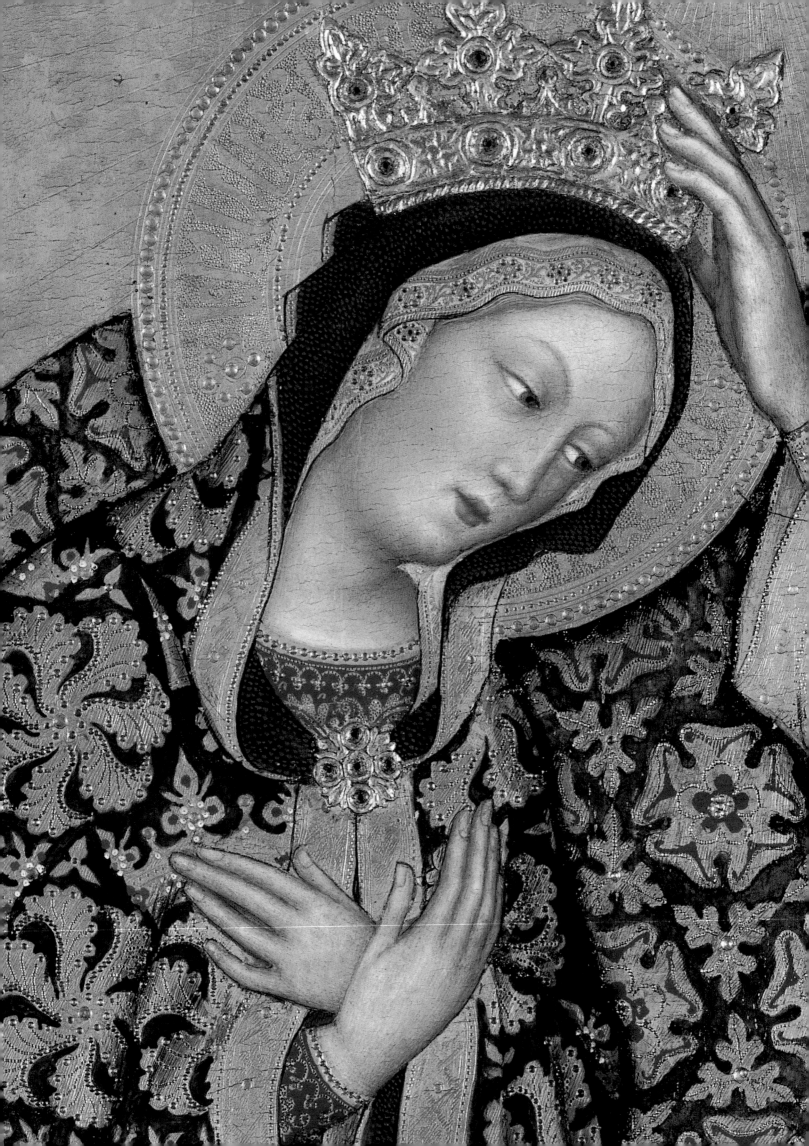

Then the angels transported her and brought her unto her beloved Son Who was seated upon His throne; and flames of fire covered him round about on the right hand and on the left. Then our Lord took her hand…and said unto her, "Hast thou come, O My Mother?" Then He made her ascend His glorious throne and He made her sit there with Him, and He told her the story of the joy and gladness which eye had never seen, and ear had never heard, and the heart of man had never imagined, that He had prepared for her.

—THE MIRACLES OF THE BLESSED VIRGIN MARY

Gentile da Fabriano, *Coronation of the Virgin*

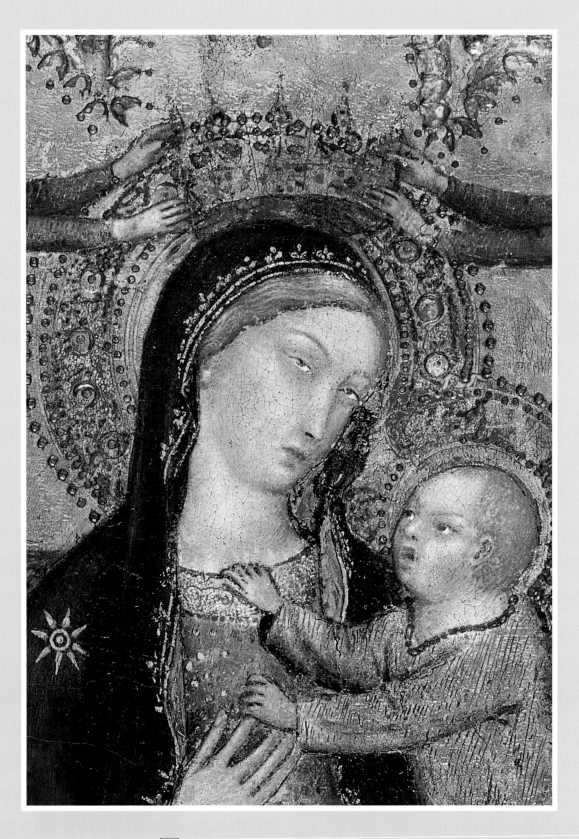

Thou art the Star, blazing with beames bright
Above these worldes waves so violent,
Our sins dark enclearing with thy light,
Man's Mediatrice to God Omnipotent.

—ALEXANDER BARKLAY, *Star of the Sea*

(above) Italian School, *The Virgin & Child with Saint Dominic, Saint Catherine, & Donor*
(opposite) Jacopo Tintoretto, *The Madonna of the Stars*

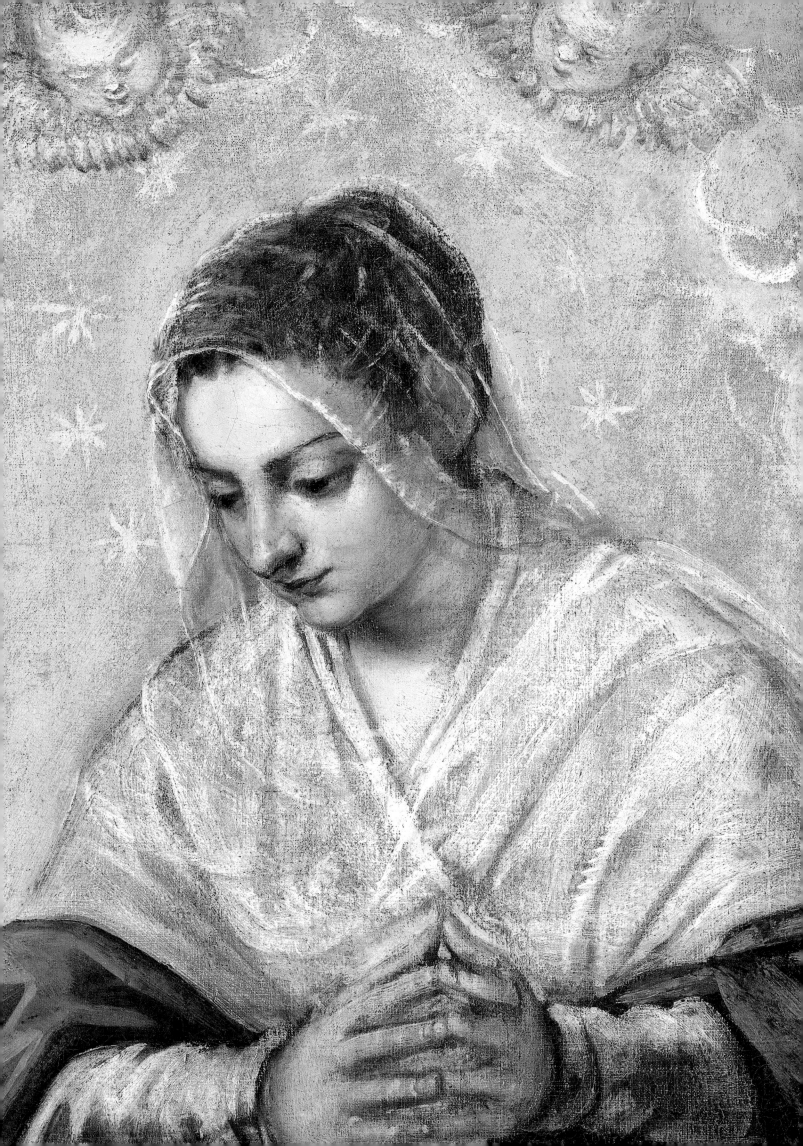

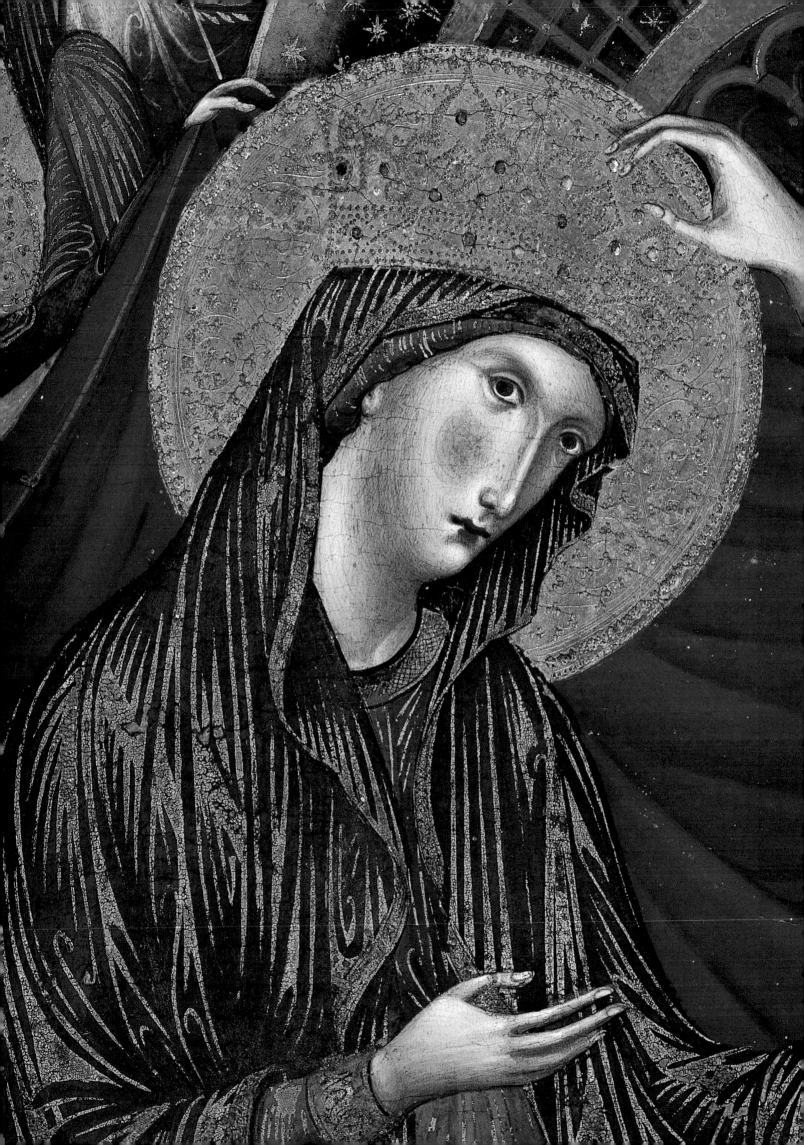

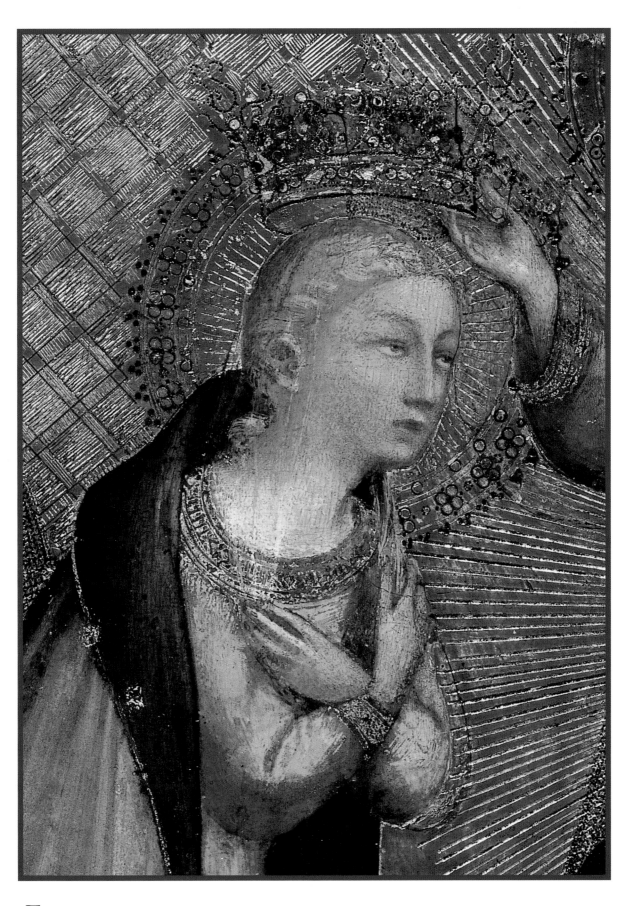

Fire of heaven's eternal ray
Gentle and unscorching flame,
Strength in moments of dismay,
Grief's redress and sorrow's balm,—
Light thy servant on his way!

(opposite) Paolo Veneziano, *The Coronation of the Virgin*
(above) Fra Angelico (Guido di Piero), *Coronation of the Virgin*

—RODRIQUEZ DE PADRÓN, *Prayer to the Blessed Virgin*

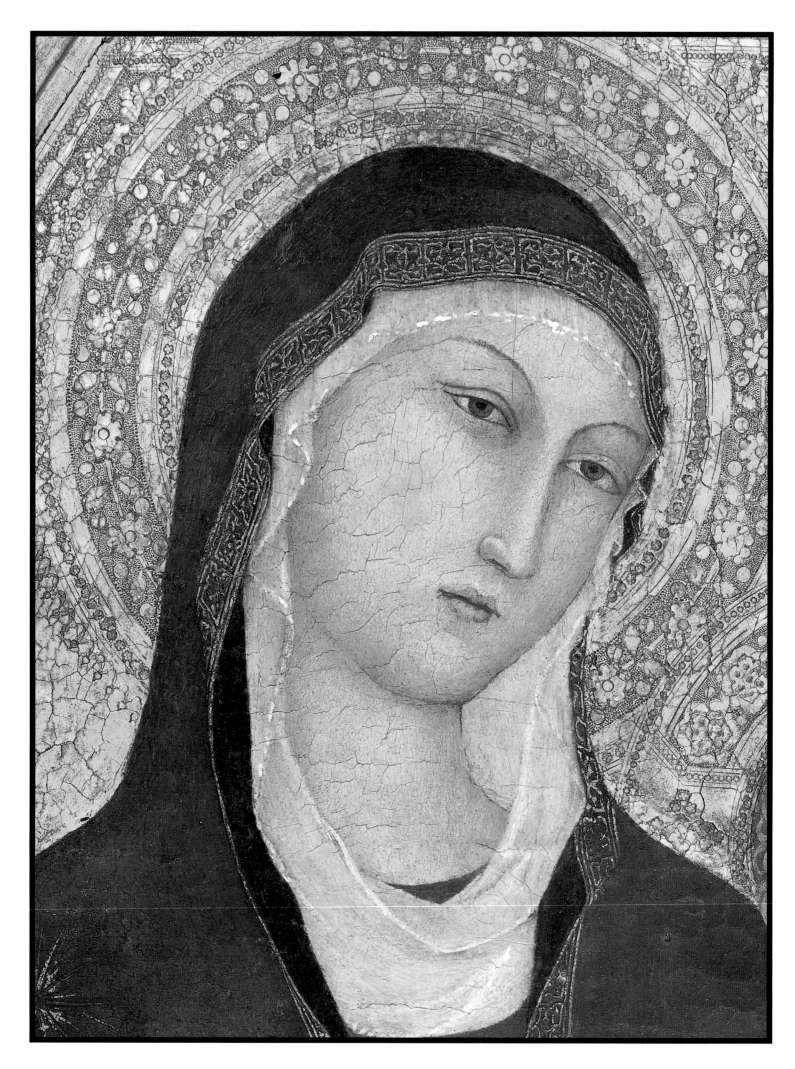

116

(above) Lippo Memmi, *Virgin & Child*
(opposite) Lorenzo Veneziano, *Madonna & Child*

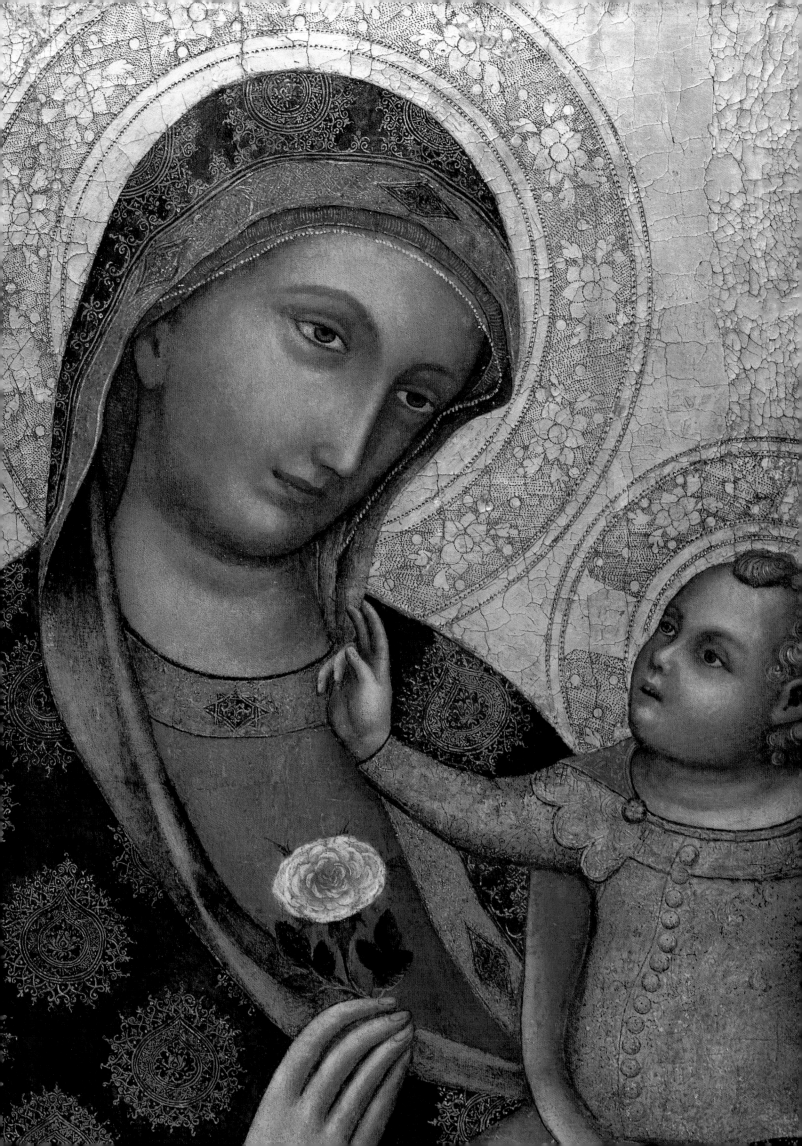

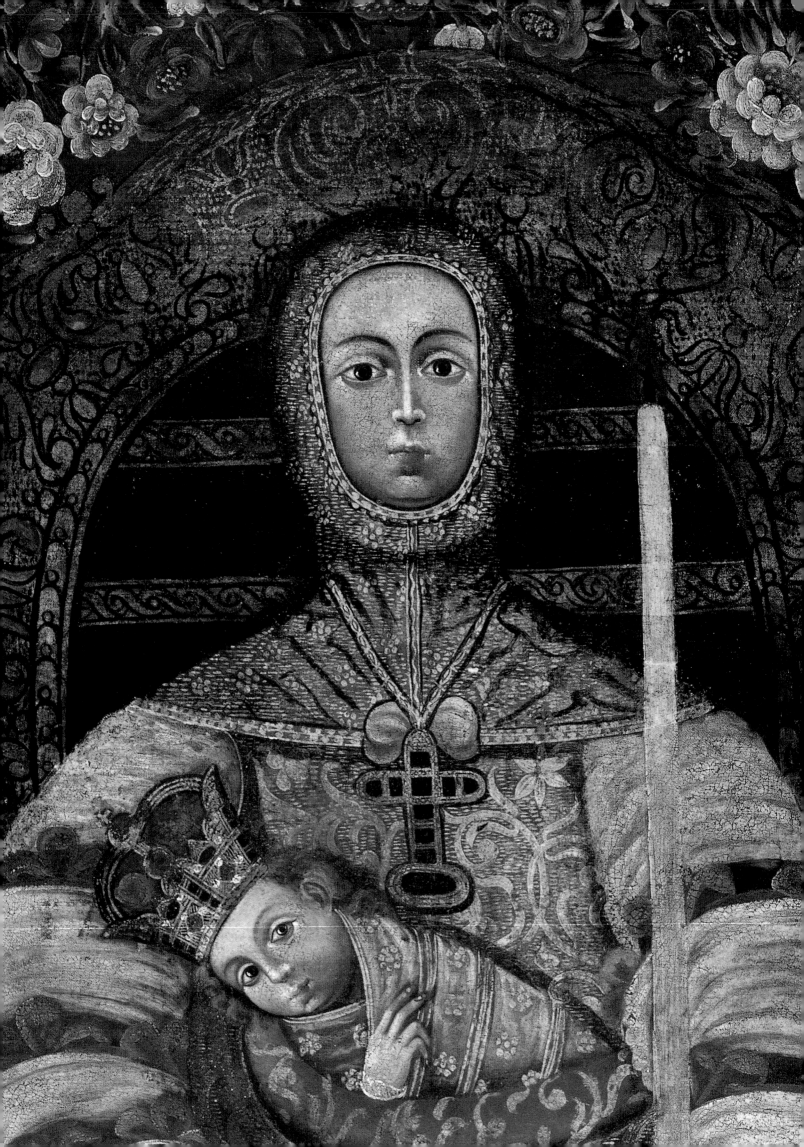

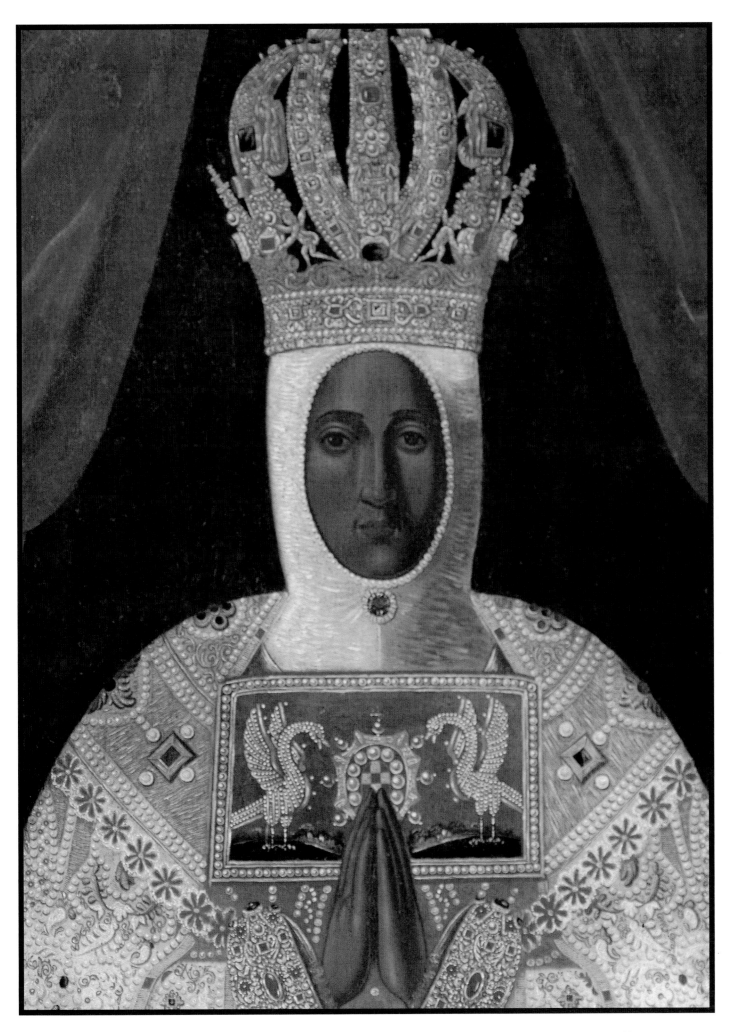

(opposite) Peruvian, Cuzco School, *La Virgen De Pomata y El Nino Jesus (The Virgin of Pomata & the Child Jesus)*
(above) Attributed to the Atelier of Leonardo Flores, *The Virgin of Pomata* 119

Salutation unto MARY the Queen, the true vine, on which, although it hath never been cultivated, thou shalt find blessed fruit....Thou has found grace, O Virgin. Many shall hold converse concerning thy honour, for the Word of the Father came and took upon Himself human nature from thee; Hallelujah!

—Miracles of the Blessed Virgin Mary

Abbott Handerson Thayer, *Virgin Enthroned*

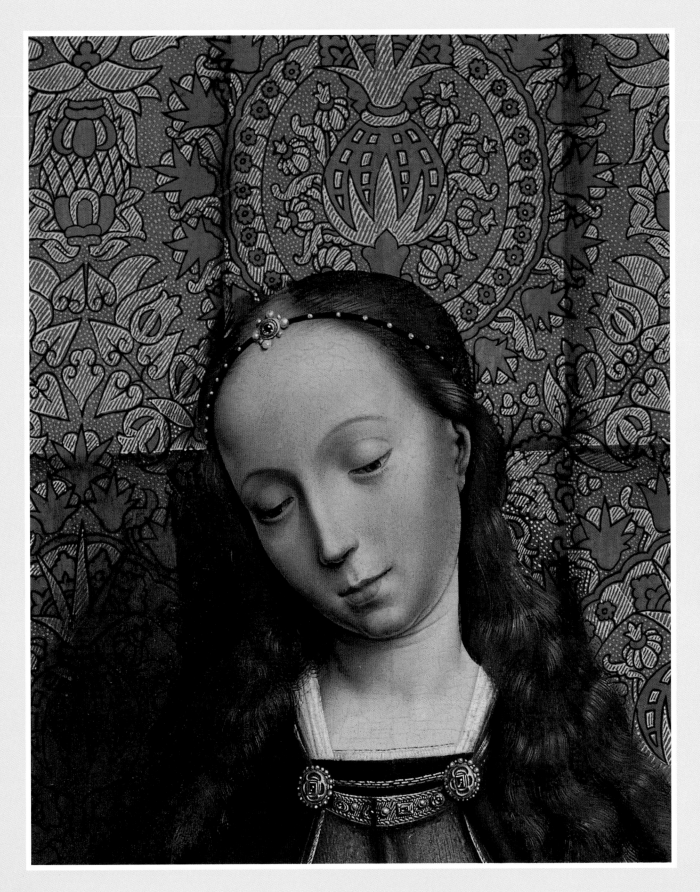

Come ye and look upon this Bride, this Woman who is adorned, the mother of the Lamb, who
enveloped in such great glory, even as saith the son of thunder, John the pure virgin, who cried out,
saying, "He hath made this bride to shine exceedlingly, yea, more than the star of the morning.
This is the New Zion, the city of our God, wherein dwelleth the joy of all the holy prophets."

—Miracles of the Blessed Virgin Mary

Master of the Embroidered Foliage, *The Virgin & Child Enthroned* 121

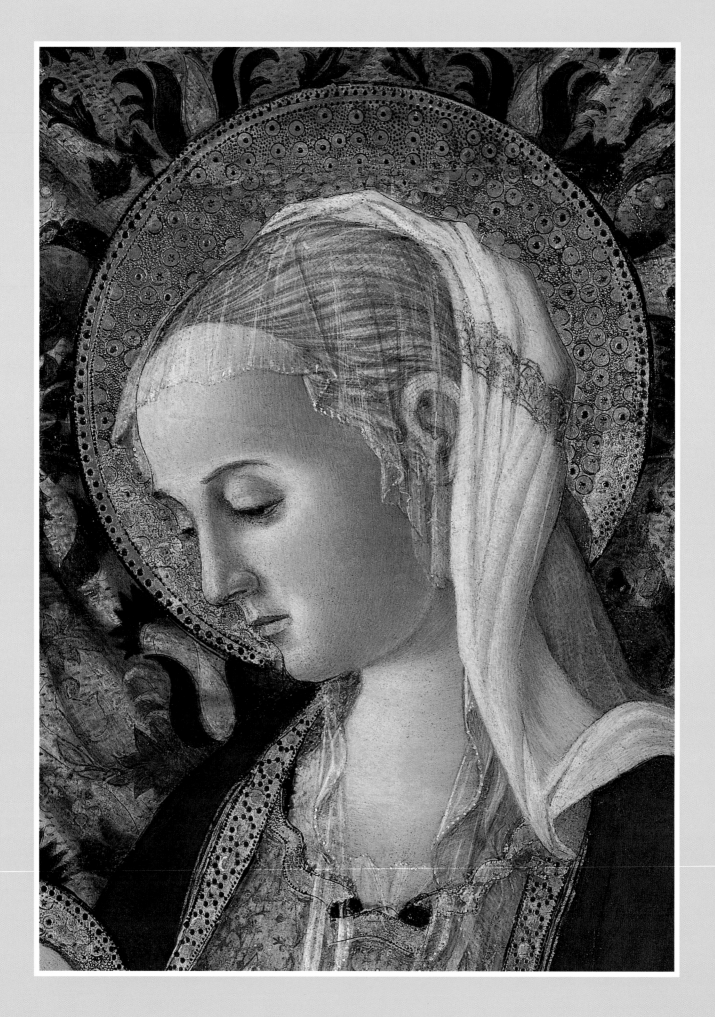

Francesco Botticini, *Madonna & Child*

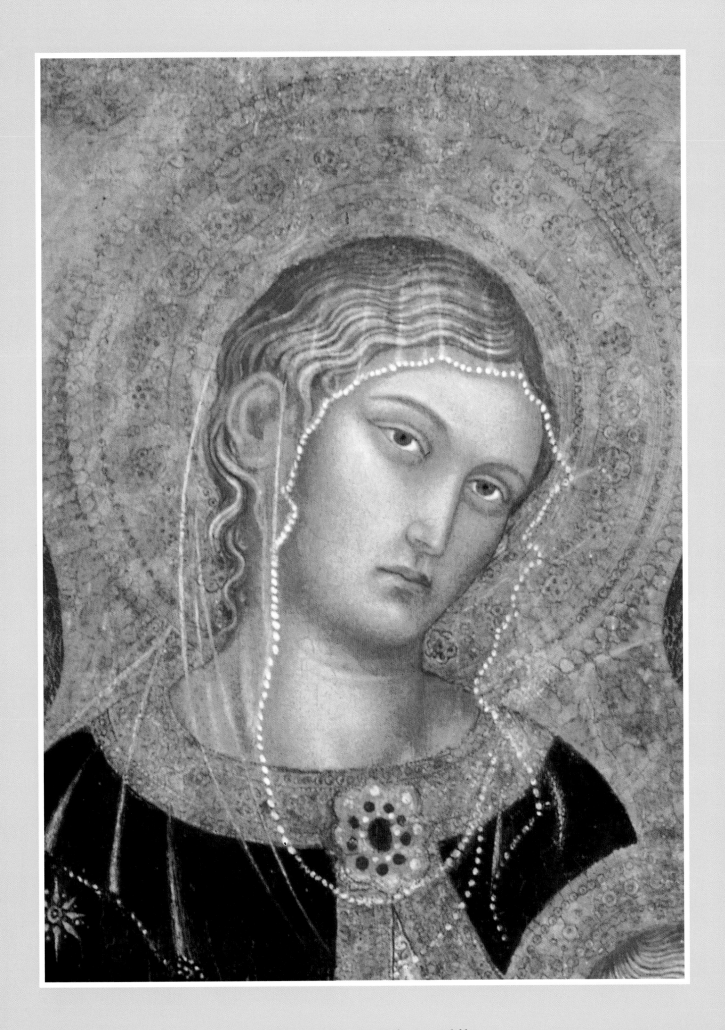

Taddeo di Bartolo, *Madonna & Child*

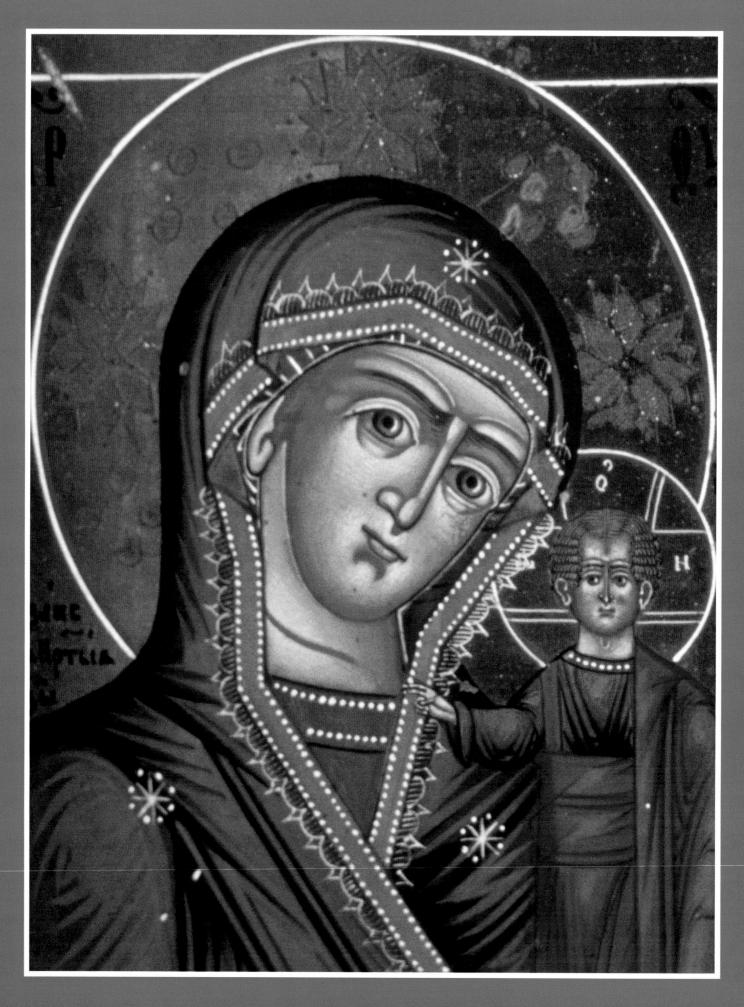

Hail, Mother of the Star that never sets.
Hail, dawn of the mystic day.

—*The Akathistos Hymn*

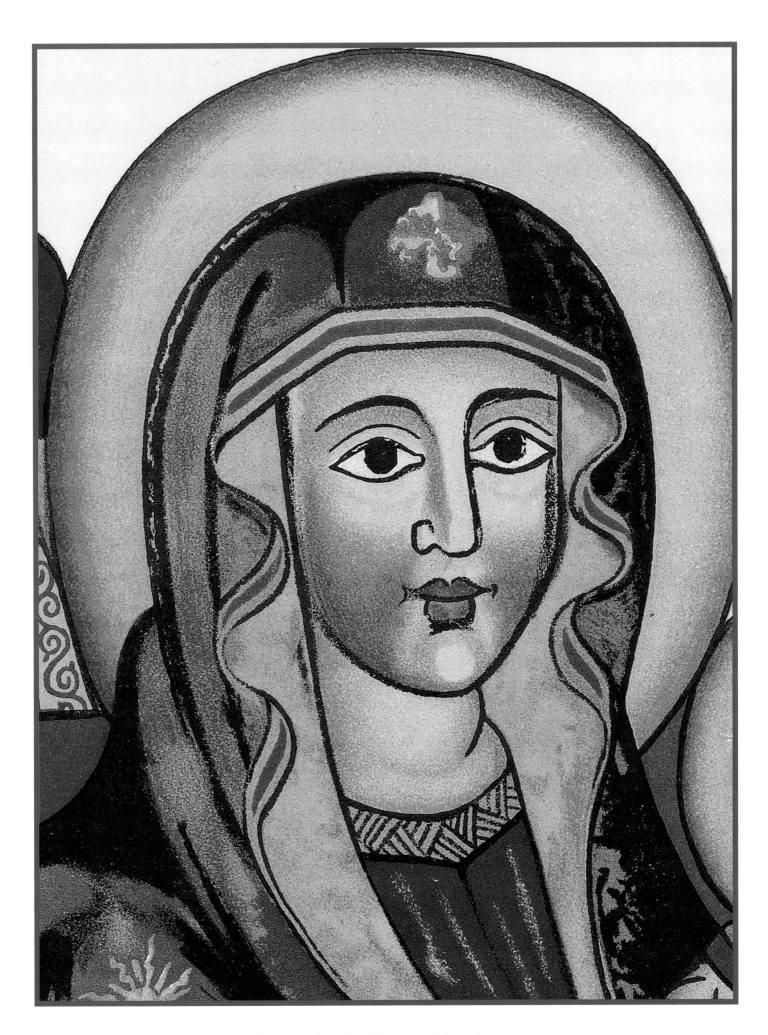

(opposite) Russian, *Mother of God Kazanskaya*
(above) Ethiopian, *The Blessed Virgin Mary*

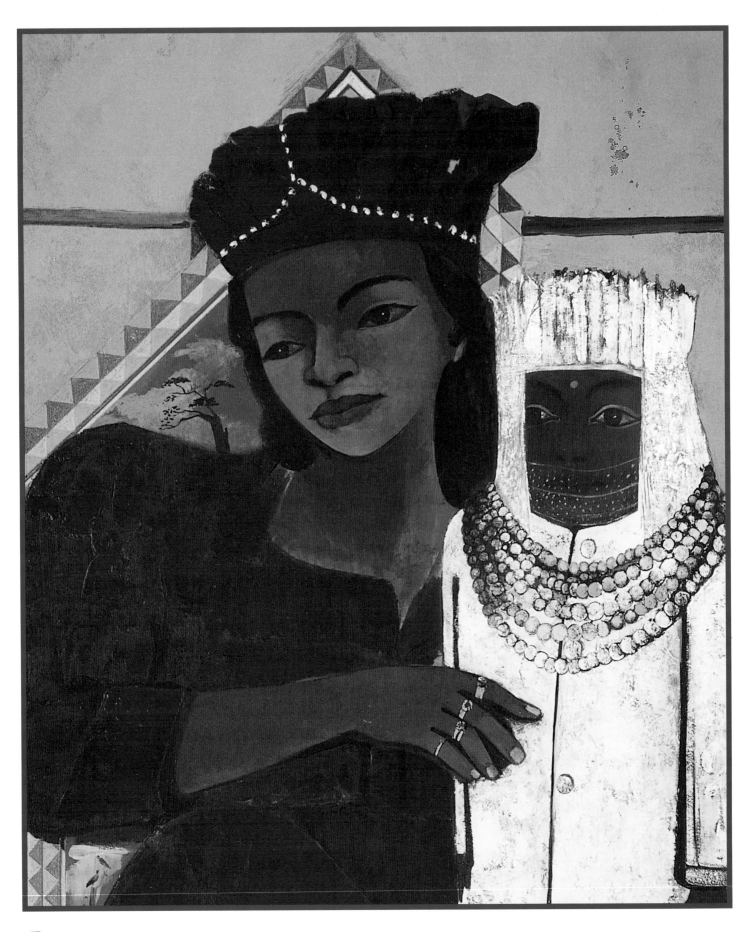

Black Madonna, coal-like vortex,
visionary poverty, star opposing the sun.
From the well of the irreversible millennium,
you are a river that flows like a blood jet.

—Maria Luisa Spazione, *Black Madonnas*

(above) Paul Claude Gardère, *Madonna (Madame Duvalier)*
(opposite) Yves Michel, *Eternal Flowers*

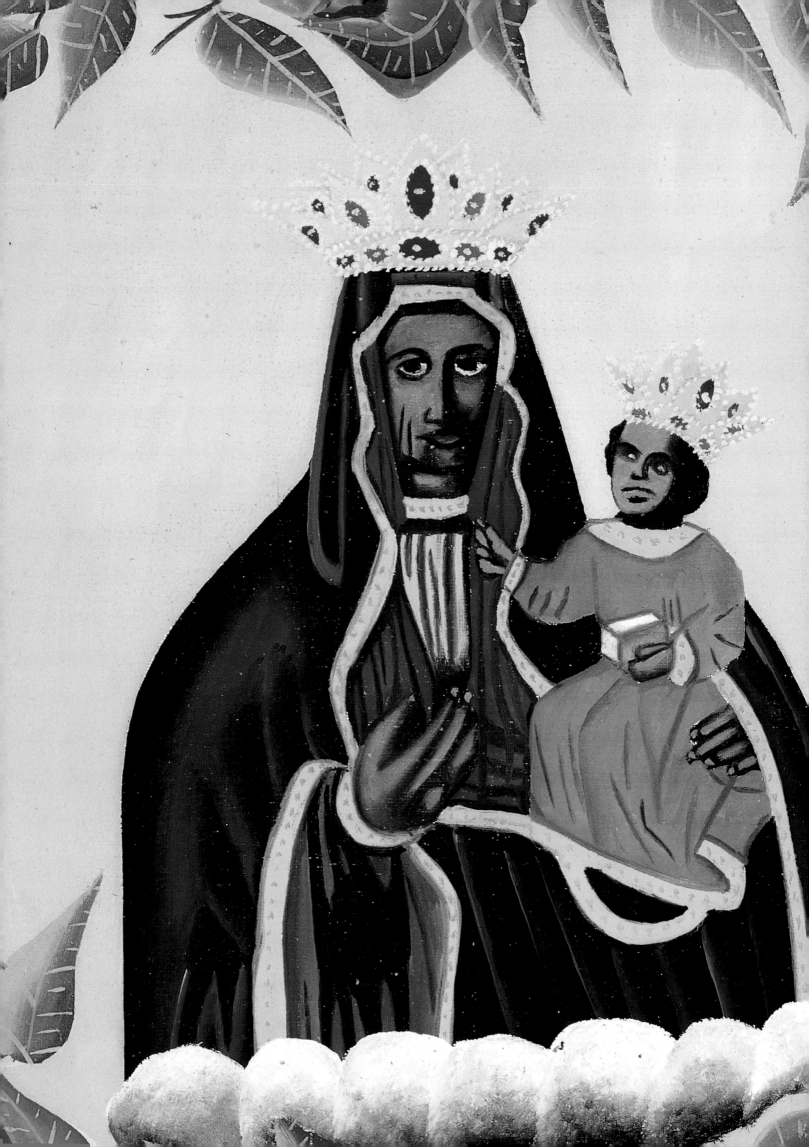

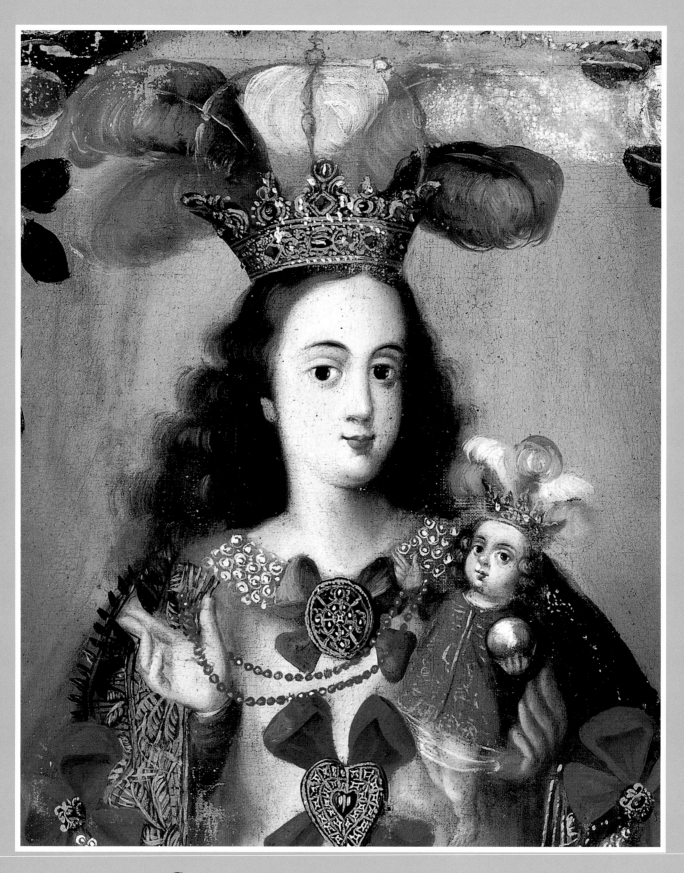

Salutation unto thine eyes which are like two lamps
that have been suspended
by a cunning workman in the exalted palace of thy body.

—Miracles of the Blessed Virgin

Peruvian, Cuzco School, *Nuestra Senora del Rosario (Our Lady of the Rosary)*

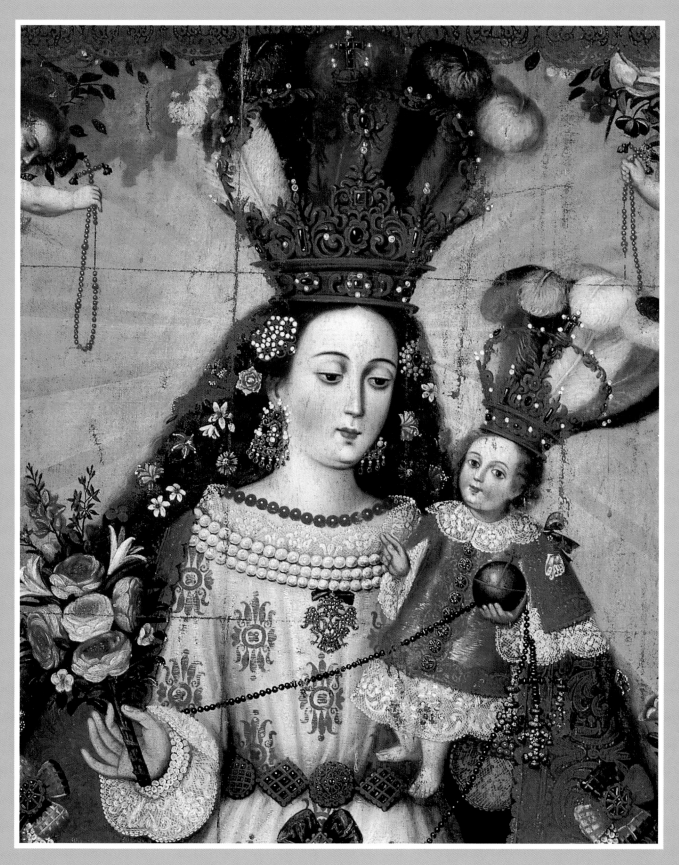

Hail you the Sun's bright star
Who God's Pure mother are;
A Virgin Still and ever
The happy gate of heaven.

—*The Three Offices of our Blessed Lady*

Peruvian, Cuzco School, *Nuestra Senora del Rosario (Our Lady of the Rosary)*

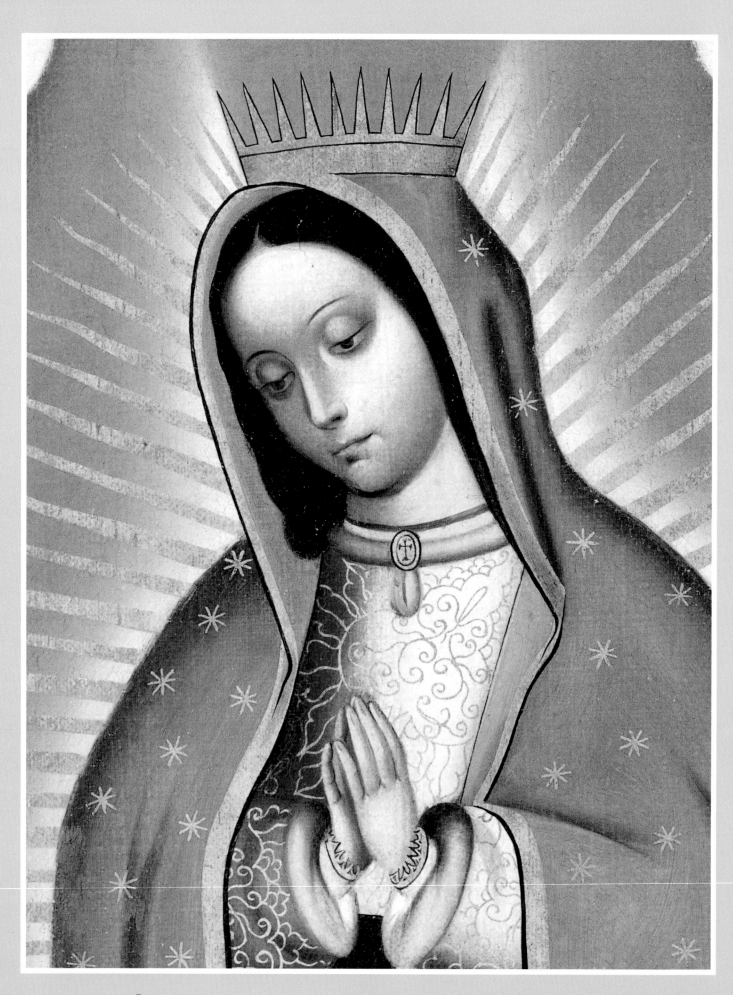

Lady, as I know thy power,
 I place my hopes in thee;
Thy shrine in Guadalupe's tower,
 My pilgrim steps shall see.

Thy welcome ever was most sweet
 To those who come in care;
When from this prison I retreat,
 I'll seek thine image there.

—PÉRO LOPEZ DE AYALA, *Song to the Virgin Mary*

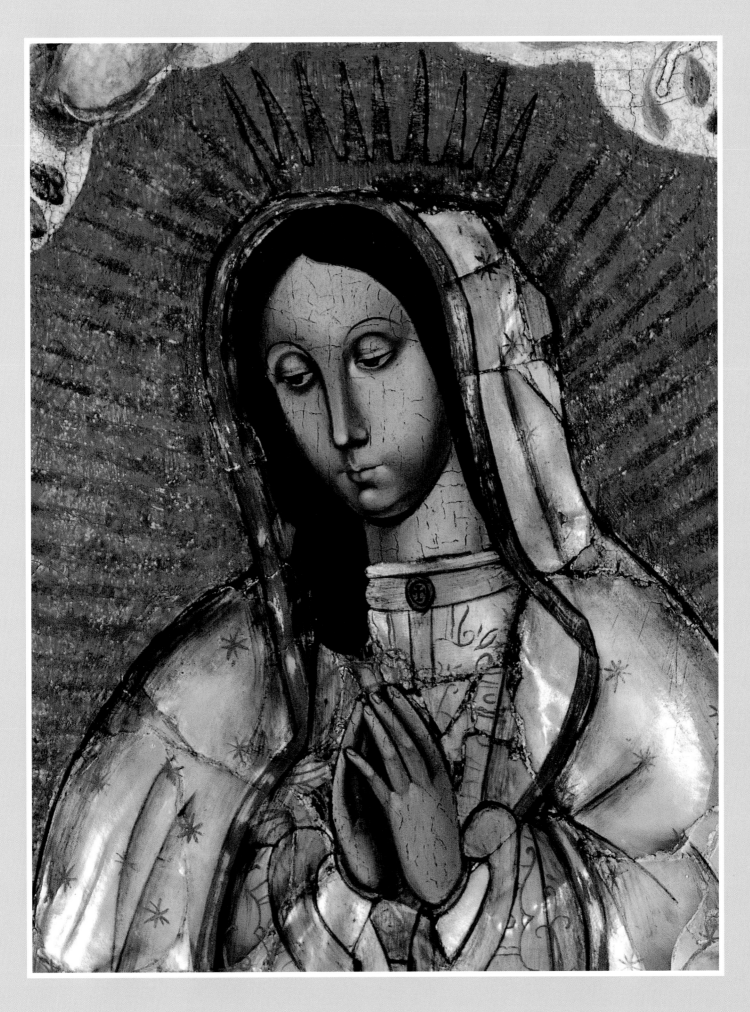

(opposite) Mexican, *La Virgen de Guadalupe* (*The Virgin of Guadalupe*)
(above) Mexican, *La Virgen de Guadalupe*

Wise Virgin, one of the many blessed wise virgins,

the first, and the one with the brightest lamp,

O solid shield of the afflicted people

against the blows of Death and Fortune,

under which they triumph, not simply escape,

O relief from the blind passion

that flames here among foolish mortals:

Virgin, turn those beautiful eyes…to my endangered state,

and to me who dismayed comes to you for counsel.

—PETRARCH, *RIME SPARSE*

Follower of Piero della Francesca, *Virgin & Child with an Angel*

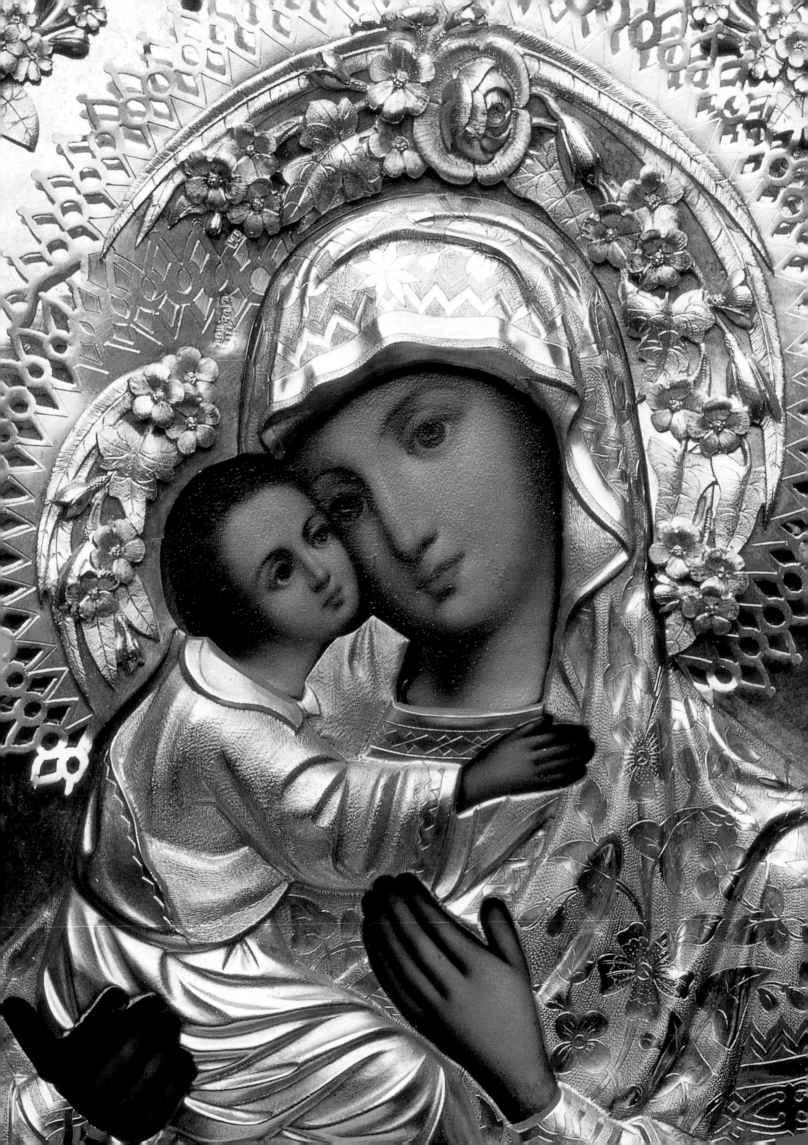

Hence, as it was through the Theotokos alone that the Lord came to us, appeared upon earth and lived among men, being invisible to all before this time, so likewise in the endless age to come, without her mediation, every emanation of illuminating divine light, every revelation of the mysteries of the Godhead, every form of spiritual gift, will exceed the capacity of every created being. She alone has received the all-pervading fullness of Him that filleth all things, and through her all may now contain it, for she dispenses it according to the power of each, in proportion and to the degree of the purity of each. Hence she is the treasury and overseer of the riches of the Godhead.

—St. Gregory Palamas, *Homily on the Supremely Pure Lady Theototokos*

(opposite) Russian, *Vladimir Mother of God (Bagomater Vladimirskaya)*
(above) Ascribed to Miguel Cabrera, *The Madonna of the Rosary*

Queen of the Angels, Mary, thou whose smile
 Adorns the heavens with their brightest ray;
 Calm star that o'er the sea directs the way
Of wandering barks unto their homing isle;
By all thy glory, Virgin without guile,
 Relieve me of my grievous woes, I pray!

—GIOVANNI BOCCACCIO, *The Queen of the Angels*

Sebastiano Mainardi, *Madonna & Child with St. John & Angels*
Michelangelo di Pietro Membrini, *Virgin & Child Enthroned with Two Angels Holding a Crown*

Mother of God! no lady thou:

Common woman of common earth!

Our Lady ladies call thee now,

But Christ was never of gentle birth;

A common man of the common earth.

For God's ways are not as our ways.

The noblest lady in the land

Would have given up half her days,

Would have cut off her right hand

To bear the Child that was God of the land.

Never a lady did He choose, Only a maid of low degree,

So humble she might not refuse

The carpenter of Galilee.

A daughter of the people, she.

Out she sang the song of her heart.

Never a lady so had sung.

She knew no letters, had no art;

To all mankind, in woman's tongue

Hath Isrealitish Mary sung.

And still for men to come she sings,

Nor shall her singing pass away

"He hath filled the hungry with good things"—

Oh, listen, lords and ladies gay!—

"And the rich He hath sent empty away."

—MARY COLERIDGE, *Our Lady*

Piero della Francesca, *Virgin & Child Enthroned with Four Angels*

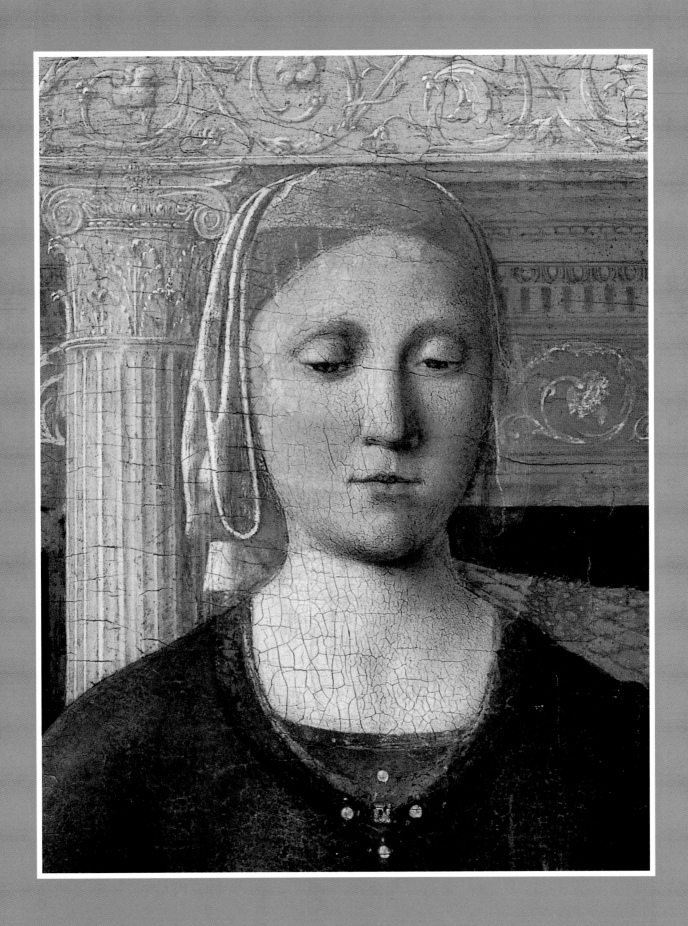

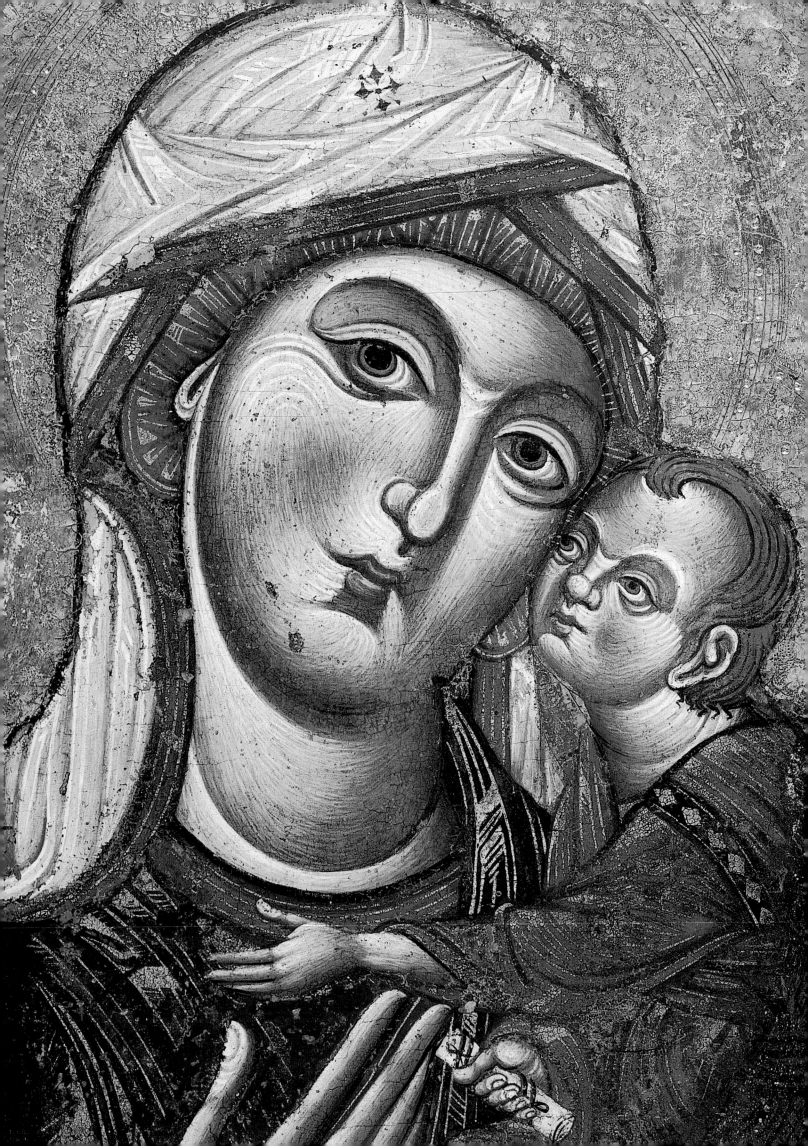

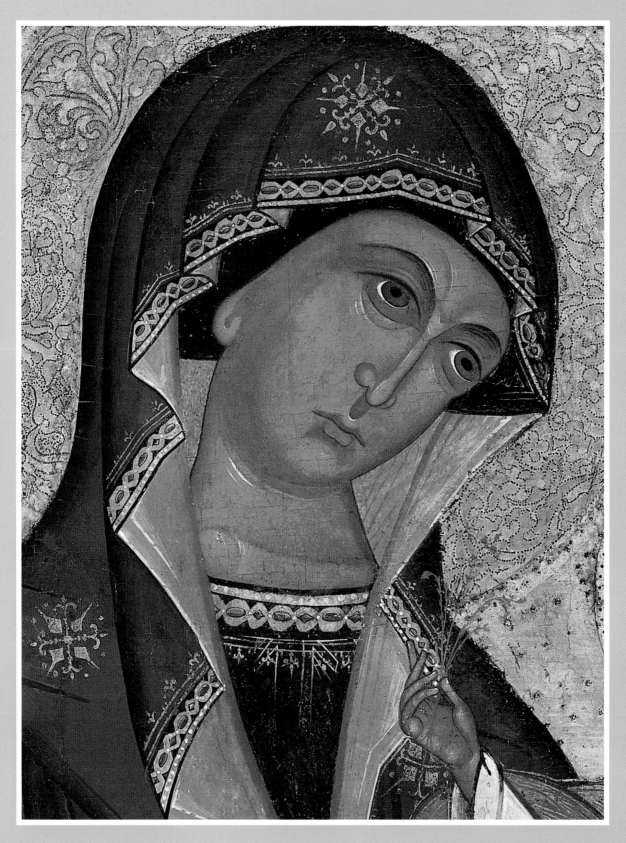

It is proper to call you blessed, ever-esteemed Theotokos, most pure,
 and mother of God.
You who are more worthy of honor than the cherubim and far more
 glorious than the seraphim.
You who incorruptibly gave birth to God the Word, Theotokos, we fervently
 extol you.

 —ST. JOHN CHRYSOSTOM, *Great Hymn to Theotokos*

(opposite) Master of the Saints Cosmos and Damian Madonna, *The Virgin & Child*
(above) Moscow School, *Our Lady of Jerusalem*

The Blessed Virgin is called Star,
Star of the Seas, Longed-For Guide,
She is watched by mariners in peril
for when they see Her, their ship is guided.

She is called and She is Queen of Heaven,
Temple of Jesus Christ, Morning Star,
Natural Mistress, Merciful Neighbor,
Health and Cure of Bodies and Souls.

She is the Fleece that was Gideon's,
on which fell the rain, a great vision;
She is the Sling with which young David
destroyed the ferocious giant.

She is the Fount from which we all drink,
She gave us the food of which we all eat;
She is called the Port to which we all hasten,
and the Gate through which we all await entrance.

She is called the Closed Gate;
for us She is open, to give us entrance;
She is the Gall-Cleaned Dove
in Whom lies no wrath; She is always pleased,

She rightfully is called Zion,
for She is our Watchtower, our Defense;
She is called the Throne of King Solomon,
king of justice and admirably wise.

There exists no goodly name
that in some way does not apply to Her;
there is none that does not have its root in Her,
neither Sancho nor Domingo, not Sancha nor
　　　Dominga.

She is called Vine, She is Grape, Almond and
　　　Pomegranate,
replete with its grains of grace,
Olive, Cedar, Balsam, leafy Palm,
Rod upon which the serpent was raised.

The Staff that Moses carried in his hand,
that confounded the wise men esteemed by Pharaoh,
the one that parted the waters and then closed them—
if it did not signify the Virgin, it signified nothing.

If we think upon the other staff
that settled the dispute concerning Aaron,
it signified nothing else—so says the text—
but the Glorious One, and with good reason.

—Gonzalo de Berceo, *Miracles of our Lady*

Hail, Queen of heaven;
Hail, Mistress of the Angels;
Hail, root of Jesse;
Hail, the gate through which the Light
　　　rose over the earth.
Rejoice, Virgin most renowned
　　　and of unsurpassed beauty.

—*Ave Regina Caelorum*

Master of the Saint Lucy Legend, *Mary Queen of Heaven*

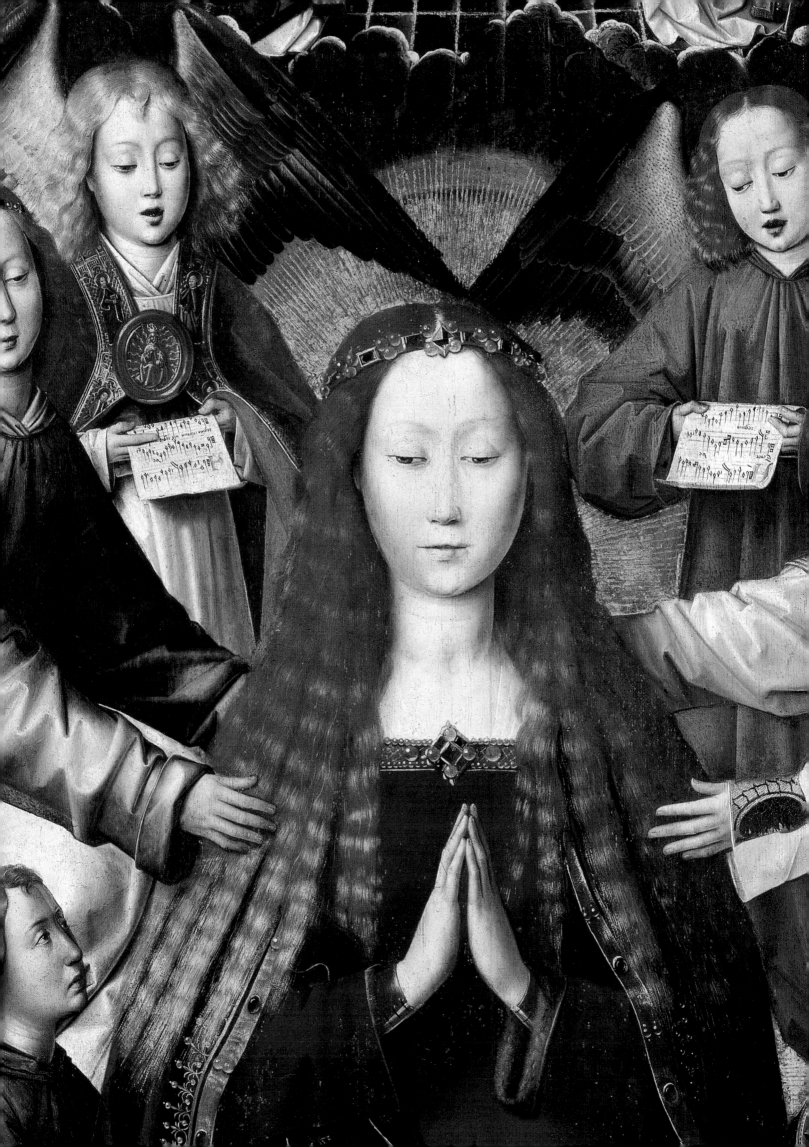

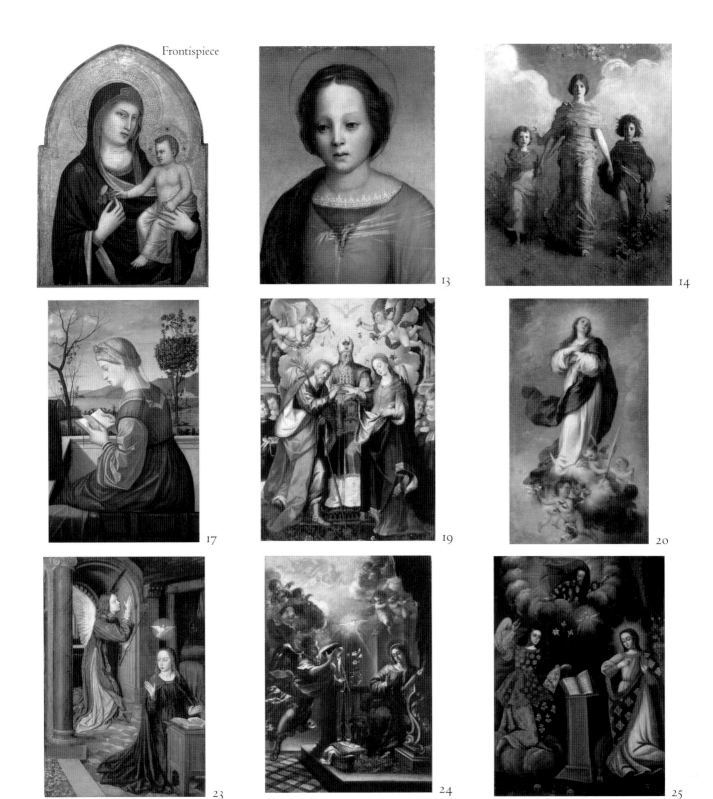

Frontispiece

13

14

17

19

20

23

24

25

LIST OF COLOR PLATES
Note: All the color reproductions are details.

Frontispiece: GIOTTO, Italian (Florentine), 1266–1337
Madonna and Child
Tempera on panel, .855 x .620 m. (33 ⅝ x 24 ⅜ in.)
National Gallery of Art, Washington
Samuel H. Kress Collection
1939.1.256

13 ANDREA DEL SARTO, Italian (Florentine), 1486–1530
Head of the Madonna (fragment)
38.1 x 29.2 cm.
The Metropolitan Museum of Art, New York
Bequest of Michael Friedsam: The Friedsam Collection
Photograph © 1984 The Metropolitan Museum of Art

14 THAYER, ABBOTT HANDERSON, American, 1849–1921
Virgin
Oil on canvas, 229.7 x 182.5 cm (90 ⅜ x 70 ⅞ in.)
Courtesy of the Freer Gallery of Art,
The Smithsonian Institution, Washington
93.11

17 CARPACCIO, VITTORE, Italian (Venetian), c. 1460/5–1523/6
The Virgin Reading
Oil on panel transferred to canvas, .781 x .506 m.
(30 ¾ x 20 in.)
National Gallery of Art, Washington
Samuel H. Kress Collection
1939.1.354

19 JUÁREZ, LUIS, Spanish, 1885–1636
The Marriage of the Virgin (Los Desposorios de la Virgen)
Oil on linen, 83 x 57 in.
Collection of Davenport Museum of Art
Gift of an Anonymous Donor
95.6

20 MURILLO, BARTOLOMÉ ESTEBÁN, Spanish, 1618–1682
The Immaculate Conception
Oil on canvas, 220.5 x 127.5 cm.
© The Cleveland Museum of Art
Leonard C. Hanna, Jr., Fund
1959.189

23 HEY, JEAN (MASTER OF MOULINS), French, c. 1490–1510
The Annunciation
Oil on panel, 72 x 50.2 cm.
Photograph © 1998, The Art Institute of Chicago. All
Rights Reserved.
Mr. and Mrs. Martin A. Ryerson Collection

24 LEAL, JUAN DE VALDÉS, Spanish, 1622–1690
The Annunciation
Oil on canvas, 108.2 x 79.3 cm.
University of Michigan Museum of Art, Ann Arbor
1962/1.99

25 PERUVIAN, CUZCO SCHOOL, 18th century
The Annunciation
Oil on canvas, 63 ½ x 46 ⅜ in. (161.4 x 117.8 cm.)
Private collection
Courtesy of Christie's Images, New York

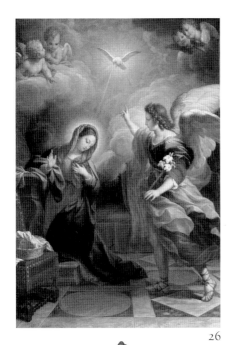

26

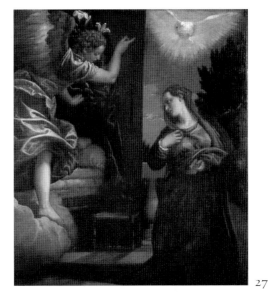

27

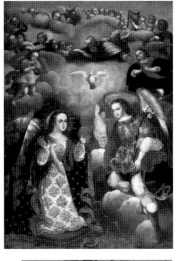

28

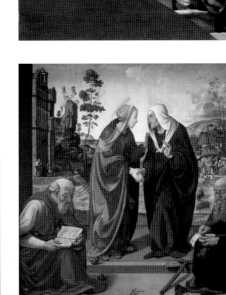

31

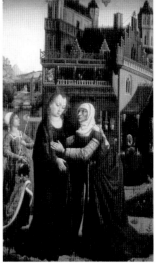

32

29

33

35

26 Masucci, Agostino, Italian (Roman), 1691–1758
The Annunciation
Oil on linen, 38 ³/4 x 26 ⁷/8 in.
The Minneapolis Institute of Arts
The Ethel Morrison Van Derlip Fund
62.47

27 Veronese (Paolo Calieri), Italian (Venetian), 1528–1588
The Annunciation
Oil on canvas, 150 x 133.4 cm.
© The Cleveland Museum of Art
Gift of the Hanna Fund
1950.251

28 Pumacallao, Basilio Santa Cruz, Mexican,
The Annunciation
Oil on canvas laid down on masonite, 71 ¹⁵/16 x 51 in.
(182.3 x 129.5 cm.)
Private collection
Courtesy of Christie's Images, New York

29 Workshop of Agnolo Gaddi,
Italian (Florentine), c. 1350–1415
The Annunciation
Tempera on panel, 120 x 62.2 cm. (47 ¹/4 x 24 ¹/2 in.)
The Nelson-Atkins Museum of Art, Kansas City

31 Guercino (Barbieri, Giovanni Francesco), Italian
(Bolognese), 1591–1666
The Annunciation
Oil on canvas, 76 ¹/4 x 108 ³/4 in.
Bequest of John Ringling
The John and Mable Ringling Museum of Art
The State Art Museum of Florida, Sarasota

32 Master of the Retablo of the Reyes Catolicos,
Spanish or Flemish, late 15th century
The Visitation
Oil on wood panel, 152.4 x 93.7 cm. (60 x 36 ⁷/8 in.)
Collection of the University of Arizona
Museum of Art, Tucson
Gift of Samuel H. Kress Foundation
61.13.22

33 Piero di Cosimo, Italian (Florentine) c. 1462–1521
The Visitation with Saint Nicholas & Saint Anthony Abbot
Oil on panel, 1.842 x 1.886 m. (72 ¹/2 x 74 ¹/4 in.)
National Gallery of Art, Washington
Samuel H. Kress Collection
1939. I. 361

35 Stella, Joseph, American, 1877–1946
The Virgin
Oil on canvas, 100.5 x 98.4 cm. (39 ⁹/16 x 38 ³/4 in.)
Brooklyn Museum of Art
Gift of Adolph Lewisohn
28.207

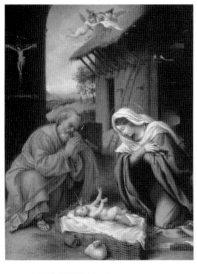

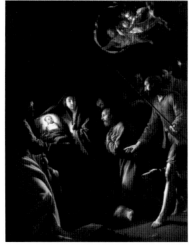

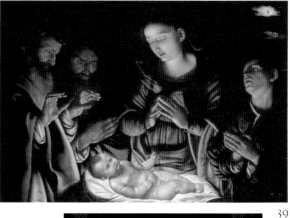

37

38

39

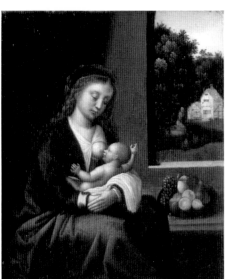

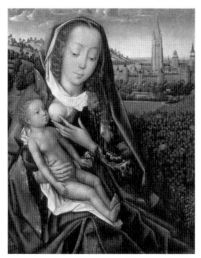

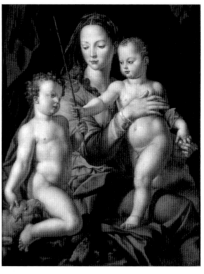

40

41

42

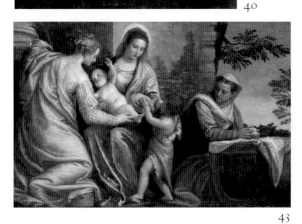

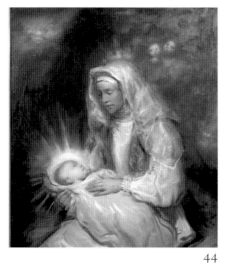

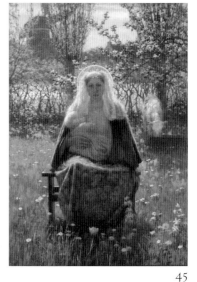

43

44

45

37 LOTTO, LORENZO, Italian (Venetian), 1480–1556
The Nativity
Oil on panel, .460 x .359 m. (15 1/8 x 14 1/8 in.)
National Gallery of Art, Washington
Samuel H. Kress Collection
1939.1.288

38 CHAMPAIGNE, PHILIPPE DE, Flemish, 1602–1674
Adoration of the Shepherds
Oil on canvas
Portland Art Museum, Portland, Oregon
Gift of Dr. and Mrs. Edwin Binney, 3rd
66.83

39. SAVOLDA, GIOVANNI GIROLAMO, Italian, c. 1450–in or after 1548
The Adoration of the Shepherds
Wood/Oil on wood, .845 x1.197 m. (33 1/4 x 47 1/8 in.)
National Gallery of Art , Washington
Samuel H. Kress Collection

40 SCHOOL OF ADRIAEN ISENBRANDT, Flemish, active c. 1510–1551
Madonna & Child in Interior
Oil on panel, 17.6 x 14.2 cm. (6 15/16 x 5 5/8 in.)
Smith College Museum of Art, Northampton, Massachusetts
Gift of Mrs. Charles Lincoln Taylor (Margaret Goldthwait, class of 1921)

41 MASTER OF THE LEGEND OF SAINT LUCY, Netherlandish, active 1480–1490
Virgin & Child in a Landscape
Tempera with oil on panel, 40.4 x 32 cm. (15 7/8 x 12 9/16 in.)
The Sterling and Francine Clark Art Institute, Williamstown, Massachusetts
1995.942

42 BRONZINO, AGNOLO, Italian (Florentine), 1503–1572
The Holy Family
Oil on panel, 1.013 x .787 m. (39 7/8 x 31 in.)
National Gallery of Art, Washington
Samuel H. Kress Collection
1939.1.387

43 VERONESE, PAOLO (CALIARI), Italian (Venetian), c. 1528–1588
Madonna & Child with St. Elisabeth, the Infant St. John the Baptist & St. Catherine
Oil on canvas, 40 7/8 x 62 1/4 in.
Timken Museum of Art, San Diego
Putnam Foundation

44 MASON, FRANK, American, b. 1921
Madonna & Child
Oil on canvas, 40 x 36 in.
Collection of the artist

45 HITCHCOCK, GEORGE, American, 1850–1913
Madonna & Child
Oil on canvas, 160.3 x 112 cm.
© The Cleveland Museum of Art
Gift of Mr. and Mrs. J. H. Wade
1916.1057

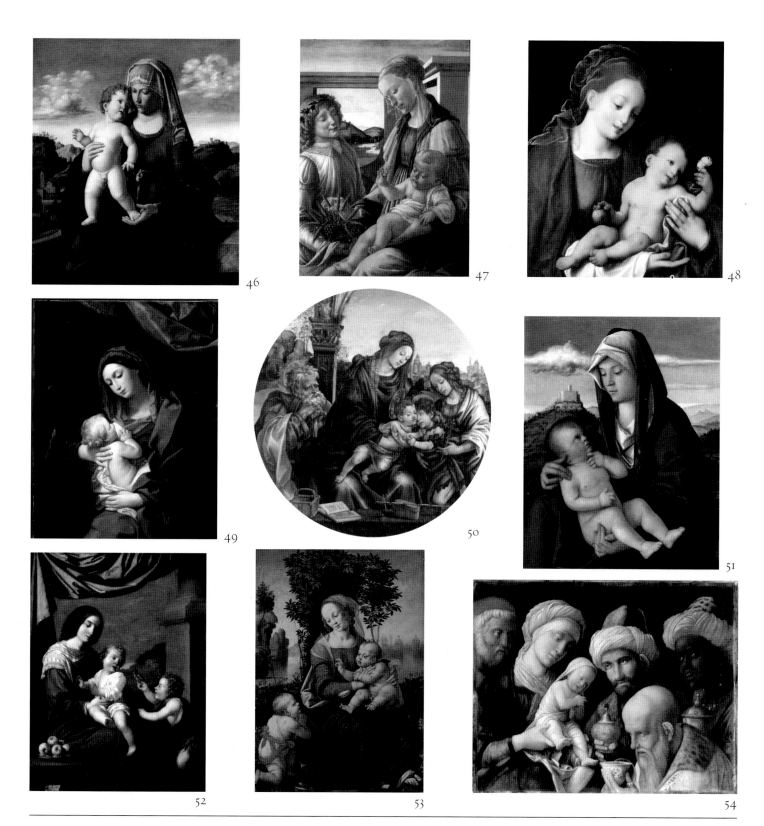

46 CIMA DA CONEGLIANO, GIOVANNI BATTISTA, Italian (Venetian), c. 1459–1517/18
Madonna & Child in a Landscape
Oil on panel, 71.1 x 62.9 cm. (28 x 24 3/4 in.)
North Carolina Museum of Art, Raleigh
52.9.152

47 BOTTICELLI, SANDRO (ALESSANDRO FILIPEPI), Italian (Florentine), c. 1445–1510
Madonna & Child with an Angel
Tempera on panel, 85.2 x 65 cm.
Isabella Stewart Gardner Museum, Boston

48 VAN CORNELIS, CLEVE, Flemish
Madonna & Child
Oil on panel, 55.93 x 43.34 cm. (22 3/4 x 17 1/4 in.)
The Minneapolis Institute of Arts
The Putnam Dana McMillan Fund
69.4

49 RENI, GUIDO, Italian (Bolognese), 1575–1642
Madonna & Child
Oil on canvas, 114.3 x 91.4 cm. (45 x 36 in.)
North Carolina Museum of Art, Raleigh
Gift of Mr. And Mrs. Robert Lee Humber
in memory of their daughter, Eileen Genevieve
G.55.12.1

50 LIPPI, FILIPPINO, Italian (Umbrian) c. 1457–1504
The Holy Family with John the Baptist & Saint Margaret
Oil and tempera on wood (poplar), diam. 53 cm.
© The Cleveland Museum of Art
The Delia E. Holden Fund and a fund donated as a memorial to Mrs. Holden by her children: Guerden S. Holden, Delia Holden White, Roberta Holden Bole, Emery Holden Greenough, Gertrude Holden McGinley
1932.227

51 BELLINI, GIOVANNI, Italian (Venetian), 1430-1516
Madonna & Child
Oil on canvas, transferred from panel, 72.5 x 55.4 cm. (28 9/16 x 21 13/16 in.)
The Nelson-Atkins Museum of Art, Kansas City
Gift of the Samuel H. Kress Foundation

52 ZURBARÁN, FRANCISCO DE, Spanish, 1598–1664
Madonna & Child with the Infant St. John
Oil on canvas, 138.4 x 106.7 cm. (54 1/2 x 42 in.)
San Diego Museum of Art
Gift of Anne R. and Amy Putnam
1935:022

53 LORENZO DI CREDI, Italian (Florentine), 1458/59–1537
Madonna & Child with the Infant St. John
Oil on panel with tempera highlights, 39 3/8 x 28 1/16 in. (100 x 71.3 cm.)
The Nelson-Atkins Museum of Art, Kansas City
(Purchase: Nelson Trust)

54 MANTEGNA, ANDREA, Italian (Mantuan), c. 1431–1506
Adoration of the Magi
Distemper on linen, 54.6 x 69.2 cm. (21 1/2 x 27 3/8 in.)
The J. Paul Getty Museum, Los Angeles
85.PA.417

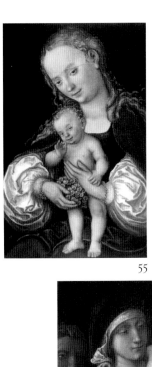
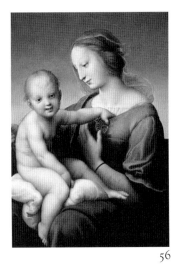
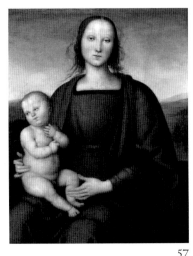
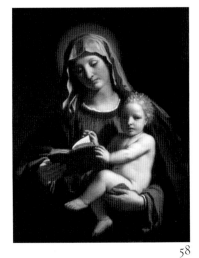

55 56 57 58

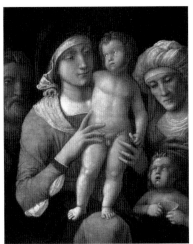
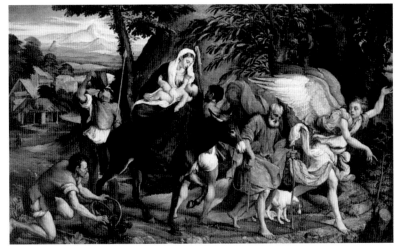

59 60

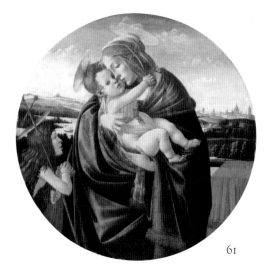
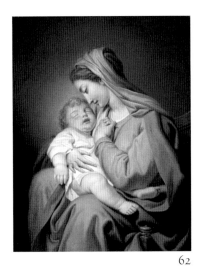
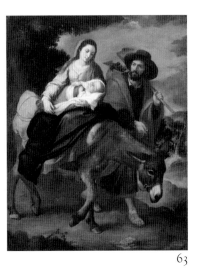

61 62 63

55 CRANACH THE ELDER, LUCAS, German, 1472–1553
Madonna & Child with Grapes
Oil on panel, 22 3/8 x 13 3/4 in.
The Minneapolis Institute of Arts
Bequest of Miss Tessie Jones in memory of Herschel V.
Jones
68.41.4

56 RAPHAEL, (RAFFAELLO SANZIO), Italian (Umbrian),
1483–1520
The Niccolini-Cowper Madonna
Oil on panel, .807 x .575 m. (31 3/4 x 22 3/8 in.)
National Gallery of Art, Washington
Andrew W. Mellon Collection
1937.1.25

57 PERUGINO, PIETRO, Italian (Umbrian), 1450–1523
Madonna & Child
Tempera on panel, 80.7 x 64.8 cm.
The Detroit Institute of Arts
Bequest of Eleanor Clay Ford
77.3

58 GUERCINO (GIOVANNI FRANCESCO BARBIERI), Italian
(Bolognese), 1591–1666
Madonna & Child
Phoenix Art Museum
Museum Purchase with Funds Provided by an Anonymous
Donor
Photographed by Craig Smith

59 MANTEGNA, ANDREA, Italian (Venetian), 1431–1506
*The Holy Family with Saint Elizabeth & the Infant Saint John the
Baptist*
Distemper, oil, and gold on canvas, 24 3/4 x 20 3/16 in.
Kimbell Art Museum, Fort Worth

60 BASSANO (JACOPO DA PONTE), Italian(Venetian),
1510–1592
The Flight into Egypt
Oil on canvas, 48 1/2 x 77 1/4 in.
Norton Simon Museum, Los Angeles

61 BOTTTICELLI, ALESSANDRO FILIPEPI, Italian (Florentine), c.
1447–1510
Virgin & Child with Saint John the Baptist
Tempera with some oil on panel, diam. 34 7/8 in. (88.6 cm.)
Sterling and Francine Clark Art Institute, Williamstown,
Massachusetts

62 CORVI, DOMENICO, Italian (Roman), 1721–1803
Virgin & Child
Oil on canvas, 60 x 48.5 cm. (23 5/8 x 19 1/8 in.)
Courtesy, Museum of Fine Arts, Boston
Bequest of Mrs. Henry Edwards
90.76

63 MURILLO, BARTOLOMÉ ESTEBÁN, Spanish, 1618–1682
The Flight into Egypt
Oil on canvas, 209.6 x 166.4 cm.
The Detroit Institute of Arts
Gift of Mr. and Mrs. K. T. Keller, Mr. and Mrs. Leslie H.
Green and Mr. and Mrs. Robert N. Green
48.96

64 65 66

67 68 69

71 72 73

64 GOSSAERT, JAN (MALBODIUS, JOANNES), Netherlandish, active 1503–1532
Virgin & Child
Oil on wood, 47.7 x 36.6 cm.
© The Cleveland Museum of Art
John L. Severance Fund
1972.47

65 SASSOFERRATO (GIOVANNI BATTISTA SALVI), Italian, 1609–1685
Madonna & Child
Oil on canvas, 35 ¹/₂ x 28 ¹/₂ in.
Bequest of John Ringling
Collection of The John and Mable Ringling Museum of Art, The State Art Museum of Florida, Sarasota

66 GUERCINO (BARBIERI, GIOVANNI FRANCESCO), Italian (Bolognese), 1591–1666
Rest on the Flight into Egypt
Oil on canvas, diam. 68.5 cm.
© The Cleveland Museum of Art
Mr. and Mrs. William H. Marlatt Fund
1967.123
67 TREVISANI, FRANCESCO, Italian, 1656–1746

The Holy Family with Sts. Anne, Joachim & John the Baptist
Oil on canvas, 158 x 106.7 cm.
© The Cleveland Museum of Art
Mr. and Mrs. William H. Marlatt Fund
1967.108

68 CARRACCI, LODOVICO, Italian (Bolognese), 1555–1619
The Dream of Saint Catherine of Alexandria
Oil on canvas, 1.388 x 1.105 m. (54 ⁵/₈ x 43 ¹/₂ in.)
National Gallery of Art, Washington
Samuel H. Kress Collection
1952.5.59

69 PROCACCINI, GIULIO CESARE, Italian, 1574–1625
Holy Family with the Infant Saint John & an Angel
Oil on canvas, 189.9 x 124.8 cm. (74 ³/₄ x 49 ¹/₈ in.)
The Nelson-Atkins Museum of Art, Kansas City
Purchase: Acquired through the generosity of an anonymous donor

71 CORREGGIO (ANTONIO ALLEGRI), Italian, c. 1494–1534
Virgin & Child with the Young Saint John the Baptist
Oil on panel (poplar), transferred to processed wood support, 64.2 x 50.2 cm.
Photograph © 1998, The Art Institute of Chicago. All Rights Reserved.
Clyde M. Carr Fund
1965.688

72 PESELLINO, FRANCESCO DI STEFANO, Italian, 1422–1457
Madonna & Child with Saint John
Tempera on wood panel, 72.4 x 54 cm. (18 ¹/₂ x 21 ¹/₄ in.)
The Toledo Museum of Art
Purchased with funds from the Libbey Endowment
Gift of Edward Drummond Libbey

73 PINTORICCHIO (BERNARDINO DI BETTO), Italian (Umbrian), c. 1454–1513
Virgin & Child with Saint Jerome
Oil on Panel, 53 x 39 cm.
Courtesy, Museum of Fine Arts, Boston
Gift of Mrs. W. Scott Fitz
20.431

74

75

76

77

78

79

80

81

74 Bouguereau, Adolphe William, French, 1825–1905
Madonna & Child with Saint John
Oil, 190.5 x 110.8202 cm.
Herbert Johnson Museum of Art
Cornell University, Ithaca, New York
Gift of Louis V. Keeler (Class of 1911) and Mrs. Keeler
60.082

75 Pintoricchio, Bernardino di Betto, Italian (Umbrian)
c. 1454–1513
Virgin & Child
Tempera and oil on wood, 45.5 x 34.2 cm.
© The Cleveland Museum of Art
The Elisabeth Severance Prentiss Collection
1944.89

76 Cranach, Lucas the Elder, German, 1472–1553
Madonna & Child with St. Catherine
Paint on panel
Portland Art Museum, Portland, Oregon
Gift of Mrs. Charlotte A. Maser

77 El Greco, Spanish, 1541–1641
The Holy Family with Mary Magdalen
Oil on canvas, 130 x 100 cm.
© The Cleveland Museum of Art
Gift of the Friends of the Cleveland Museum of Art
in Memory of J. H. Wade, 1926.247

78 Gossart, Jan (Mabuse), Flemish, 1462/70–1533/41
Madonna & Child
Tempera on wood panel, 12 1/4 x 12 7/8 in.
Memphis Brooks Museum of Art
Gift of Mrs. Morrie A. Moss
61.175

79 Workshop of Andrea del Sarto, Italian, 1485–1531
Madonna & Child & Infant Saint John
Oil on canvas, diam. 26 3/4 in.
The Lowe Art Museum
University of Miami, Coral Gables
Samuel H. Kress Foundation
61.017.000

80 Bronzino Agnolo, Italian (Florentine), 1503–1572
The Holy Family
Oil on panel, 1.013 x .787 m. (39 7/8 x 31 in.)
National Gallery of Art, Washington
Samuel H. Kress Collection
1939.1.387

81 Tiepolo, Giovanni Battista, Italian (Venetian),
1696–1770
Madonna of the Goldfinch
Oil on canvas, .991 x .775 m. (39 x 30 1/2 in.)
National Gallery of Art, Washington
Samuel H. Kress Collection
1943.1.45

82 RUBENS, PETER PAUL, Flemish, 1577–1640
The Holy Family
Oil on canvas, 174.6 x 142.2 cm. (68 ³/₄ x 56 in.)
North Carolina Museum of Art, Raleigh
Purchased with funds from the State of North Carolina
52.9.107

83 LOTTO, LORENZO, Italian (Venetian), c. 1480–1556
Virgin & Child with Saints Jerome & Anthony
Oil on canvas, 94.33 x 77.8 cm. (37 ¹/₈ x 30 ⁵/₈ in.)
Courtesy, Museum of Fine Arts, Boston
Charles Potter Kling Fund
60.154

85 RICCI, SEBASTIANO, Italian (Venetian), 1659–1734
The Marriage Feast of Cana
Oil on canvas, 167 x 137.2 cm. (65 ³/₄ x 54 in.)
The Nelson-Atkins Museum of Art, Kansas City
Purchase: Nelson Trust

86 CONSTANTINI DE'SERVI, Italian, 1554–1622
Virgin & Child
Oil on wood, diam. 87.5 cm.
© The Cleveland Museum of Art
Gift of Mr. and Mrs. Preston H. Saunders
in memory of Senator Robert J. Bulkley
1971.278

87 ZURBARAN, FRANCISCO DE, Spanish, 1598–1664
Christ & the Virgin in the House of Nazareth
Oil on canvas, 165 x 218.2 cm.
© The Cleveland Museum of Art
Leonard C. Hanna, Jr., Fund
1960.117

88 TANNER, HENRY O., African/American, 1858–1937
Mary
Oil on canvas, 34 ¹/₂ x 43 ¹/₄ in.
LaSalle University Art Museum, Philadelphia
Given by Regan and Regina Henry

90 GRUNEWALD, MATTHIAS, German, c. 1475/80–1480
The Small Crucifixion
Oil on panel, .613 x.460 m. (24 ¹/₈ x 18 ¹/₈ in.)
National Gallery of Art, Washington
Samuel H. Kress Collection
1961.9.19

91 CRIVELLI, CARLO, Italian (Venetian), active 1457–died 1495
Tempera on panel, 75 x 55.2 cm.
Photograph © 1998. The Art Institute of Chicago. All
Rights Reserved.
Wirt D. Walker Fund, 1929.862

92 CRIVELLI, CARLO, Italian (Venetian), active 1457–died 1495
The Virgin with the Dead Christ & Saints Mary Magdalen & John
Tempera on panel, 88.5 x 52.6 cm (34 ⁷/₈ x 20 ³/₄ in.)
James Fund and Anonymous Gift
Courtesy, Museum of Fine Arts, Boston

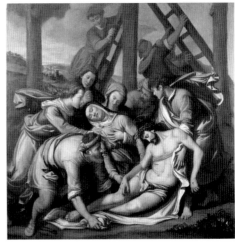

93

97

94

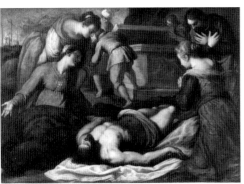

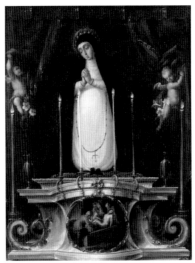

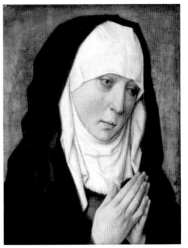

95

99

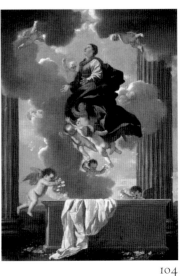

98

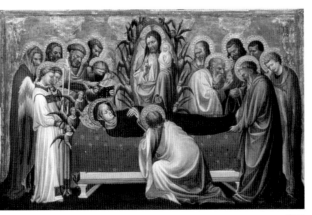

101

102

104

93 Solario, Andrea, Italian (Milanese), active 1495–1524
Pietà
Oil on panel, 1.686 x 1.520 m. (66 ³/₈ x 59 ⁷/₈ in.)
National Gallery of Art, Washington
Samuel H. Kress Collection
1961.9.40

94 Santi di Tito Titi, Italian, 1536–1603
Oil on panel, 69 ³/₄ x 69 ¹/₂ in.
The Minneapolis Institute of Arts
The John R. Van Derlip Fund

95 Palma, Jacopa, Italian (Venetian), c. 1480–1528
Lamentation Over the Dead Christ
Oil on canvas, 156.200 x 226.400 cm. (61 ¹/₂ x 89 ¹/₈ in.)
Seattle Art Museum
Samuel H. Kress Collection

97 Bougereau, William Adolphe, French, 1825–1905
Pietà
Collection of Stuart Pivar, New York
Photograph courtesy of Musée des beaux-arts de Montréal

98 Juárez, Nicolas Rodriguez, Spanish, 1667–1734
Mater Dolorosa
Oil on wood panel, 16 x 12 ¹/₄ in.
Davenport Museum of Art, Davenport, Ohio
Gift of C. A. Ficke
25.323

99 Bouts, Dieric, Netherlandish, c. 1420–1475
Mater Dolorosa
Oil on panel, 38.8 x 30.4 cm.
Photograph © 1998, The Art Institute of Chicago.
All Rights Reserved. Chester D. Tripp Endowment Fund;
Max and Leola Epstein through exchange;
Chester D. Tripp Restricted Gift Fund
1986.998.

101 Follower of Rogier van der Weyden, Netherlandish,
c. early to mid 14th century
Christ Appearing to the Virgin
Oil on panel, 1.630 x .930 m. (64 ¹/₈ x 36 ⁵/₈ in.)
National Gallery of Art, Washington
Andrew W. Mellon Collection
1937.1.45

102 Starnina (Gherardo di Jacopo), Italian (Florentine),
active 1387–1413
The Dormition of the Virgin
Tempera on panel (poplar), 43.6 x 67.6 cm.
Photograph © 1998, The Art Institute of Chicago.
All Rights Reserved.
Mr. and Mrs. Martin A. Ryerson Collection
1933.1017

104 Poussin, Nicolas, French, 1594–1665
The Assumption of the Virgin
Oil on canvas, 1.344 x .981 m. (52 ⁷/₈ x 38 ⁵/₈ in.)
National Gallery of Art, Washington
Ailsa Mellon Bruce Fund
1963.5.1

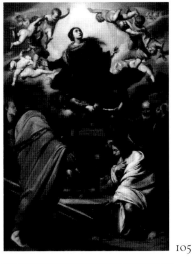

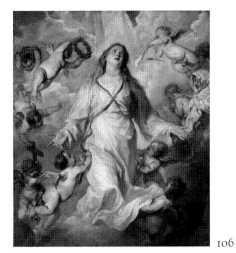

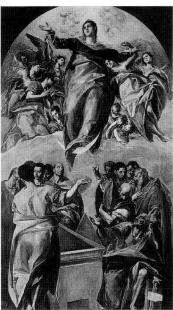

105

106

109

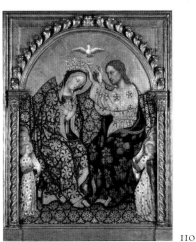

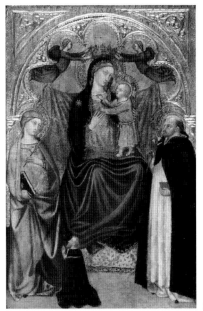

110

113

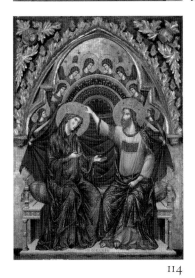

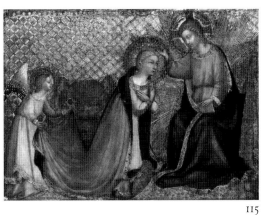

114

115

112

116

105 STANZIONE, MASSIMO, Italian (Neopolitan), 1585/6–1656
The Assumption of the Virgin
Oil on canvas, 275.6 x 189.6 cm. (108 1/2 x 74 5/8 in.)
North Carolina Museum of Art, Raleigh
Gift of the Samuel H. Kress Foundation
GL.60.17.52

106 VAN DYCK, SIR ANTHONY, Flemish, 1599–1641
The Virgin as Intercessor
Oil on canvas, 1.181 x 1.022 m. (46 1/2 x 40 1/4)
National Gallery of Art, Washington
Widener Collection
1492.9.88

109 EL GRECO (DOMENICO THEOTOKÓPOULOS), Spanish,
b. Greece, 1441–1614
The Assumption of the Virgin
Oil on canvas, 401.4 x 228.7 cm.
Photograph © 1998, The Art Institute of Chicago.
All Rights Reserved.
Gift of Nancy Atwood Sprague
in memory of Albert Arnold Sprague
1906.99

110 GENTILE DA FABRIANO, Italian, c. 1370–1427
Coronation of the Virgin
Tempera and gold leaf on panel, 87.5 x 64 cm.
(34 1/2 x 25 1/2 in.)
The J. Paul Getty Museum, Los Angeles
77.PB.92

112 ITALIAN SCHOOL (SIENESE), mid to late 14th century
The Virgin & Child with Saint Dominic, Saint Catherine & Donor
Tempera on panel, 39.2 x 24.9 cm. (15 7/16 x 9 13/16 in.)
Sterling & Francine Clark Art Institute, Williamstown,
Massachusetts
1968.295

113 TINTORETTO, JACOPO, Italian (Venetian), 1518–1594
The Madonna of the Stars
Oil on canvas, .927 x .727 m. (36 1/2 x 28 5/8 in.)
National Gallery of Art, Washington
Ralph and Mary Booth Collection
1947.6.6

114 VENEZIANO, PAOLO, Italian (Venetian), active
1333–1358/1362
The Coronation of the Virgin
Tempera on panel, .991 x .775 m. (39 x 30 1/2 in.)
National Gallery of Art, Washington
Samuel H. Kress Collection
1952.5.87

115 FRA ANGELICO (GUIDO DI PIERO), Italian (Venetian), d.1455
Coronation of the Virgin
Tempera and gold on wood, 27 x 37.2 cm.
© The Cleveland Museum of Art
The Elisabeth Severance Prentiss Collection
1944.79

116 MEMMI, LIPPO (FILLIPPO DI MEMMO), Italian (Sienese),
active 1317–1347
Virgin & Child
Tempera on panel, 75.4 x 55.5 cm. (25 7/8 x 18 3/8 in.)
Courtesy, The Museum of Fine Arts, Boston
Charles Potter Kling Fund
36.144

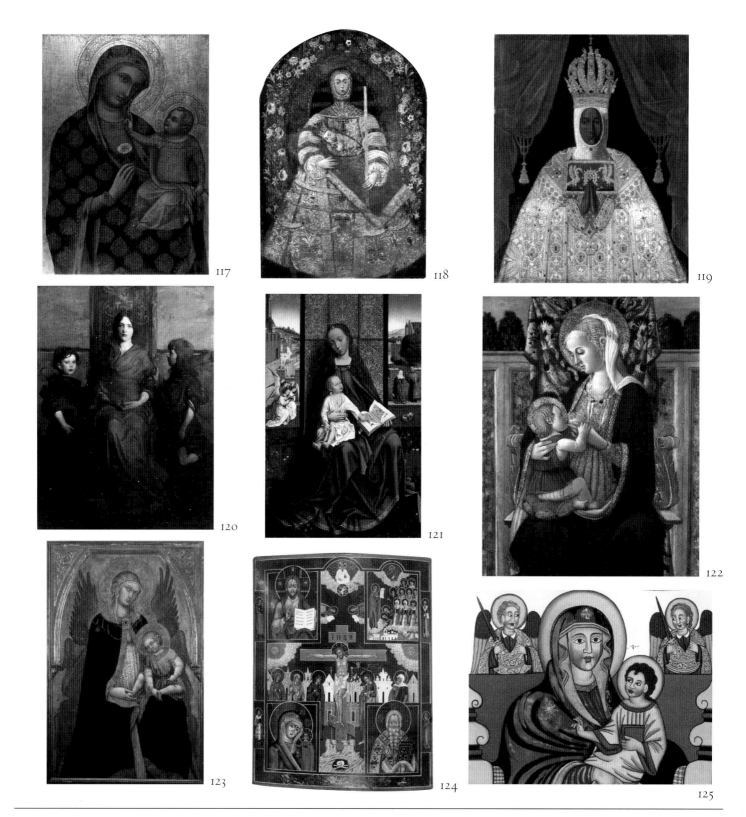

117 Veneziano, Lorenzo, Italian (Venetian), active
c. mid to late 1300
Madonna & Child
Tempera on wood, 34 1/2 x 25 in.
Birmingham Museum of Art, Birmingham, Alabama
Gift of the Samuel H. Kress Foundation
1961.100

118 Peruvian, Cuzco School, 18th century
*La Virgen de Pomata y el Nino Jesus (The Virgin of Pomato
and the Child Jesus)*
Oil on canvas, 47 3/4 x 33 3/8 in. (121.3 x 84.8 cm.)
Private collection
Courtesy of Christie's Images, New York

119 Follower of Friar Diego de Ocano, Peruvian,
School of Lima, early 17th century
La Virgen de Toledo
Oil on canvas, 41 x 33 in. (104.4 x 84 cm.)
Private collection
Courtesy of Christie's Images, New York

120 Thayer, Abbott Handerson, American, 1849–1921
Virgin Enthroned
Oil on canvas
National Museum of American Art
The Smithsonian Institution, Washington, DC
Photograph courtesy of Art Resource, New York

121 Master of the Embroidered Foliage, Netherlandish,
active c. 1500
The Virgin & Child Enthroned
Oil on panel, 38 11/16 x 25 15/16 in.
Sterling & Francine Clark Art Institute
Williamstown, Massachusetts
Gift of the Executors of Governor Hehman's Estate
and the Edith and Herber Lehman Foundation
1968.299

122 Botticini, Francesco, Italian (Florentine),
1445/46–1497
Madonna & Child
Tempera on wood panel, 31 7/8 x 26 1/4 in.
Memphis Brooks Museum of Art
Gift of the Samuel H. Kress Foundation
61.206

123 Taddeo di Bartolo, Italian (Sienese), 1363–1422
Madonna & Child
The Philbrook Museum of Art, Tulsa, Oklahoma
1961.9.22

124 Russian, 19th century
*Mother of God Kazanskaya (detail from an icon also depicting Christ
Pantocrator, Mother of God Bogulubskaya, St. Charalampios,
and the Crucifixion)*
Egg tempera on panel, 53 x 43 cm.
Maryhill Museum of Art, Goldendale, Washington

125 Ethiopian, c. 14th to 15th century
Blessed Virgin Mary (detail)
From The Miracles of the Blessed Virgin Mary, and the
Life of Hannaea, and the Magical Prayers of "Aheta
Mikaeaeel. The Ethiopic Texts. c. 14th to 15th century
Reproduced by chromolithography in the edition edited
and translated by E. A. Wallis Budge (London: W. Griggs,
1900), frontispiece. General Collection, Beinecke Rare Book
and Manuscript Library, Yale University

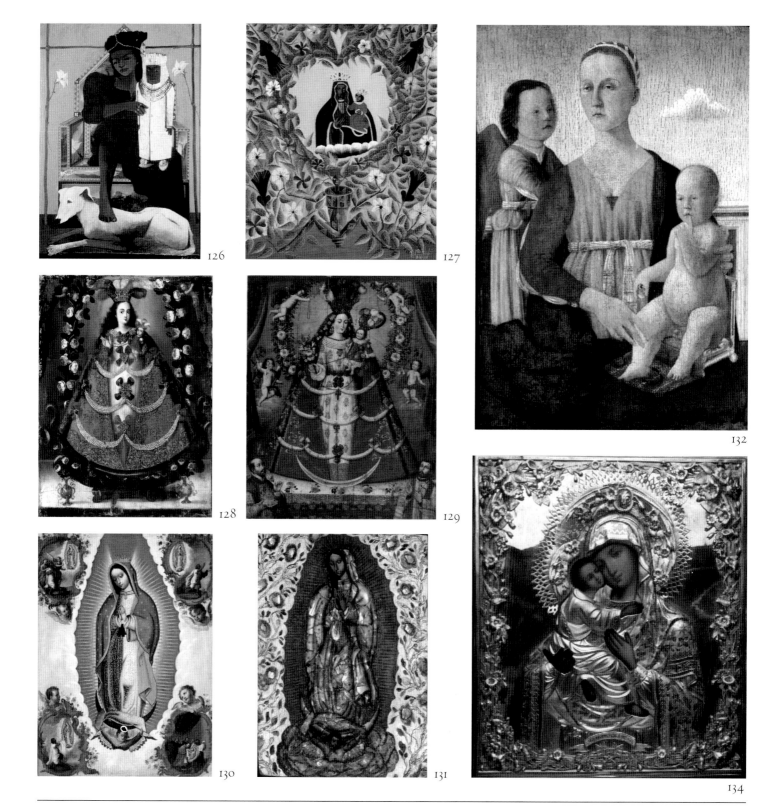

126

127

132

128

129

130

131

134

126 GARDÈRE, PAUL CLAUDE, Haitian, b. 1944
Madonna (Madame Duvalier)
Acrylic on masonite panel, 48 x 33 ³/4 in.
Davenport Museum of Art, Davenport, Iowa
Gift of Dr. Walter E. Neiswanger
94.12

127 MICHEL, YVES, Haitian, b. 1949
Eternal Flowers
Acrylic on canvas, 24 x 20 in.
Davenport Museum of Art, Davenport, Iowa
Gift of Mitchell D. Cohen
81.19

128 PERUVIAN, CUZCO SCHOOL, 18th century
Nuestra Senora del Rosario (Our Lady of the Rosary)
Oil on canvas, 92 x 73 ¹/2 in. (223.6 x 186.5 cm.)
Private collection
Courtesy of Christie's Images, New York

129 ATTRIBUTED TO THE ATELIER OF LEONARDO FLORES,
Bolivian, School of La Paz, 17th century
The Virgin of Pomato
Oil on canvas, 46 ¹/4 x 33 ⁵/8 in. (117 x 85.7 cm.)
Private collection
Courtesy of Christie's Images, New York

130 MEXICAN, 18th century
La Virgen de Guadalupe
Oil on canvas, 32 ⁷/8 x 24 ¹/8 in. (83.5 x 61.3 cm.)
Private collection
Courtesy of Christie's Images, New York

131 MEXICAN, 17th century
La Virgen de Guadalupe
Oil and mother-of-pearl on panel, 26 ³/4 x 19 ¹/2 in.
(68 x 49.5 cm.)
Private collection
Courtesy of Christie's Images, New York

132 FOLLOWER OF PIERO DELLA FRANCESCA, Italian
(Florentine), active 1439–died 1492
Virgin & Child with an Angel
Tempera on panel, 59 x 40.5 cm. (23 ¹/4 x 16 in.)
Courtesy, Museum of Fine Arts, Boston
Marie Antoinette Evans Fund
22.697

134 RUSSIAN, late 19th century
Vladimir Mother of God (Bagomater Vladimirskaya)
Egg tempera on panel, 335 x 29 cm.
Gilded silver riza dated 1874
Maryhill Museum of Art, Goldendale, Washington

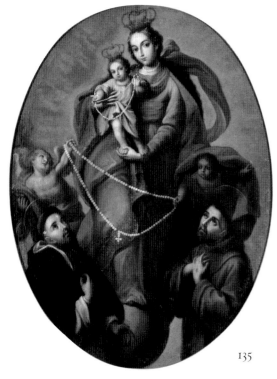

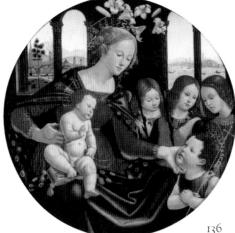

135

136

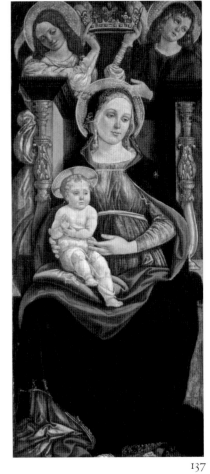

137

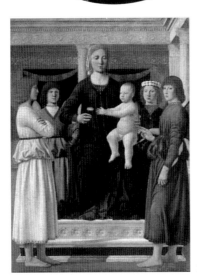

139

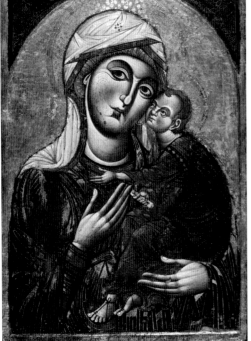

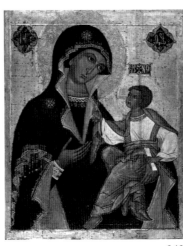

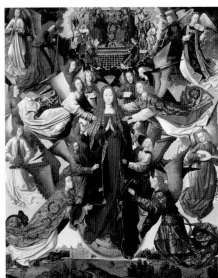

140

141

143

135. Ascribed to Miguel Cabrera, Spanish, 1695–1768
The Madonna of the Rosary
Oil on canvas, 41 1/4 x 31 in.
Davenport Museum of Art, Davenport, Iowa
Gift of C. A. Ficke
25.42

136 Mainardi, Sebastiano, Italian, c. mid to late 16th century
Madonna & Child with St. John & Angels
Tempera on panel, diam. 33 1/2 in.
The Birmingham Museum of Art, Birmingham, Alabama
Gift of the Samuel H. Kress Foundation
1961.97

137 Membrini, Michelangelo di Pietro, Italian, active 1484–1525
Virgin & Child Enthroned with Two Angels Holding a Crown
Tempera on panel, 107.8 x 46.5 cm.
Photograph © 1998, The Art Institute of Chicago. All Rights Reserved.
Mr. and Mrs. Martin A. Ryerson Collection
1933.1016

139 Piero della Francesca, Italian (Florentine), c. 1420–1492
Virgin & Child Enthroned with Four Angels
Oil possibly with some tempera on panel, transferred
to fabric on panel, 107.8 x 78.4 cm. (42 7/16 x 30 7/8 in.)
Sterling & Francine Clark Art Institute, Williamstown, Massachussets
1955.948

140 Master of the Saints Cosmos and Damian
Madonna, Italian, 1265–1285
The Virgin & Child
Tempera on panel, 63.82 x 43.82 cm.
The Fogg Art Museum
Harvard University Art Museums, Cambridge
Gift of Friends of the Fogg Art Museum
1926.41

141 Russian, Moscow School
Our Lady of Jeruselem
The Putnam Foundation
Timken Museum of Art, San Diego

143 Master of St. Lucy Legend, Flemish, active c. 1480–1510
Mary, Queen of Heaven
Oil on wood panel, 1.992 x 1.618 m. (78 7/16 x 63 3/4 in.)
National Gallery of Art, Washington
Samuel H. Kress Collection
1952.2.13

NOTES ON THE TEXT

Half-title page. Translated from the German by Jessie Lemont in Thomas Walsh, *The Catholic Anthology* (New York: The Macmillan Company,1927), p. 474.

Frontispiece. From "The Forty-Four Salutations to the Members of the Body of the Blessed Virgin Mary" in *The Miracles of the Blessed Virgin Mary, and the Life of Hannæa* (St. Anne), *and the Magical Prayers of 'Aheta Mikæaæel*. The Ethiopic texts edited with English translations by E. A. Wallis Budge (London: W. Griggs, 1900), p. 150. General Collection, Beinecke Rare Book and Manuscript Library. Yale University. According the introduction to the English translation, the Ethiopic texts and translations of them are found in the Lady Meux Collection, numbers 2, 3 ,4, and 5. The original manscripts are translations from the Arabic written for the King of Ethiopia c. 14th or 15th century.

9. From Gonzalo de Berceo, *Miracles of Our Lady* (*Milagros de Neustra Señora*, 13th century), translated and with an introduction by Richard Terry Mount and Annette Grant Cash (Lexington: The University Press of Kentucky, 1997), p. 23.

HER YOUTH

12 & 15. From "The Protogospel of James, or *Protevangelium*" in *The Apocryphal New Testament*, edited and translated by Montague Rhodes James (Oxford: Oxford University Press, 1924), p. 41.

16. From the hymn translated from the Abyssinian by Father Baetman in *The Catholic Anthology*.

18. Ibid., p. 42-43.

21. From the poem quoted in full in *The Catholic Anthology*.

HER JOY

22. "Protogospel of James" in *The Apocryphal New Testament*, p. 43.

25. Canto 3, stanza 102.

28. From Rainer Maria Rilke, *The Life of the Virgin Mary*, translated by Stephen Spender (London: Vision Press Limited, 1951), p. 19.

33. Ibid., p. 21.

34. From Paul Claudel, *Coronal*, translated by Sister Mary David, S.S.N.D. (New York: Pantheon Books, 1943), p. 87. Romanus Melodus cited in John Saward, *Redeemer in the Womb: Jesus Living Mary* (San Francisco: Ignatius Press, 1993), p. 41.

36. From "How the Virgin Mary Appeared Unto the Archbishop Theophilus" in *The Miracles of the Blessed Virgin Mary*, pp. 111-131. Mary's apparition and this, Mary's own account of the annunciation, nativity, circumcision, flight into Egypt, slaughter of the innocents, and Jesus as a child, was reported and recorded in Alexandria in the 4th century. Variations on the account appear throughout the centuries in various versions in many languages of the legends of Mary.

38. From the poem quoted in full in *The Catholic Anthology*, p. 177.

40-41. From the poem translated by Henry Wadsworth Longfellow, quoted in full in *The Harper Book of Christian Poetry*, selected and introduced by Anthony S. Mercante (New York: Harper & Row,1972), p. 122.

43. From the hymn translated from the Latin by Thomas Walsh, quoted in full in *The Catholic Anthology*.

45. From the poem translated from the French by Sister Mary David, quoted in full in *Coronal*, p. 23.

54. From "How the Virgin Mary Appeared Unto the Archbishop Theophilus" in *The Miracles of the Blessed Virgin Mary*, pp. 111-131.

56. From the poem translated from the Latin by Thomas Walsh, quoted in full in *The Catholic Anthology*, p. 3.

59. From the poem translated from the French by Sister Mary David, quoted in full in *Coronal*, p. 207.

61. From "How the Virgin Mary Appeared Unto the Archbishop Theophilus" in *The Miracels of the Blessed Virgin Mary*, pp. 111-131.

64-65. From *"La Vierge du Midi"* in Paul Claudel, *Oeuvre Poétique* (Paris: Bibliothèque de la Pléiade, 1957), p. 545. The translation from the French by Barbara Parry is acknowledged with gratitude.

67. From "How the Virgin Mary Appeared Unto the Archbishop Theophilus" in *The Miracles of the Blessed Virgin Mary*, pp. 111-131.

73, 75, 76. From W. H. Auden, *Collected Longer Poems* (New York: Random House, Inc., 1967).

84. From the poem translated by Sister Mary David, quoted in full in *Coronal*, p. 29.

86. From the poem translated from the German by Stephen Spender, quoted in full in *The Life of Mary*, p. 37.

HER SORROW

89, 97, 98. *"Planctus ante nescia"* ("Ignorant before of lamentation") in Karl Young, *Drama of the Medieval Church* (London: Oxford University Press, 1933), pp. 496-498. The translation from the Latin by Stephen M. Wheeler, Pennsylvania State University, is acknowledged with gratitude. Many of the *planctus Mariae* (lamentations of Mary), composed in the 12th and 13th centuries, are related to the Passion play. Some like the *Planctus ante nescia* are monologues, others, dialogues between the Virgin and Christ and/or John the Baptist, sometimes with responses by bystanders, spoken at the foot of the cross. The strophe/antistrophe stanzaic form intensifies the dramatic and emotional impact of the monologue by portraying the tension betweem Mary's natural maternal anguish and her perfect obedience to the divine plan. The Virgin Mary speaks only four times in the New Testament. Her final words are spoken at the marriage feast at Cana. The tradition of the *planctus Mariae* provides the Virgin Mary with a voice and an active rather than passive presence as Christ dies to redeem humankind, prefiguring her eternal role as mediatrix between Christ and the descendents of Adam and Eve.

91. Translated from the Latin by Thomas Walsh in *The Catholic Anthology*, p. 78. This dialogue between with the Virgin and Christ at the foot of the cross, c. 1288-1388, which evolves into a monologue spoken by Mary is evidence of the enduring influence of the *planctus Mariae*.

93. Cited in Marina Warner, *Alone of All Her Sex* (New York: Alfred A. Knopf, 1976), p. 209.

HER GLORY

103. From "The Discourse of Theodosius" in *The Apocryphal New Testament*, p. 188-200.

107. From the poem published in Gerard Manley Hopkins, *The Collected Poems* (London/New York: Oxford University Press, 1967), pp. 93-94.

108. From the poem quoted in full in *The Book of Modern Catholic Verse*, compiled by Theodore Maynard (New York: Henry Holt and Company, 1926), p. 331.

111. From *The Miracles of the Blessed Virgin Mary*, p. 16.

112. From the poem quoted in full in *The Catholic Anthology*, p. 135.

115. From the poem translated from the Spanish by Thomas Walsh, quoted in full in *The Catholic Anthology*, p. 115.

120-121. From *The Miracles of the Blessed Virgin Mary*, p. 10.

124. From the hymn translated from the Greek by R. J. Schork, published in full in his *Sacred Song from the Byzantine Pulpit: Romanos the Melodist* (Gainesville, et al.: University Press of Florida, 1955), p. 213. Active in Constantinople, c. 527 to 565, Romanos the Melodist (or Romanus Melodus as he is also known) was the creator of the *kontakion*, a sung sermon in the form of a poem chanted from the pulpit. The *kontakion*, a unique form of religious instruction, is in equal parts an exegesis of scripture and a moral lesson. Portions of these hymn/sermons are still chanted today in Greek Orthodox churches.

126. From the poem translated from the Italian by Laura Anna Stortoni, quoted in full in Lucia Chiavola Birnbaum, *Black Madonnas: Feminism, Religion, and Politics in Italy* (Boston: Northeastern University Press, 1993), footnote 96, p. 227.

128. From "The Forty-Four Salutations to the Members of the Body of the Blessed Virgin Mary" in *The Miracles of the Blessed Virgin Mary*, p. 150.

129. "The Three Offices of Our Blessed Lady" in *The Primer more ample and in a new order: containing the three offices of the B. Virgin Mary in Latin and English, all all offices and devotions which were in former primers* (Roven: Printed by David Mavrry, 1669). University of Michigan Microfilm, p. 198.

130. From the poem translated from the Spanish by Thomas Walsh, quoted in full in *The Catholic Anthology*.

133. From the 366th lyric in *Rime Sparse*. My translation from the Italian.

136. From the poem translated from the Italian by Thomas Walsh, quoted in full in *The Catholic Anthology*, p. 94.

142. From Gonzalo de Berceo, *The Miracles of Our Lady*, p. 25-26. From a Latin antiphon traditionally sung after Evening Prayer in Lent.

SELECTED BIBLIOGRAPHY

Birnbaum, Lucia Chiavola. *Black Madonnas: Feminism, Religion, and Politics in Italy*. Boston: Northeastern University Press, 1993.

Budge, Sir Ernest Alfred Wallis, ed. and trans. *The Miracles of the Blessed Virgin Mary, and the Life of Hanæa (Saint Anne), and the Magical Prayers of 'Aheta Mikæaæl*. London: W. Griggs, 1900.

Carroll, Eamon R. *Understanding the Mother of Jesus*. Wilmington, Del.: M. Glazier, 1979.

Carroll, Michael P. *The Cult of the Virgin Mary: Psychological Origins*. Princeton, N. J.: Princeton University Press, 1986.

Castillo, Ana, ed., *Goddess of the Americas (La Diosa de las Americas): Writings on the Virgin of Guadalupe*. New York: Riverhead Books, 1996.

Catholic Church. *Mary, God's Yes to Man: Pope John Paul II Encyclical Letter, Mother of the Redeemer*. San Francisco: Ignatius Press, 1988

Cunneen, Sally. *In Search of Mary: The Woman and the Symbol*. New York: Ballantine Books, 1996.

Damian, Carol. *The Virgin of the Andes: Art and Ritual in Colonial Cuzco*. Miami Beach: Grassfield Press, 1995.

Durham, Michael. S. *Miracles of Mary: Apparitions, Legends, and Miraculous Works of the Blessed Virgin Mary*. San Francisco: HarperSanFrancisco, 1995.

Gatta, John. *American Madonna: Images of the Divine Woman in Literary Culture*. New York: Oxford University Press, 1998.

Graef, Hilda. *Mary: A History of Doctrine and Devotion*. 2 vols. London/New York, 1963.

Guerber, Helene Adeline. *Legends of the Virgin and Christ, with Special References to Literature and Art*. New York: Dodd, Mead, 1896.

Guitton, Jean. *The Blessed Virgin*. London, 1952.

Hurll, Estelle M. *The Madonna in Art*. Boston: L. C. Page and Company, 1897.

James, Montague Rhodes, trans. *The Apocryphal New Testament*. Oxford: The Clarendon Press, 1924.

Jameson, Anna, ed., with additional notes by Estelle M. Hurll. *Legends of the Madonna*. Boston/New York: Houghton Mifflin, 1895.

Johnson, Geraldine A., and Sara F. Matthews Grieco, eds. *Picturing Women in Renaissance and Baroque Italy*. Cambridge: Cambridge University Press, 1997.

Mâle, Émile. *Religious Art from the Twelfth to the Eighteenth Century*. New York, 1970.

McHugh, John. *The Mother of Jesus in the New Testament*. London, 1975.

Miegge, Giovanni. *The Virgin Mary—The Roman Catholic Marian Doctrine*. Trans. by Waldo Smith. London/Toronto, 1955.

Neumann, Erich. *The Great Mother: An Analysis of the Archetype*. Trans. Ralph Manheim. New York, 1955.

Newman, John Henry. *Mary, the Second Eve: Extracts for the Times from the Writings of John Henry Newman*. Comp. by Eileen Breen. Rockford, Ill.: TAN Books and Publisher, 1982.

Pelikan, Jarislov, David Flusser, and Justin Lang. *Mary: Images of the Mother of Jesus in Jewish and Christian Perspective*. Philadelphia: Fortress Press, 1986.

Rahner, Karl. *Mary, Mother of the Lord*. New York, 1963.

Rahner, Karl. *Mary, Mother of the Lord: Theological Meditations*. Trans. by W. J. O'Hara. New York: Herder and Herder, 1963.

Saward, John. *Redeemer in the Womb: Jesus Living in Mary*. San Francisco: Ignatius Press, 1993.

Tavard, George H. *The Thousand Faces of the Virgin Mary*. Collegeville, Minnesota: The Liturgical Press, 1996.

Voragine, Jacobus de. *The Golden Legend*. Translated and adapted from the Italian by Granger Ryan and Helmut Ripperger. New York, 1941, 1969.

Walsh, Michael J. *A Dictionary of Devotions*. Turnbridge Wells, Kent: Burns & Oates, 1993.

Warner, Marina. *Alone of all her Sex: The Myth and Cult of the Virgin Mary*. New York: Alfred A. Knopf, 1976.

FEAST DAYS OF THE VIRGIN

JANUARY
I The Solemnity of the Mother of God (Western Tradition, Solemn Feast Day)

FEBRUARY
2 The Purification of the Virgin, (Eastern Tradition)
11 Our Lady of Lourdes (Western Tradition, Memorial Day)

MARCH
25 The Annunciation (Eastern and Western Traditions, Solemn Feast Day)

LATE SPRING/EARLY SUMMER: First Saturday after the second Sunday after Pentecost
The Immaculate Heart of Mary (Western Tradition, Memorial Day)

MAY THE MONTH OF MARY

JULY
2 The Visitation (Eastern and Western Traditions)
16 Our Lady of Mount Carmel (Western Tradition, Memorial Day)

AUGUST
5 Dedication of the Basilica of Saint Mary Major (Western Tradition, Memorial Day)
8 The Conception of the Blessed Virgin Mary (Eastern and Western Traditions,
 Solemn Feast Day)
15 The Dormition of the Virgin (Eastern Tradition)
 The Assumption of the Virgin (Western Tradition, Solemn Feast Day)
16 The Assumption of the Virgin (Eastern Tradition)
22 The Queenship of Mary (Western Tradition, Solemn Feast Day)

SEPTEMBER
8 The Birth of Mary (Eastern andWestern Traditions)
12 The Holy Name of Mary (Western Tradition, Memorial Day)
15 Our Lady of Sorrows (Western Tradition, Memorial Day)

OCTOBER THE MONTH OF THE ROSARY
7 Our Lady of the Rosary (Western Tradition, Memorial Day)

NOVEMBER
21 The Presentation of the Virgin in the Temple (Western Tradition, Memorial Day)

DECEMBER
8 The Immaculate Conception (Western Tradition, Solemn Feast Day)
12 Our Lady of Guadalupe

ACKNOWLEDGMENTS

The author and Chameleon Books are grateful for the reproduction services provided by the museums and archives which have made the production of this book both possible and a pleasure. Our thanks to James Petersen, Timken Museum of Art; Roberto Prcela and Emily S. Rosen, The Cleveland Museum of Art; Marcia Erickson, North Carolina Museum of Art; Mary Sluskonis, Museum of Fine Arts, Boston; Martha Asher, Sterling and Francine Clark Art Institute; Nancy Stanfield, National Gallery of Art; Steve Jones and Lynn Braunsdorff, Beinecke Rare Book and Manuscript Library; Michael Goodison, Smith College Art Museum; Elizabeth Gombosi, Fogg Art Museum; Deborah Labatte, Minneapolis Institute of Arts; Leesha Bonila, Phoenix Art Museum; Christina Geijer, Christie's Images; Anne Adams, Kimbell Art Museum; Stacy Lynette Sherman, Nelson-Atkins Museum of Art; Ruth Janson, Brooklyn Museum of Art; Josie E. De Falla and Colleen Schafroth, Maryhill Museum of Art; Patrick Sweeney, Davenport Museum of Art; Lee Mooney, Toledo Museum of Art; Jacklyn Burns, J. Paul Getty Museum of Art; Pamela Steudemann, Art Institute of Chicago; Jennifer Zapanta, Norton Simon Museum of Art; Ann Eichelberg, Portland Art Museum, Rebecca Engelhardt, The John and Mable Ringling Museum of Art, Luisa Orto and Joanne Greenbaum, Art Resource, Warren F. Bunn, Herbert F. Johnson Museum of Art, Cornell University, Susan Lucke, Lowe Art Museum, University of Miami, Lori A. Mott, University of Michigan Museum of Art, and Melissa Faulkner, Birmingham Museum of Art. We thank Frank Mason for providing the transparency of his painting, *Madonna and Child*.

The author is also indebted to a number of people—friends, family, and colleagues—for helpful suggestions, professional expertise, useful contributions, and reliable counsel. Grateful thanks are owed Stephen M. Wheeler, Barbara Parry, Vicki Brooks, Mary Bellino, Ruth Julian, David King, Caroline Carrithers, Paula Debnar, Richard Whelan, KC Scott, Margaret Keith and Ronald Johnson. Arnold Skolnick's extraordinary sensitivity to the synergy between art and language, typography and book design is acknowledged with special thanks and appreciation.